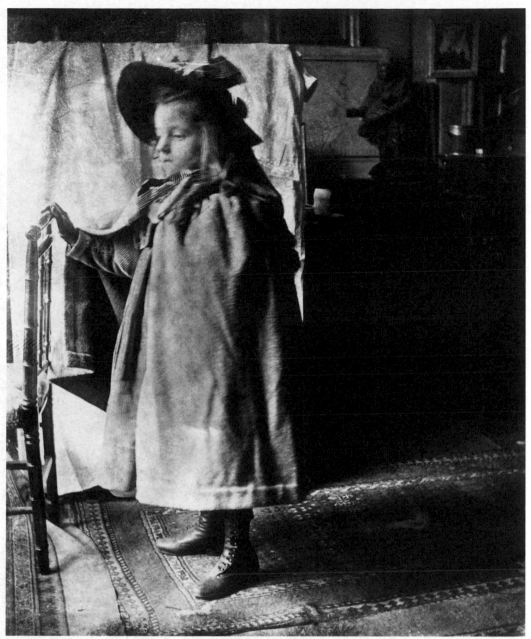

Fig. 1 Edgar Degas or René de Gas, *Odette Degas in the Studio of Her Uncle, Edgar Degas.* Bibliothèque Nationale de France, Paris.

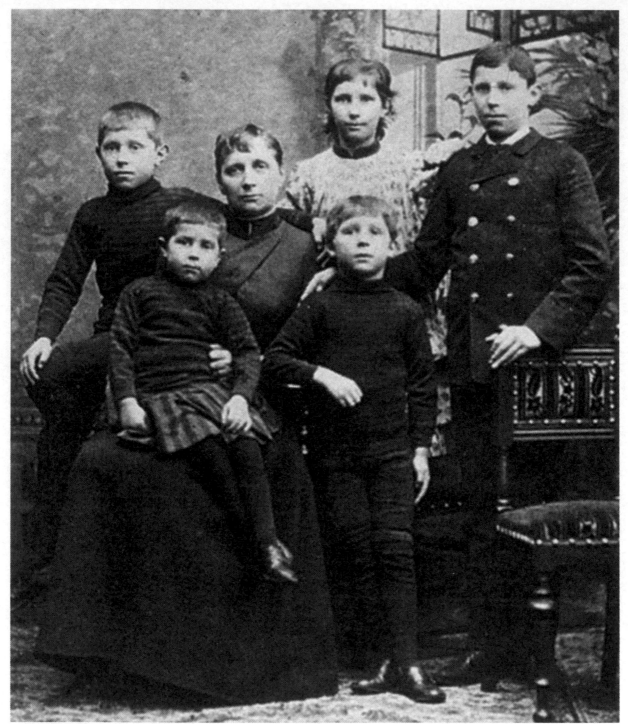

Fig. 2 Mette Gauguin, Wife of the Artist Paul Gauguin, with Their Five Children in Copenhagen, 1888.

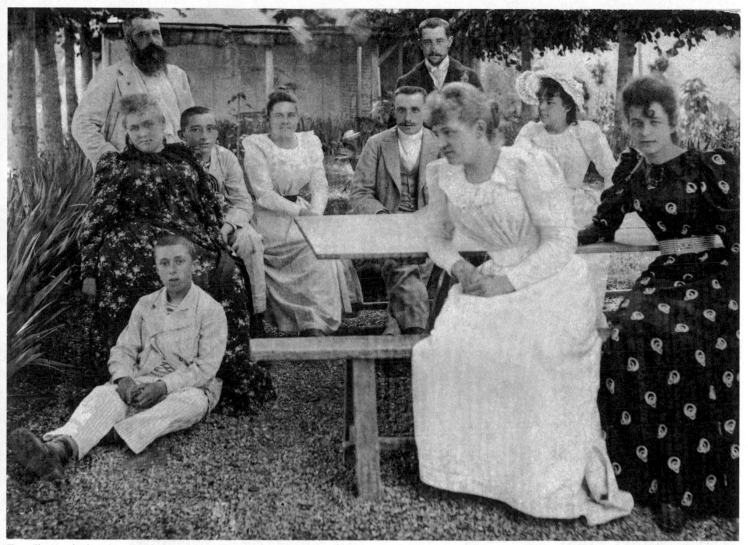

Fig. 3 *The Hoschedé-Monet Family Outside the House, Giverny, c. 1886.*
Philippe Piguet Collection.

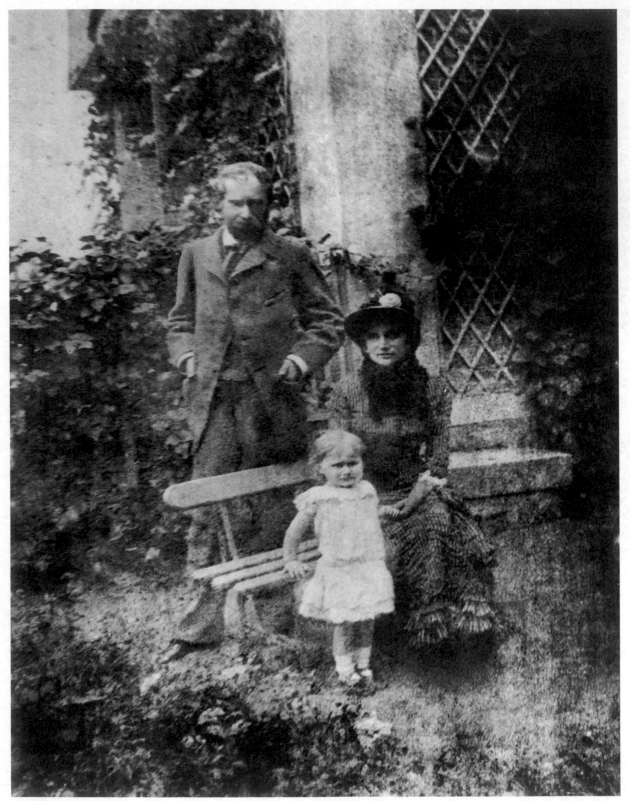

Fig. 4 *Eugène Manet, Berthe Morisot, and Their Daughter Julie in Bougival*, c. 1882.
Musée Marmottan Monet, Paris.

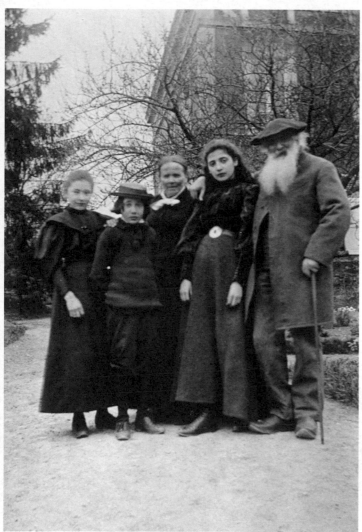

Fig. 5 *The Pissarro Family in Éragny, c. 1893–1897.*
Pissarro Family Archives.

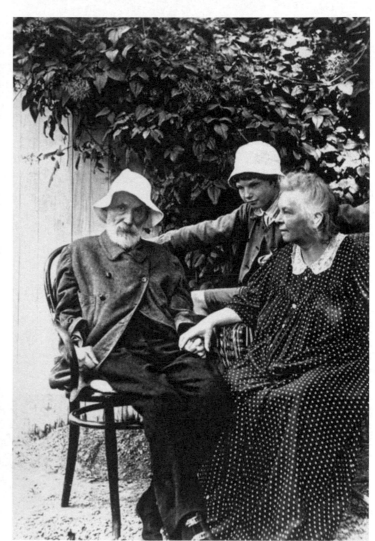

Fig. 6 *Pierre-Auguste, Claude, and Aline Renoir, 1912.*

Family

Fig.7 Ange Leccia, *Laure*, 1998. Video, 36 min. 2 sec.
Musée des Impressionnismes, Giverny.

Por

Fig. 8 *Julie Wearing a Hat, 1894.*
Musée Marmottan Monet, Paris.

traits:

Figs. 9, 10 Laurence Reynaert, *Portraits*, 2000–2003.
Black-and-white prints on baryta paper, 16 × 19½ in. (40 × 50 cm).
Frac Normandie Collection, Sotteville-lès-Rouen.

Chil

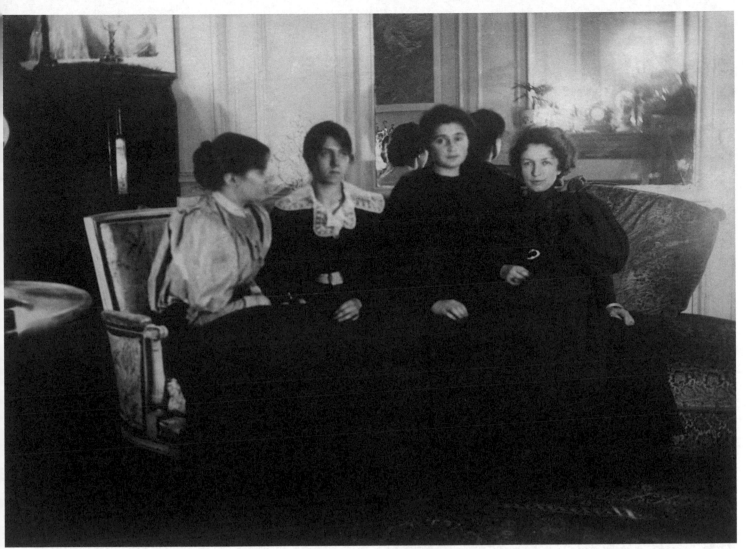

Fig. 11 Edgar Degas, *Paule Gobillard, Jeannie Gobillard, Julie Manet, and Geneviève Mallarmé*, 1895. The Metropolitan Museum of Art, New York.

dren

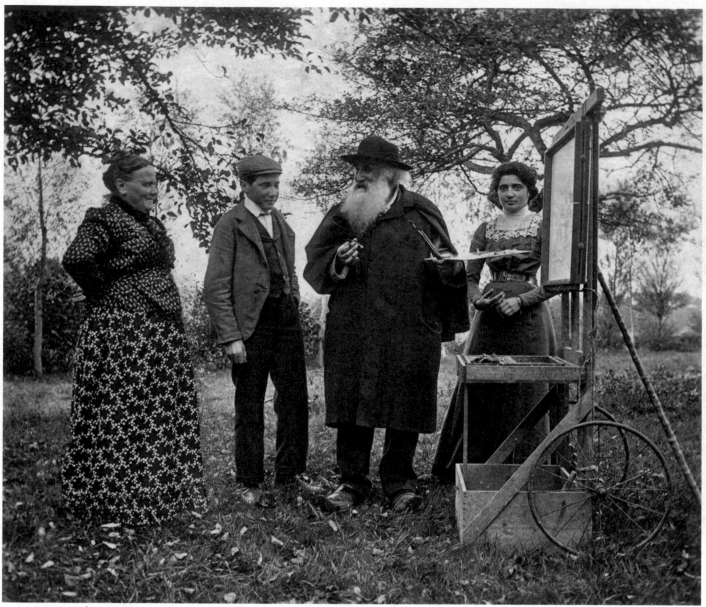

Fig. 12 Julie, Paul-Émile, Camille, and Jeanne Pissarro, 1905.

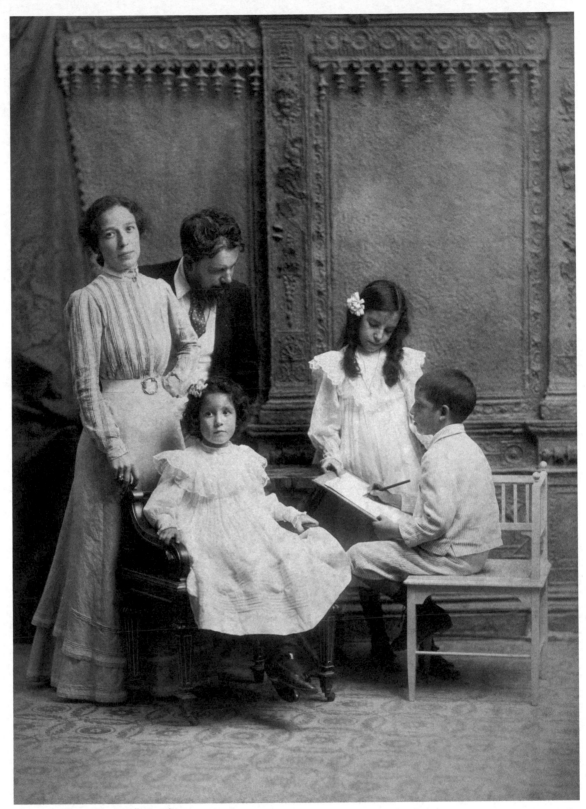

Fig. 13 A. Garcia, *The Sorolla Family*, 1900.
Private collection.

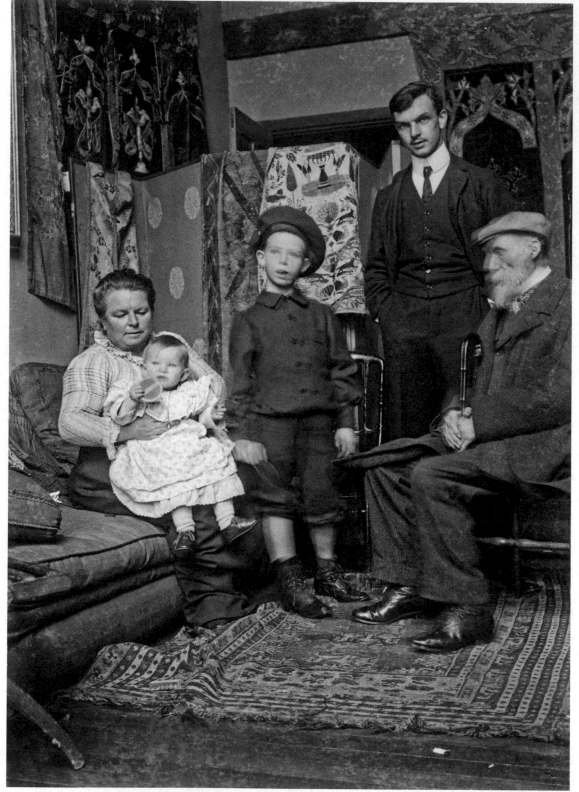

Fig. 14 *The Renoir Family in the Painter's Studio*, c. 1902–1903.
Musée d'Orsay, Paris.

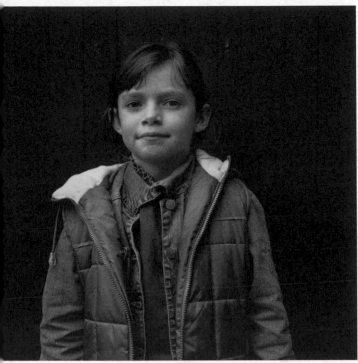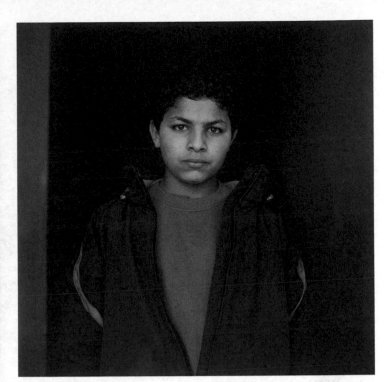

Figs. 15, 16 Laurence Reynaert, *Portraits*, 2000–2003.
Black-and-white print on baryta paper, 16 × 19½ in. (40 × 50 cm).
Frac Normandie Collection, Sotteville-lès-Rouen.

pressio

Fig. 17 Martial Caillebotte, *Jean and Geneviève Caillebotte*, n.d.

nist

Fig. 18 *Clovis, Paul, and Aline Gauguin, c. 1884.*

Fig. 19 *Georges and Félix Standing, Lucien and Ludovic-Rodo Seated, Camille Pissarro, the Maid Juliette (?), Julie with Paul-Émile on Her Knees, Jeanne and Eugénie Estruc, c. 1886.* Pissarro Family Archives.

Family Portraits

Children in Impressionist Art

Editorial direction by
Cyrille Sciama and Marie Delbarre

Giverny
musée
impressionnismes

Flammarion

Foreword

In spring 2023, the Musée des Impressionnismes Giverny presented a major exhibition on a theme that is immensely popular with the public: children in impressionist painting. The subject is both vast and complex, given the extent to which exhibitions and publications have disseminated these joyous images of a carefree period of life. The exhibition and this accompanying work explore the relationship between the artists, as parents, and their children. In the works of painters such as Claude Monet, Camille Pissarro, Pierre-Auguste Renoir, and Berthe Morisot, portrayals of childhood vary depending on the disposition of each artist and their own parental or domestic situation. To be a child of impressionism was no simple matter. To capture this complexity, the book is divided into sections that focus on different aspects of family concerns and socio-economic contexts. From the 1880s, when the Jules Ferry Laws enacted compulsory education in France, to the upheavals of World War I (1914–1918), which tore families apart, the concept of childhood underwent many major changes, which the impressionists portrayed in their work. Some artists who never became parents—Mary Cassatt and Edgar Degas, among others—painted portraits of the children in their social circles: a paradox that lends a certain sharp insight to their atypical perspective.

This volume also addresses the themes of education, leisure activities and games, and the slow progression toward adulthood, placing a special focus on adolescence, which is reinforced by a selection of works by contemporary photographers including Martin Parr and Rineke Dijkstra. In this way, the museum pursues its commitment to establishing a dialogue between impressionism and the present day.

For this exhibition and its accompanying catalog, the museum once again received the unwavering and generous support of the Musées d'Orsay et de l'Orangerie—Valéry Giscard d'Estaing. We are extremely grateful to the many museums and public and private collections in France and abroad that agreed to part with major works for a few months. We would also like to thank our patrons and friends, as well as the museum team, who embraced this exhibition wholeheartedly.

Sébastien Lecornu
President of the Musée des Impressionnismes Giverny
Minister for Armed Forces

Christophe Leribault
Vice president of the Musée des Impressionnismes Giverny
President of the Musées d'Orsay et de l'Orangerie—Valéry Giscard d'Estaing

Cyrille Sciama
General director and chief curator of the
Musée des Impressionnismes Giverny

Facing page:
Winslow Homer,
Beach Scene, detail, c. 1869.
Carmen Thyssen-Bornemisza
Collection, on long-term loan
to the Museo Nacional
Thyssen-Bornemisza, Madrid.
Fig. 132

Foreword

The Caisse d'Épargne Normandie is proud to be the principal patron of the Musée des Impressionnismes Giverny for the twelfth consecutive year. A cooperative bank committed to social solidarity and serving both individuals and communities, the Caisse d'Épargne Normandie supports the museum's dynamic approach: its choice of innovative exhibitions, its acquisition of artworks, and its many projects that bring art to life in the bucolic setting of Giverny. Our two institutions, each in its own way, have a unique role to play in cultivating the development and appeal of Normandy, through our shared values: the fostering of close relationships, whether it be with clients or visitors, as well as a commitment to making art accessible to all, and to balancing economic performance with social responsibility.

In spring 2023, the museum—a renowned center of impressionism in Normandy—held an exhibition dedicated to children in impressionist art, inviting visitors to discover the different facets of childhood in the late nineteenth century; this volume continues to explore these themes. Works by Pierre-Auguste Renoir, Claude Monet, Camille Pissarro, Mary Cassatt, and Berthe Morisot convey the impressionists' enthusiasm for depicting their families, as well as their friends, art dealers, and patrons. This book, just like the exhibition, brings to light the ambiguity of this subject and reveals a hidden reality, while also presenting the tender, private moments and daily life of children in the time of the impressionists.

I am certain that this publication will prove a resounding success, just as the museum's previous exhibitions have.

Bruno Goré
Chairman of the board of directors of the Caisse d'Épargne Normandie

Facing page:
Claude Monet,
Jean Monet dans son berceau
(*The Cradle—Camille with
the Artist's Son Jean*), detail, 1867.
National Gallery of Art,
Washington, D.C.
Fig. 25

Preface

The theme of children in impressionism and nineteenth-century art is as well known as it is vast, and has been the subject of many exhibitions and publications. Yet few of these have actually focused on the children of impressionist artists. What was it like to be the son or daughter of an impressionist painter? How did they live their own lives and develop their own personalities or talents when they had last names like Pissarro, Renoir, or Monet? Was there an impressionist lifestyle that influenced the education and lives of these artists' children? What personal stories underlie the often engaging and sometimes ambiguous images of childhood left to us by the impressionists?

The concept was appealing, but a way had to be found to address such an immense theme. From the outset, it seemed pertinent to structure this book, as well as the exhibition, into broad chapters that could accommodate a multitude of social, economic, psychological, and personal histories. We wanted to create a truly informative experience—from motherhood to toys to education, and from the garden to the beach, encompassing portraits of the artists' children themselves. This volume provides an opportunity to discover the often unknown or unfamiliar facets of life as it was for the children of Monet, Renoir, Pissarro, and Morisot, but also for those who knew Cassatt, Degas, or other less prominent artists, some of whom were closer in age to the children of the impressionists than to the painters themselves, and who have contributed, in their own way, to a form of heritage. A special focus is placed on adolescence: the age of possibilities and of ambiguity that provided artists with unlimited inspiration. Their work reveals that they often projected much of themselves and their own doubts onto the subject.

It seemed relevant and complementary to take a look at contemporary works as well, as the Musée des Impressionnismes Giverny strives to do in each of its exhibitions. Throughout this book, a selection of photographs of children and adolescents by Martin Parr, Laurence Reynaert, Rineke Dijkstra, and Elaine Constantine, from the years 1984 to 2015, appear alongside impressionist works. In these photographs, humor vies with melancholy, questioning gazes with arrogant stares—in other words, they offer a highly sensitive depiction of this unpredictable age. This section is further enriched by Ange Leccia's beautiful film *Laure*, about a teenager who is viewed through the porthole of a ferry. The work was generously donated to the museum by the artist, to whom we are extremely grateful.

Such an exhibition and publication would not have been possible without the generosity of the lenders, both public and private, from France and abroad, who parted with their works for the duration of the event. To them we would like to express our sincerest thanks. The support of the Établissement Public du Musée d'Orsay et du Musée de l'Orangerie–Valéry Giscard d'Estaing was once again indispensable, and we would like to thank its president, Christophe Leribault, in particular, for his support.

This volume owes much to the authors who kindly agreed to contribute to it: Sylvain Cordier, Dominique Lobstein, Marianne Mathieu, Sylvie Patry, Philippe Piguet, Lionel Pissarro, Marie Simon, Philippe Thiébaut, and Elise Wehr. We are very grateful to them for sharing their knowledge on what was, at times, a deeply personal subject. Annie Dufour, who oversaw the editorial process of the original French catalog, and Valérie Reis, who managed the picture research, provided invaluable assistance.

Cyrille Sciama and Marie Delbarre

Facing page:
Mary Fairchild MacMonnies,
Roses et lys (Roses and Lilies),
detail, 1897.
Musée des Beaux-Arts, Rouen.
Fig. 34

23

This book was originally published in French to accompany the exhibition *Les Enfants de l'impressionnisme (Children of Impressionism)*, organized by the Musée des Impressionnismes Giverny, March 31–July 2, 2023.

The Musée des Impressionnismes Giverny is most grateful for the generosity of the Cercle des Mécènes du Musée des Impressionnismes Giverny, Les Amis du Musée, and the Caisse d'Épargne Normandie.

Cercle des
Mécènes du musée
des impressionnismes
Giverny

Les Amis
du Musée
des Impressionnismes
de Giverny

CAISSE
D'ÉPARGNE
Normandie

Founding Members of the Musée des Impressionnismes Giverny:

DÉPARTEMENT DE
L'EURE
en Normandie

RÉGION
NORMANDIE

Seine
Normandie
AGGLOMÉRATION

Ville de Vernon
EN NORMANDIE

EPMO
ÉTABLISSEMENT PUBLIC
DU MUSÉE D'ORSAY
ET DU MUSÉE DE L'ORANGERIE
VALÉRY GISCARD D'ESTAING

Exhibition curators

Cyrille Sciama,
general director and chief curator of the Musée des Impressionnismes Giverny

Marie Delbarre,
research assistant, Musée des Impressionnismes Giverny

Musée des Impressionnismes Giverny

President
Sébastien Lecornu

Vice president
Christophe Leribault

General director
Cyrille Sciama

General secretary
Cécile Stumpf-Meraly

Administration
Vincent Gosselin, Francine Le Massu, Xavier Poc

Curatorial assistance
Marie Delbarre, Valérie Reis, Véronique Roca

Maintenance
Denis Atanné, Didier Guiot, and the maintenance team

Visitor services and security
Olivier Touren and his team

Communication and marketing
Laurine Dallard, Aurore Hoair Fouquet, Romane Pinard, Charlène Potier

Press
Valérie Solvit Communication

Public programs and education
Élisa Bonnin, Éléonore Coutau-Bégarie, Charlotte Guimier, Laurette Roche, and the education team

Bookstore and boutique
Cassandre Baron, Sandrine Couture, Carole Thuillier

Gardens
Emmanuel Besnard, Nicolas Feray, Aurélien Le Bras

Lenders

Belgium
Musée d'Ixelles, Brussels
Museum voor Schone Kunsten, Ghent

France
Bibliothèque de l'Institut National d'Histoire de l'Art, Jacques Doucet Collection, Paris
Centre National des Arts Plastiques, Paris
Château-Musée, Nemours
Frac Normandie, Sotteville-lès-Rouen
Frac Provence-Alpes-Côte-d'Azur, Marseille
Musée Albert-André, Bagnols-sur-Cèze
Musée Carnavalet – Histoire de Paris, Paris
Musée d'Allard, Montbrison
Musée d'Art Moderne et Contemporain, Strasbourg
Musée d'Art Sacré du Gard, Pont-Saint-Esprit
Musée de Dieppe, Dieppe
Musée de Grenoble, Grenoble
Musée de l'Orangerie, Paris
Musée de Pont-Aven, Pont-Aven
Musée des Beaux-Arts, Bordeaux
Musée des Beaux-Arts, Limoges
Musée des Beaux-Arts, Lyon
Musée des Beaux-Arts, Pau
Musée des Beaux-Arts, Reims
Musée des Beaux-Arts, Rouen
Musée des Beaux-Arts, Tours
Musée des Ursulines, Mâcon
Musée d'Orsay, Paris
Musée Eugène-Boudin, Honfleur
Musée Marmottan Monet, Paris
Musée Sainte-Croix, Poitiers
Musée Unterlinden, Colmar
Petit Palais, Musée des Beaux-Arts de la Ville de Paris, Paris

Germany
Arp Museum Bahnhof Rolandseck/Rau Collection for UNICEF, Remagen

Italy
Intesa Sanpaolo Collection, Milan
Musei Civici, Mantua
Palazzo Pitti, Galleria d'Arte Moderna, Florence

Spain
Carmen Thyssen-Bornemisza Collection, on long-term loan to the Museo Nacional Thyssen-Bornemisza, Madrid
Museo Sorolla, Madrid

Switzerland
Musée du Petit-Palais, Geneva

United Kingdom
National Galleries of Scotland, Edinburgh
Royal Cornwall Polytechnic Society Collection, Falmouth Art Gallery, Falmouth
Sheffield Museums Trust, Sheffield

United States
Art Institute of Chicago, Chicago
National Gallery of Art, Washington, D.C.
Virginia Museum of Fine Arts, Richmond
Wadsworth Atheneum Museum of Art, Hartford
Yale University Art Gallery, New Haven

David and Ezra Nahmad Collection
Elaine Constantine, courtesy of Industry Art
Indivision Petiet
R & G Little Collection
Rineke Dijkstra, courtesy of Marian Goodman Gallery

And the private collectors who wish to remain anonymous

Editorial coordination: Annie Dufour, ad.édition
Design: Léo Grunstein

Musée des Impressionnismes Giverny
Picture research: Valérie Reis
Editorial supervision: Marie Delbarre

Flammarion
Editorial directors: Kate Mascaro and Julie Rouart
Editor: Helen Adedotun
Administration manager: Delphine Montagne
Translation from the French: Kate Robinson
Cover design: Audrey Sednaoui
Copyediting: Penelope Isaac
Typesetting: Alice Leroy
Proofreading: Rebecca du Plessis
Additional picture research: Lucía Pasalodos
Production: Corinne Trovarelli
Color separation: Les Artisans du Regard
Printed in Slovenia by Florjancic

Originally published in French as *Les Enfants de l'impressionnisme*
© Musée des Impressionnismes Giverny, Giverny, 2023
© Éditions Flammarion, Paris, 2023

English-language edition
© Musée des Impressionnismes Giverny, Giverny, 2024
© Éditions Flammarion, Paris, 2024

24 25 26 3 2 1

ISBN: 978-2-08-042630-7
Legal Deposit: 03/2024

Acknowledgments

Cyrille Sciama and Marie Delbarre wish to express their warmest thanks to Sébastien Lecornu, president of the Musée des Impressionnismes Giverny, and Christophe Leribault, president of the Musées d'Orsay et de l'Orangerie—Valery Giscard d'Estaing, for the trust they have shown in them and for their support throughout the project.

The exhibition could never have taken place without the unfailing support of the Departmental Council of Eure, in particular Alexandre Rassaërt, Pascal Lehongre, Pierre Stussi, Orlane Jauregui, Ludivine Ponte, and all of their teams.

The members of the board of trustees and scientific council of the Musée des Impressionnismes Giverny have also demonstrated their loyalty and faith in the project.

The museum would also like to express its appreciation for the generosity of the Cercle des Mécènes (Patrons' Circle) of the Musée des Impressionnismes Giverny, under its president Alain Missoffe; Les Amis du Musée (Friends of the Museum), under its president Charles-Élie de La Brosse; as well as that of the museum's principal patron, the Caisse d'Épargne Normandie, under its president Bruno Goré.

The curators extend their sincere thanks to the teams of the Musée des Impressionnismes Giverny: Denis Atanné, Cassandre Baron, Emmanuel Besnard, Élisa Bonnin, Audrey Bonvallet, Éléonore Coutau-Bégarie, Sandrine Couture, Laurine Dallard, Hassan El Oundi, Nicolas Feray, Aurore Fouquet, Christian Géraud, Vincent Gosselin, Charlotte Guimier, Didier Guiot, Emmanuel Hargous, Quentin Hautot, Frédéric Ksiezarczyk, Nathalie Lanéelle, Aurélien Le Bras, Laurent Lefrançois, Francine Le Massu, Ludovic Louis, Pascal Mérieau, Céline Mittelette, Emmanuelle Moy, Romane Pinard, Xavier Poc, Charlène Potier, Adeline Ramos-Munoz, Emmeline Raout, Valérie Reis, Véronique Roca, Laurette Roche, Cécile Stumpf, Carole Thuillier, Olivier Touren, Vincent Turquet, and Stéphane Vigouroux.

They extend their gratitude to the authors who contributed to this book: Sylvain Cordier, Dominique Lobstein, Marianne Mathieu, Sylvie Patry, Philippe Piguet, Lionel Pissarro, Marie Simon, Philippe Thiébaut, and Elise Wehr. They are particularly grateful to Annie Dufour for her contribution to the project, and to Léo Grunstein for his design. Valérie Solvit and her agency provided invaluable assistance.

The curators would also like to thank all those who helped in the preparation of the exhibition and this book: Ikram Achi, L. Lynne Addison, Patricia Allerston, Sylvain Amic, Marián Aparicio, Catherine Arnold, Jacqui Austin, Sophie Barthélémy, Stéphane Bayard, Viola Bender, Sophie Bernard, Claire Bernardi, Maryse Bertrand, Jérôme Bessière, Susanne Blöcker, Stephen Bonadie, Armelle Bonneau-Alix, Claire Bray, Lizzy Broughton, Jeffrey N. Brown, Myriam Bru, Mary Busick, Thierry Cahn, Gemma Cammidge, Anne Carre, Delphine Charpentier, Éric de Chassey, Ludovic Chauwin, Pauline Choulet, Estelle Clavel, Simonella Condemi, Elaine Constantine, Michele Coppola, Caroline Corbeau-Parsons, Stephanie D'Alessandro, Jessica Degain, Catherine Delot, Erik Desmazières, Rineke Dijkstra, Christiane Dole, Clémence Ducroix, Guillaume Dufresne, Marjorie Dugerdil Klein, Coralie Dupinet, Muriel Enjalran, Juliette Eoche-Duval, Thomas Eschbach, Pascal Faracci, Marie-Louise Favre, Kaywin Feldman, Benjamin Findinier, Pascal Foulon, Jérôme Fourmanoir, Valérie Fours, Frances Fowle, David Gadanho, Nathalie Gaillard, Aurélie Gavoille, Claude Ghez, Émilie Gil, Mary Godwin, Frédérique Goerig-Hergott, Ann Goldstein, Claire Gooden, Meg Grasselli, Darrell Green, Gloria Groom, Yoann Groslambert, Sarah Guernsey, Valérie Guillaume, Servane Hardouin, Annette Haudiquet, Josef Helfenstein, Pierre Ickowicz, Fanny Jacquinet, Hélène Jagot, Kimberly A. Jones, Julie Jousset, Laurence Kanter, Sophie Kervran, Oliver Kornhoff, François Lafabrié, Anne Laffont, Paul Lang, Claire Leblanc, Sir John Leighton, Astrid Lerouge, Matthieu Leverrier, Morwenna Lewis, Susanne Leydag, Marie Lhiaubet, Elizabeth Lindley, Ruth and Gary Little, Nathalie Louis, Paula Luengo, Lisa M. MacDougall, Laura Majan, Laurène Marin, Alice Marsal, Raphaële Martin-Pigalle, Aurore Méchain, Mitchell Merling, Lisa Michel, Odile Michel, Manoli Miremont-Saves, Mathilde Moebs, Laure Morand, Laura Mori, Mary Morton, Michele Moyne-Charlet, Nathalie Muller, David and Ezra Nahmad, Esther Navarro Escudero, Nancy Nichols, Alex Nyerges, Sarah Kelly Oehler, Stéphane Paccoud, Pantxika de Paepe, Vincent Pécoil, Howell Perkins, Jet Peters, Roberta Piccinelli, Estelle Pietrzyk, Joëlle Pijaudier-Cabot, María del Pilar Herrera Arbona, Catherine Pimbert, Dina Pissarro, Julia Pissarro, Sandrine et Lionel Pissarro, Isolde Pludermacher, Sara Pozzato, Pascal Prompt, Fabienne Queyroux, Sylvie Ramond, Scarlett Reliquet, Natalie Rigby, Béatrice Riou, Andrew Robinson, Béatrice Roche, James Rondeau, Eleanor Royer, Maureen Ryan, Marco Santucci, Eike Schmidt, Shannon N. Schuler, Corinne Sigrist, Henrique Simoes, Anna Simonovic, Guillermo Solana, Emily Spargo, Petra Spielmann, Mary Sullivan, Hélène Thomas, Guy Tosatto, Giulia Trabaldo Togna, Maya Urich, Enrique Varela Agüí, Isabelle Varloteaux, Dominique Vazquez, Cathérine Verleysen, Elisa Viola, Simone Wagner, Sophie Weygand, Stephanie Wiles, and Martha Wolff.

To Reine, Gabriel, Tristan, Lucien, Henri, Denis, Georges, and Antoine

25

Authors

**Editorial direction
by Cyrille Sciama**
General director and chief curator
of the Musée des Impressionnismes
Giverny

and Marie Delbarre
Research assistant, Musée
des Impressionnismes Giverny

Sylvain Cordier
Paul Mellon curator and head
of the department of European art
at the Virginia Museum of Fine Arts,
Richmond, VA

Dominique Lobstein
Art historian

Marianne Mathieu
Art historian

Sylvie Patry
Artistic director, Galerie Mennour,
Paris; general heritage curator

Philippe Piguet
Art historian and critic;
independent curator

Lionel Pissarro
Art dealer; Camille Pissarro's
great-grandson

Marie Simon
Art historian

Philippe Thiébaut
Art historian; honorary
general heritage curator

Elise Wehr
Graduate of the École
du Louvre

Contents

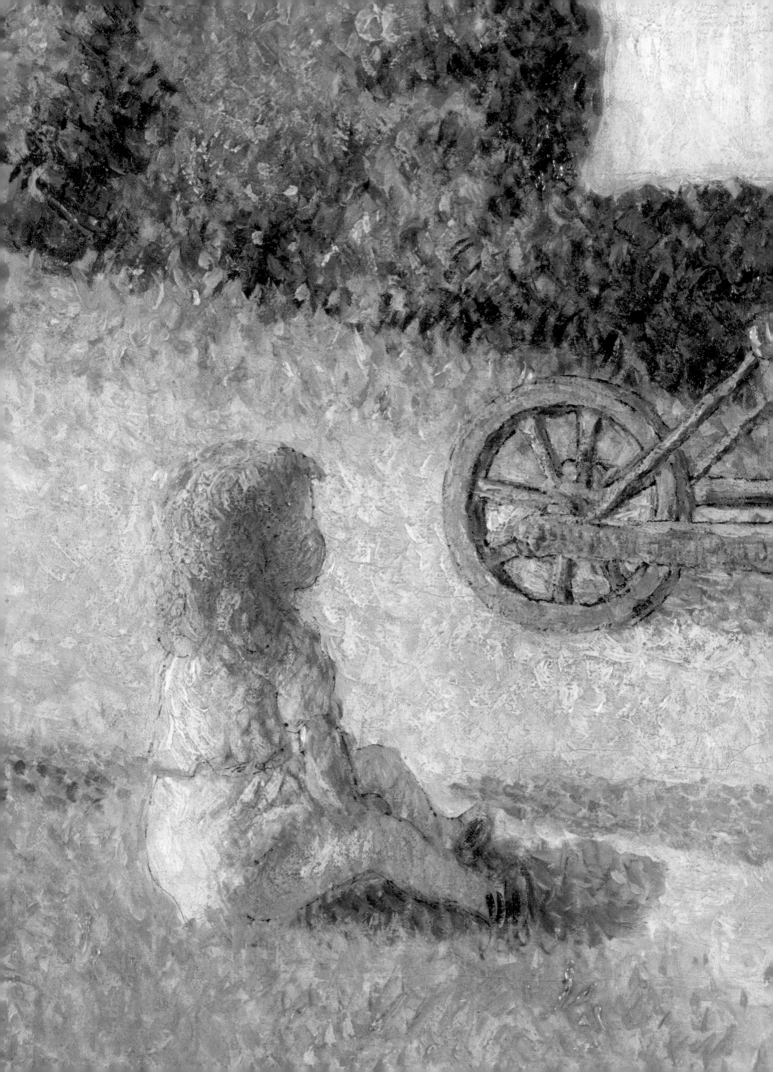

1

L'Art et l'enfant (Art and the child),
Musée Marmottan Monet, Paris,
March 10–July 3, 2016.

2

See the exhibition *Être jeune
au temps des impressionnistes,
1860–1910* (Childhood in the era
of the impressionists), Musée
Eugène-Boudin, Honfleur,
June 25–October 3, 2016.

Facing page:
Camille Pissarro,
Femme étendant du linge
(Woman hanging laundry), detail,
1887.
Musée d'Orsay, Paris.
Fig. 35

"It is true, my dear friend, you put it well—you are my family."
Edgar Degas to Alexis Rouart, December 27, 1904.

What image could be more beautiful than the intimate portrayals of children painted by Claude Monet, Pierre-Auguste Renoir, or Berthe Morisot? In our collective memory, this almost idyllic vision—a fusion of art and life—merges with poppies, swings, music lessons, and butterfly hunts. But is it a reflection of reality or a fantasy constructed by the artists? Were these model children, or child models? Recent exhibitions have highlighted the many questions raised by the experience of childhood in the last three decades of the nineteenth century.[1] Between the relative emancipation afforded to young people and the strict education that still governed, there were many ways to forge a life on the journey toward adulthood prior to World War I.[2]

Childhood: A Commonplace Theme?

The impressionists' portrayals of children varied according to their own family histories, as well as their social backgrounds. Their situations were diverse: Renoir, who became a father late in life, at the age of sixty (his son Claude was born in 1901); Monet, whose second wife Alice brought six children to the household; Camille Pissarro, who fathered eight children; and Berthe Morisot, who had just one child, Julie Manet. While Monet and Renoir aspired to a middle-class existence, and Pissarro represented the bohemian lifestyle, Morisot, for her part, never strayed from her upper-class Parisian origins. This gap explains, in part, the different approaches to childhood that can be seen in impressionist art.

Hidden beneath the cheerful images of children depicted by the impressionists, there often lie little-known stories, intimate dramas, and frustrations. Whether these are portrayals of children in impressionist art, or the children of impressionist artists, each work raises questions that make us want to lift the veil to peer more closely at their story.

Each member of the impressionist group interpreted the subject in his or her own particular way. Renoir primarily painted figures, while

Children in Impressionist Art

Cyrille Sciama

3
Philippe Ariès, *L'Enfant et la vie familiale sous l'Ancien Régime* (Paris: Plon, 1960).

4
Figures sourced from the French Institute for Demographic Studies (Ined) and The National Institute of Statistics and Economic Studies (Insee); register of births, marriages, and deaths, and population estimates for 2021.

5
Lion Murard, Patrick Zylberman, *L'Hygiène dans la République: La santé publique en France ou l'utopie contrariée (1870–1918)* (Paris: Fayard, 1998); Catherine Rollet, *La Politique à l'égard de la petite enfance sous la IIIᵉ République* (Paris: Ined/PUF, 1990); Catherine Rollet, *Les Enfants au XIXᵉ siècle: La vie quotidienne* (Paris: Hachette Littératures, 2001).

6
Jean-Claude Gélineau, *Jeanne Tréhot: La fille cachée de Pierre-Auguste Renoir* (Essoyes: Éditions du Cadratin, 2007), 20; and Marc Le Cœur, *Between Bohemia and Bourgeoisie* (Berlin and Stuttgart: Hatje Kantz, 2012).

7
Emmanuelle Héran and Joëlle Bolloch, *Le Dernier Portrait*, exh. cat. (Paris: Musée d'Orsay and RMN, 2002).

Monet remained a landscape painter who only occasionally created portraits of a few children. Others, like Mary Cassatt, made a specialty of portraying early childhood, while her friend Berthe Morisot was more interested in capturing adolescence. The artists' first models were members of their inner circle, their children—if they had any—as well as the children of their friends, neighbors, and patrons. Consequently, the artists' view of children evolved according to their relationship with the model, but also with the children's parents.

A Fragile Life

Since the publication of Philippe Ariès's seminal studies in the mid-twentieth century,[3] many researchers have turned their attention to the subjects of infant mortality and the fragility of life. Taboos surrounding death and childhood cut short have gradually lifted. Around 1880, infant mortality in France stood at around 175 per thousand (17.5 percent); in 1900, 15 percent of newborns still died before their first birthday. In 1900, life expectancy in France was forty-five years, compared with 79.4 years for men and 85.5 years for women in 2021.[4] Slow advances in vaccines gradually helped to prevent premature deaths and increase life expectancy.[5] The experiences of the impressionist painters were no exception. To portray a child during that period was to pay homage to youth, but it also acknowledged the brevity of life. Monet lost his wife Camille Doncieux in 1879, when she was just thirty-two years old. Alfred Sisley's son, Jacques, lived only a few months and died at his nurse's home in the village of Sainte-Marguerite-de-Carrouges, where Renoir had also placed his illegitimate daughter, Jeanne Tréhot.[6] Jacques lived for only five months, from September 26, 1871 to February 28, 1872. The entire impressionist group, from Sisley to Degas to Renoir to Cassatt, could not but be acutely aware of the transitory nature of life.

The late nineteenth century also saw the continued practice of creating "last portraits": images of deceased adults—for example, Monet's *Camille sur son lit de mort* (*Camille on Her Deathbed*; 1879, Musée d'Orsay, Paris)—as well as infants, created using daguerreotypes and, later, photographic prints.[7]

The presence of numerous infants, baby carriages, and cradles in impressionist art owes much to the charming nature of the subject and to the artists' tender feelings toward children, but also to this awareness of life's fragility. Focus was placed on immediate happiness, in the face of the knowledge that children could die very quickly and too early—an allegory that is also found in depictions of flowers, with their transitory blooms. Mary Fairchild MacMonnies, for example, portrays her one-year-old daughter Betty in a baby carriage, within an astonishing floral landscape (*Roses et lys* [*Roses and Lilies*]; 1897, fig. 34): all her feelings of maternal joy burst from this luminous pastoral painting. Conversely, certain artists,

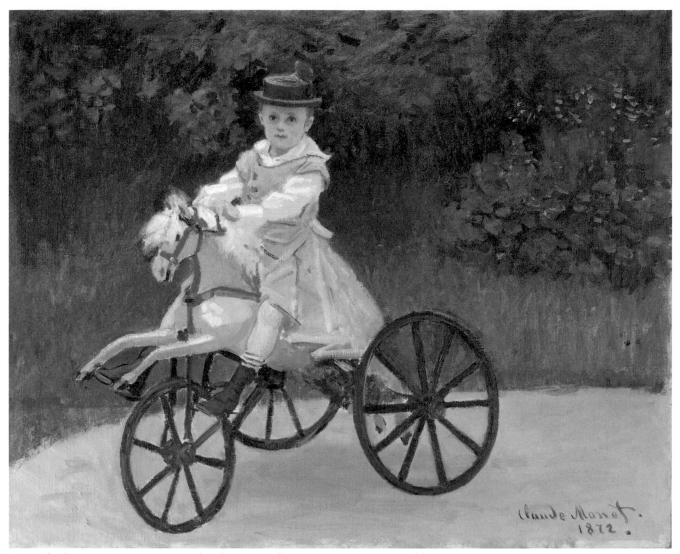

Fig. 20 Claude Monet, *Jean Monet sur son cheval mécanique* (*Jean Monet on His Horse Tricycle*), 1872.
Oil on canvas, 24 × 29½ in. (60.6 × 74.3 cm).
The Metropolitan Museum of Art, New York.

8
Degas to Édouard, probably the Marquis Édouard Guerrero, husband of Luce De Gas, n.d. [1898], in Edgar Degas, *Degas: Letters*, ed. Marcel Guérin (Oxford: Bruno Cassirer, 1947).

despite being parents or being surrounded often by children, painted few child portraits. While Claude Monet rarely painted children, when he did so he gave them strange, slightly unconventional expressions. This can be observed in the two portraits he made of his children, Jean (born in 1867) and Michel (born in 1878). They both look frightened, as though they have been caught in the act of some mischief. Even the portrait of Jean as a newborn—*Jean Monet dans son berceau* (*The Cradle—Camille with the Artist's Son Jean*; 1867, fig. 25)—is surprising, although it nevertheless expresses the artist's tender feelings toward infants: wrapped in a thick bedspread, Jean seems to blend in with his spotless white surroundings. To his left, a nurse watches over him. The child seems lost in this strange, silent world, brought to life by the yellow of the rattle lying on the bedding. The other known portraits of Jean and Michel are sometimes disconcerting: those at the Musée Marmottan Monet are treated as sketches, while the large portrait of Jean on his mechanical horse (1872, fig. 20) borrows from the codes of history painting's equestrian portraits. The result resembles a portrait of Philip IV as depicted by Velázquez! At the same time as the law separating Church and State was being prepared in France in 1905, other portrayals of children took on more religious, less historic overtones. In 1898, for example, the American painter Mary Cassatt celebrated the miraculous nature of children in a series of lithographs that equated mothers with the Virgin Mary: *By the Pond* (c. 1898, fig. 155) shows a mother holding her young son in her arms, much like Mary presenting the baby Jesus. The same approach can be observed in *Under the Horse Chestnut Tree* (1895–1897, fig. 33), in which a mother holds a small blond boy up at arm's length, like a sun illuminating the world. Finally, in *The Barefooted Child* (c. 1898, fig. 30), the mother's tenderness overflows in her protective gestures. Cassatt elevates an ordinary subject by extracting from it a semi-religious allegory of life. *Mother and Child (Maternal Kiss)* (1891, fig. 29) and *Maternal Caress* (c. 1891, fig. 156) reflect the same desire to glorify life through sensitive portrayals of infants.

The Solitude of Painters

It was not only parents who were interested in the subject of children: Mary Cassatt and Edgar Degas captured them in every possible attitude, although neither of them ever had children of their own, which no doubt makes their works so sensitive and so moving. They approached the subject with gentleness and respect, but in some cases also with singularity. Degas felt out of step with his friends and family, as he confided in 1898 to his brother-in-law: "An old bachelor like me must know nothing of the sorrows or joys of making a family—so they say."[8] Six years later, on December 27, 1904, he wrote to Alexis Rouart, "It is true, my dear friend, you put it well—you are my family." Yet, Degas actually had a large family who lived between Naples and Buenos Aires. The painter's connection

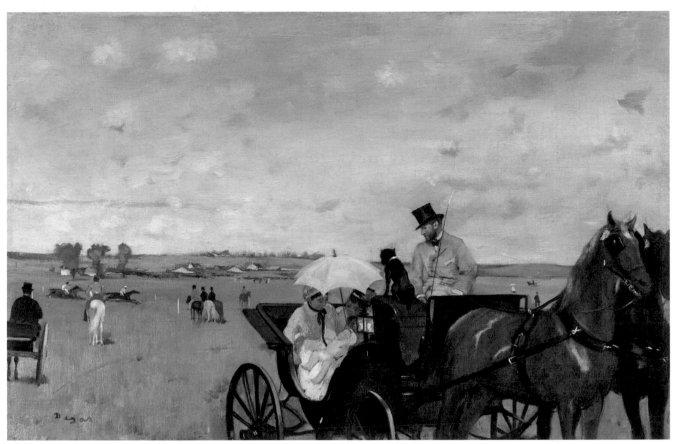

Fig. 21 Edgar Degas, *Aux courses en province* (*At the Races in the Countryside*), 1869.
Oil on canvas, 14½ × 22 in. (36.5 × 55.9 cm).
Museum of Fine Arts, Boston.

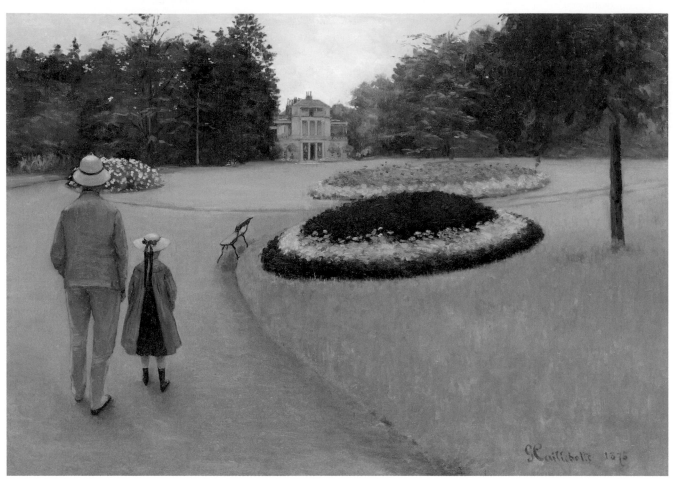

Fig. 22 Gustave Caillebotte, *Le Parc de la propriété à Yerres* (The park on the Caillebotte property at Yerres), 1875.
Oil on canvas, 2 ft. 1½ in. × 3 ft. (65 × 92 cm).
Private collection.

9
Oil on canvas, 25 × 29 in. (63 × 74 cm), private collection.

10
Daniel Halévy, *My Friend Degas*, trans. Mina Curtiss (Middleton: Wesleyan University Press, 1964), 102.

with the Rouart family was constant, close, and sincere. Henri, then his son Alexis, were his confidants. But Degas's portrayal of children is strange; there is an ambiguity in his portraits of the Rouart children. In 1886, he painted an unsettling portrait of twenty-three-year-old Hélène Rouart: *Hélène Rouart dans l'atelier de son père* (*Hélène Rouart in Her Father's Study*; c. 1886, The National Gallery, London). A solemn figure, lost in her own thoughts, she resembles the Egyptian sculpture visible in the background. The portrait thus appears as a mirror image, and recalls an earlier portrait of Hélène, aged nine, sitting on her father's lap: *Henri Rouart et sa fille Hélène* (*Henri Rouart and His Daughter Hélène*; 1877).[9] Degas was no doubt very distressed about growing old, the passing years, and death's approach, and remained isolated: the hardened bachelor. He seems, at times, to have regretted this, as he confided to Halévy:[10] "You understand, now, don't you, that people do marry?" "Oh yes, I am alone. I see how happy Rouart's son is. It's a good thing to marry—Ah, *la solitude*."

Degas's early works reflect his interest in childhood. From the late 1860s, he was able to combine his taste for racehorses with the intimacy of domestic scenes. This juggling of two pictorial themes is quite representative of his ironic and tender-hearted perspective on life. *Aux courses en province* (*At the Races in the Countryside*; 1869, fig. 21) resembles a moment frozen in time: in a large field, where horses are lined up almost like vignettes, Degas depicts a barouche carriage standing in the foreground. The elegantly dressed carriage driver turns toward the two passengers, who look tenderly at a child sleeping under a parasol. The framing is unusual: the head of the horse on the right appears truncated, the perspective is odd, and the proportions between the foreground and background are distorted. But even more striking is the position of the viewer, who seems to intrude on an intimate moment—a moment in which the innocence of childhood is portrayed as both fascinating and disturbing, in this world of adults.

Degas used this technique of intrusion in his later portraits of infants. The composition in *Une nourrice au jardin du Luxembourg* (*A nurse in the Luxembourg Gardens*; 1876–1880, Musée Fabre, Montpellier) resembles a stage set. In the foreground, an older-looking woman holds a baby on her lap. Behind her, the park stretches to the horizon. She looks attentively at the child sleeping in her arms. What is striking about this work is how the space is organized: relegated to the far left side of the painting, the pair leaves the entire foreground free, flanked by an empty chair—is this meant to underscore the nurse's solitude in the presence of the sleeping child?

Gustave Caillebotte uses the same decentered approach in certain portraits that he painted of children. Although he lived with a female companion, Charlotte Berthier, he never had children. But he was very close to his brother Martial, who had two offspring from his marriage to Marie Minoret: Jean, born in 1888, and Geneviève, born in 1890, both of whom he painted several times. A famous work by Caillebotte, in

which his cousin Zoé appears, illustrates his attitude toward childhood: in *Le Parc de la propriété à Yerres* (The park on the Caillebotte property at Yerres; 1875, fig. 22), the grounds are depicted as a large empty space, occupied by two immense beds of red flowers. But the true subject of the painting seems to be the double portrait, on the left, of a man (Caillebotte) and a little girl, probably Zoé, seen from the back. Their faces are hidden, positioning us as spectators—both intimates and intruders. Everything about this landscape, in which the child is portrayed as a small element against the immensity of nature, is startling. Zoé, the youngest daughter of Gustave Caillebotte's uncle, Charles Caillebotte, was born in 1868 and appears in many of the artist's paintings, proof of the special relationship between the painter and his cousin.

Establishing a Connection

Posing for a painter is a tiresome exercise. Staying still for long periods of time, so the artist can capture an expression, can be extremely tedious, especially for children, who are used to moving around. In his memoirs, Jean Renoir writes at length about his difficulty posing for his famous father: Gabrielle, who was both Jean's nanny and one of Renoir's models, managed to keep the child calm with toys—which explains the many portraits of Jean or of Coco with her, as in *Gabrielle et Jean* (*Gabrielle and Jean*; 1895–1896, fig. 28). *Jean dessinant* (*The Artist's Son, Jean, Drawing*; 1901, fig. 45) and *Coco écrivant* (Coco, the artist's son, writing; c. 1906, figs. 163, 164) demonstrate Renoir's talent for capturing natural, unposed moments: the children are seen engaged in an activity, immersed in their world, under the benevolent gaze of adults. However, this did not prevent Renoir from having them dress up in costumes for sittings, as Ambroise Vollard recounts in his memoirs (*Renoir*, 1920) and Albert André illustrates in his painting *Renoir peignant en famille* (Renoir painting his family; 1901, fig. 42). When he painted Martial Caillebotte's children, Jean and Geneviève (fig. 74), he depicted them on a sofa that was almost too large for them, with a somewhat lost expression on their faces and a book in their hands, already dreaming of elsewhere.

Portrayals of children also vary according to the activities being pictured: the beach, toys, and piano practice enabled artists to capture spontaneity and fleeting emotions, in contrast to the academic quality of an official portrait. Renoir illustrated this moment of release in one of his most famous paintings, *Jeunes filles au piano* (*Two Young Girls at the Piano*; 1892, Musée de l'Orangerie, Paris). He painted five versions of the scene, proof of his sustained interest in the theme, and this at a time when the French state had decided to purchase a work for the Musée du Luxembourg. The models were Yvonne and Christine Lerolle, aged eleven and thirteen respectively. The girls—the painter Henry Lerolle's daughters—would pose again for Renoir in *Yvonne et Christine Lerolle*

au piano (*Yvonne and Christine Lerolle at the Piano*; 1897–1898, Musée de l'Orangerie, Paris). The brushwork is light and gauzy, a technique that other artists at the time applied to similar subjects, as in *Enfants au piano* (Children at the piano; 1902, fig. 77) by Étienne Moreau-Nélaton. It should also be noted that the artists intended to document a distinct social environment related to children's activities. The atmosphere might be very studious and silent, as in Renoir's *L'Après-midi des enfants à Wargemont* (*Children's Afternoon at Wargemont*; 1884, fig. 72). But Renoir also plays with the presence of animals in an attempt to convey a more immediate feeling, as in *Madame Georges Charpentier et ses enfants* (*Madame Georges Charpentier and Her Children*; 1878, fig. 85). Indeed, one possible way to depict children's movements is to capture them not in a static pose, but surreptitiously, without their knowledge. Ferdinand du Puigaudeau uses this approach to great effect in his portrayals of carousels, fairs, and moonlit scenes (*Fête nocturne à Saint-Pol-de-Léon* [*Night Fair at Saint-Pol-de-Léon*], 1894–1898, fig. 67).

The Garden as Eden

The garden is also rich with possibilities, as is the beach; they are places of freedom that are portrayed beautifully by Joaquín Sorolla (fig. 130), or even John Russell (fig. 134), whose work displays a vague eroticism.

Far away from adults and close to nature, the garden is a refuge. Claude Monet's *La Maison de l'artiste à Argenteuil* (*The Artist's House at Argenteuil*; 1873, fig. 92) illustrates this well. Jean, the artist's son, who was six years old at the time, is outside the house. To his right, his mother, Camille, comes out on the front steps to watch him. The child is standing with his back to the viewer and holds a hoop in his hands. He avoids being seen, while at the same time offers a glimpse into his childhood world of play. All around him, a magnificent garden bursts with color. A row of large Chinese porcelain jars full of flowers provides a symbolic barrier between the world of adults (represented by the mother) and the child. The contrast between the immense flowerbed and the small child is striking: in this way, Monet indicates a change in scale that immerses the viewer in the world of childhood. The viewer becomes a furtive observer of a private moment in which the perspective is sympathetic to little Jean. The child's perspective also dominates in Frédéric Bazille's *La Terrasse de Méric* (The terrace at Méric; 1866, fig. 93). Well away from the group of adults, the little girl occupies the bottom left corner of the scene, accompanied by the family dogs.

Some artists lingered on the social condition of child laborers. Émile Claus portrayed the difficult conditions of certain children during the impressionist period with diaphanous brushwork that nevertheless retains details of the scene, in *Les Glaneurs* (*Gathering Corn*; 1894, fig. 101).

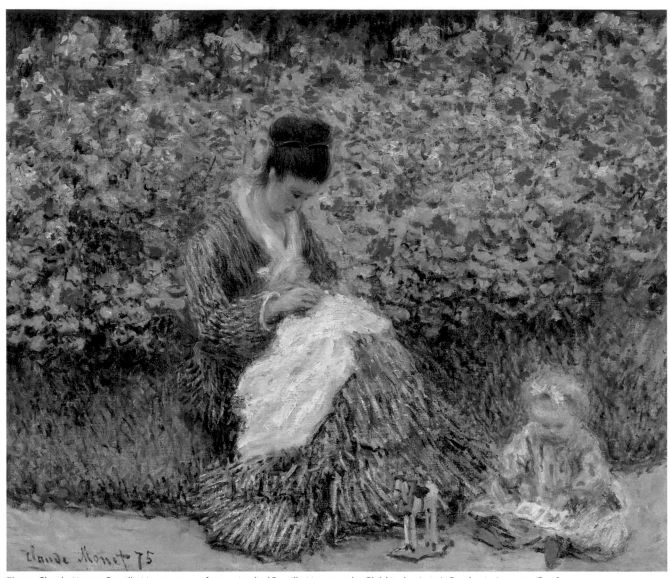

Fig. 23 Claude Monet, *Camille Monet et un enfant au jardin* (*Camille Monet and a Child in the Artist's Garden in Argenteuil*), 1875.
Oil on canvas, 22 × 25½ in. (55.3 × 64.7 cm).
Museum of Fine Arts, Boston.

Other artists preferred to completely integrate the child within a background of vegetation. For example, André Brouillet's *La Petite Fille en rouge* (Little girl in red; 1895, fig. 62) and Maurice Boutet de Monvel's *Mademoiselle Rose Worms* (c. 1900, fig. 121) both use the same structure: the solemn figures pose facing the viewer, holding an accessory—a hoop or parasol—and seem to be frozen in a personal, private, and inaccessible world. This theme of inaccessibility was also taken up by several symbolist artists, such as Gaston Bussière in his *Jeune fille aux iris* (Young girl with irises; n.d., fig. 145).

Like a hidden world, the garden reflects the inner landscape of children: a realm of secret dreams, in harmony with the colors of the flowers, trees, and meadows that respond to their private aspirations. The painting *Camille Monet et un enfant au Jardin* (*Camille Monet and a Child in the Artist's Garden in Argenteuil*; 1875, fig. 23) depicts the painter's wife with a child—most likely their son Jean. Each of them is absorbed in their activity: the mother sews, while at her feet the boy plays with a wooden horse. Behind them, a row of vibrant roses unfurls an array of bright colors, forming a wall of vegetation that protects them from the outside world. The garden in Argenteuil is an enchanting place, where childhood takes place out of sight. It remains a space of freedom, in which adults are the guardians of innocence. Sometimes, they are even absent: here, the painter positions himself as an invisible witness to an uncertain and fleeting happiness.

Adolescence: The Age of Uncertainty

The impression that emerges from Monet's ambitious composition *Un coin d'appartement* (*A Corner of the Apartment*; 1875, fig. 49) is difficult to interpret. The work portrays an intimate scene: a view of the house where the painter lived in Argenteuil (it is not, in fact, an apartment). The child—Jean, his eldest son—seems lost in a world of adults. As though he were wearing clothes too large for him, he is placed in between two milieus: that of a child and that of "grown-ups," between two doors, framed in the doorway, between sun and shadow. He is looking at us, but his features are indistinguishable. Is Monet projecting onto the uncertain world of childhood? The large palm trees that frame the scene lend an air of wild and decorative exoticism to this almost dreamlike vision. The boy holds himself erect, his hands in his pockets, and seems almost nonchalant. But the shadow in which he stands is somewhat troubling.

Two female painters, Mary Cassatt and Berthe Morisot, portrayed this time of indecision that characterizes adolescence with a subtle hand. A feeling of solitude emanates from works by these two sensitive artists, but they also express a profound sympathy with this difficult period, when one must construct one's identity and shape one's own personality, as Morisot illustrates in *Sur un banc au bois de Boulogne* (On a bench

11

See p. 130.

12

See pp. 60–71. See also *Renoir: Father and Son/Painting and Cinema*, exh. cat. (Philadelphia: The Barnes Foundation, 2014; Paris: Musée d'Orsay and Flammarion, 2018).

13

Jeannie Gobillard-Valéry, *Eurêka: Souvenirs & journal (1894–1901)*, ed. Marianne Mathieu, with the collaboration of Claire Gooden (Paris: Musée Marmottan Monet and Éditions des Cendres, 2022).

Facing page:
Claude Monet,
Un coin d'appartement
(*A Corner of the Apartment*),
detail, 1875.
Musée d'Orsay, Paris.
Fig. 49

in the Bois de Boulogne; 1894, fig. 136). The evanescent, unfinished quality of her works speaks to a feeling of uncertainty, similar to that experienced by adolescents in the time between childhood and adulthood. Perhaps Morisot also felt that her strength was diminishing and death was approaching, pushing her to urgently capture the last, elusive emotions of these young girls. She died the following year, in 1895.

Being the child of an artist is not always easy. What became of Monet's, Renoir's, and Morisot's children? Did they become recognized artists or remain anonymous? Camille Pissarro's children pursued more or less successful careers as painters, as Lionel Pissarro recounts in a hitherto unpublished text that appears in this book.[11] But Claude Monet's children did not become artists. Julie Manet painted, but did not make it a profession, while Renoir's three children worked in art and cinema, as Sylvie Patry explains in a later chapter.[12]

Some children contributed to keeping their parents' memory alive through major donations to the French state. One of the most famous examples is Michel Monet: in 1966, he bequeathed the collection of works that he had inherited from his father to the Musée Marmottan Monet, and he handed over management of the house in Giverny to the Académie des Beaux-Arts under the protection of the Institut—tangible proof that he recognized the historical importance of this artistic heritage. Julie Manet also donated many works by her mother, Berthe Morisot, and her uncle Édouard, which contributed to a renewed interest in impressionist works from the 1930s onward.

Writing their memoirs often enabled the children of these artists to make sense of their unique personal histories, and to satisfy the demands of publishers and the curious, beginning in the 1950s, when impressionism became legendary and prices of impressionist works skyrocketed at auction houses. In the same period, cinema portrayed the lives of Vincent Van Gogh (Vincente Minnelli's *Lust for Life*, 1956) and Henri de Toulouse-Lautrec (John Houston's *Moulin Rouge*, 1952). In his 1920 book, *Renoir (1841–1919)*, Ambroise Vollard recounts his memories of the artist. Renoir's son Jean published *Renoir* in 1962. In doing so, he continued a tradition that Julie Manet, the only child of Berthe Morisot and Eugène Manet, had observed with her *Journal* (Diaries) from the years 1893 to 1899. Jeannie Gobillard, Paul Valéry's wife and Julie Manet's cousin, also wrote her diaries (1894–1901), which were recently published by the Musée Marmottan Monet.[13] In 1945, the complete letters of Camille Pissarro were published. Two years later, Marcel Guérin's *Degas: Letters* (published some years earlier in French) appeared in English. In 1949, Jeanne Fèvre published *Mon oncle Degas* (My uncle: Degas), and in 1960, Daniel Halévy wrote *Degas parle* (Degas speaks), an account of Degas' close connection with Ludovic Halévy's family. The legend of impressionism and the happy image that it reflects has continued to flourish since then, giving rise to numerous projects and exhibitions.

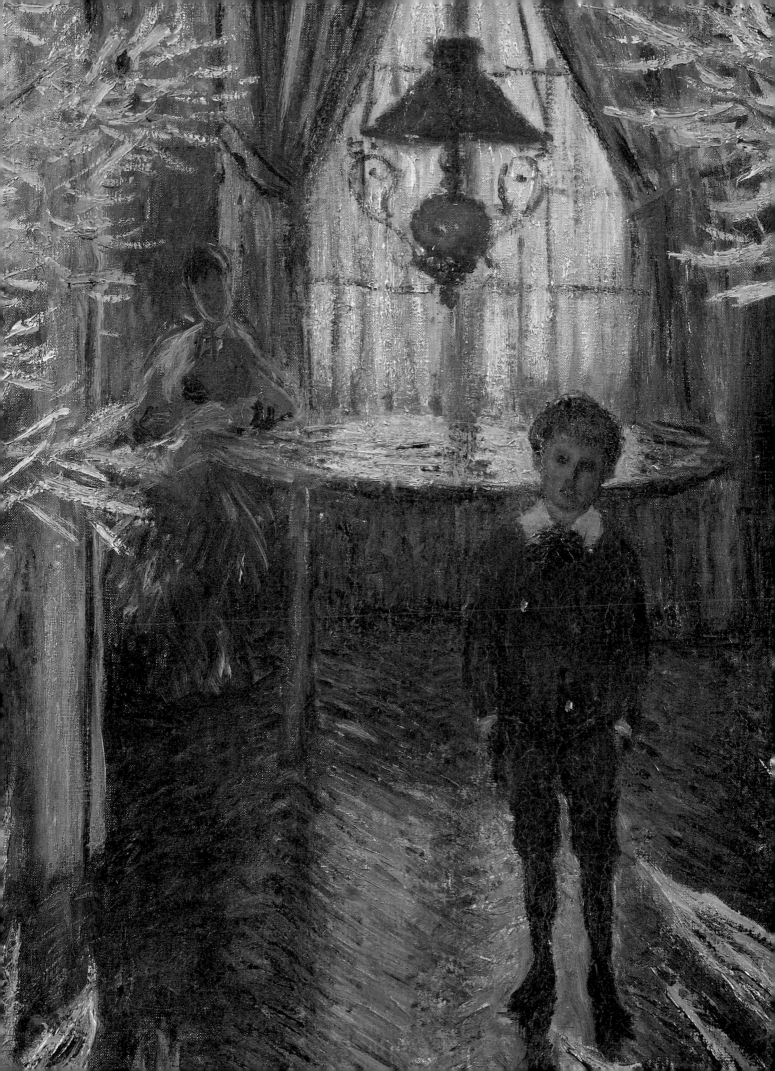

Fig. 24 *Elaine Greffulhe, a Nanny, and Three Children in the Parc de Boisboudran*, c. 1885.
Musée d'Orsay, Paris.

Rose [Julie] **Manet has finally arrived. She already has hair, and small, very bright eyes, and came into the world wriggling her arms and legs like a little frog.**

Eugène Manet to Jeanne Pontillon, c. November 14–16, 1878

MOTHERHOOD

Fig. 25 Claude Monet,
Jean Monet dans son berceau
(*The Cradle—Camille with
the Artist's Son Jean*), 1867.
Oil on canvas, 3 ft. 10 in. ×
2 ft. 11 in. (116.2 × 88.8 cm).
National Gallery of Art,
Washington, D.C.

Camille Doncieux gave birth to Jean,
Claude Monet's eldest child, on
August 8, 1867, in Paris. Nothing
in this painting suggests the great
poverty that the young couple lived
in at the time. The figure watching
over the newborn was long identified
as Camille or Julie Vellay, Pissarro's
companion and Jean's godmother.
In fact, the woman is a wet nurse
hired by Théophile Beguin-Billecocq,
a functionary in the Ministry of
Foreign Affairs who kept company
with the Monet family in Le Havre
and provided significant financial
support to the young painter. In his
unpublished diaries, Beguin-Billecocq
writes that Camille was unable
to breastfeed, and so he found a wet
nurse from Champagne. The baby
is lying in a pretty cradle that may
also have been a gift from
Beguin-Billecocq.

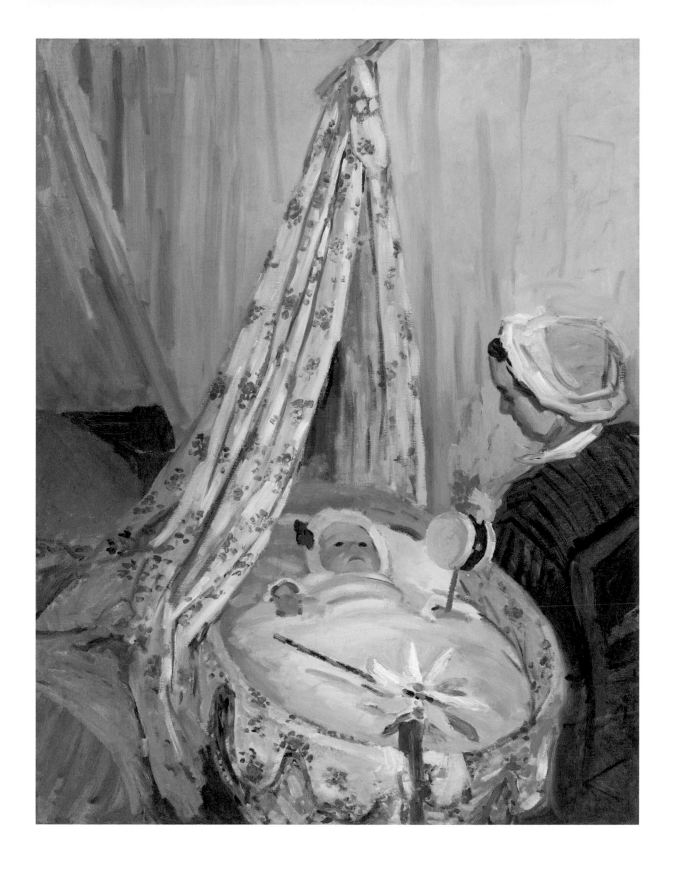

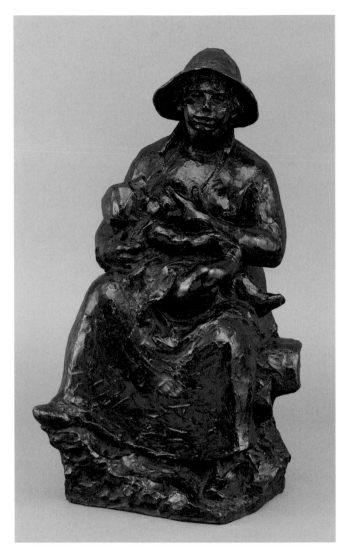

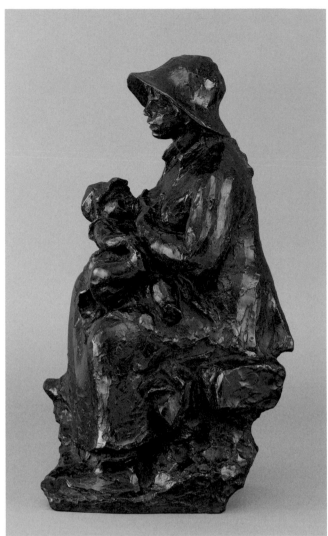

Fig. 26 Pierre-Auguste Renoir,
Richard Guino, *Mère et enfant*
(*Mother and Child*), 1916.
Bronze, 21½ × 11 × 12½ in.
(55 × 28 × 32 cm).
Musée des Beaux-Arts, Lyon.

In 1913, the young sculptor
Richard Guino began working for
Renoir, whose rheumatoid arthritis
prevented him from sculpting.
Commissioned in 1916, this grouping
represents Aline and Pierre, and
was inspired by a mother-and-child
scene painted by the artist in 1885,
now held at the Musée d'Orsay, Paris
(fig.41).

Facing page:
Fig. 27 Pierre-Auguste Renoir,
Femme allaitant un enfant
(*A Woman Nursing a Child*),
1893–1894.
Oil on canvas, 16 × 13 in.
(41.2 × 32.5 cm).
National Galleries of Scotland,
Edinburgh.

When Pierre was born in 1885,
Renoir began exploring the mother-
and-child theme. Returning to
that subject here, the artist depicts
his second son, Jean, born on
September 15, 1894, in the arms
of a young woman who resembles
his nanny, Gabrielle Renard.

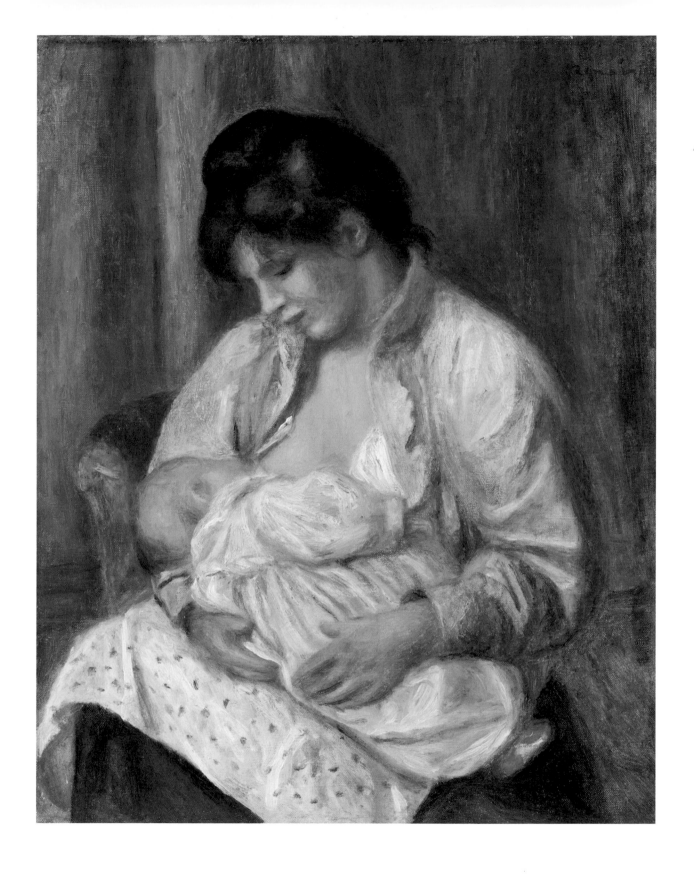

Pierre-Auguste Renoir
1841–1919

Gabrielle et Jean (Gabrielle and Jean)
1895–1896

Oil on canvas
25½ × 21 in. (65 × 54 cm)
Musée de l'Orangerie, Paris

1
Jean Renoir, *Pierre-Auguste Renoir, mon père*, (Paris: Gallimard, 1981), 437.

Born on September 15, 1894, Jean Renoir was still very young when he posed for this painting, one in a series of double portraits that Renoir painted between 1895 and 1896 of his second son with his nanny. The two models, who were among Renoir's favorites, had just entered the painter's life; Gabrielle Renard, a cousin of Renoir's wife, Aline, had arrived at the Renoir home several weeks before Jean's birth. Gabrielle holds the little boy on her knees, wrapping her left arm around him, while with her right hand she holds up a cow figurine to entertain him. It is unclear what object the child is holding. The table and the toys, deliberately left unfinished, contrive—along with the section of green floral tapestry in the background—to focus the viewer's attention on the models' faces. Renoir's brushwork is more precise in the details of his son's blond curls and Gabrielle's brown hair, a lock of which falls on her face. No one could calm Jean like Gabrielle could. In paintings where they appear together, she is seen holding him in her arms, giving him a lesson, or playing with him. In the book that he wrote about his father, Jean Renoir reveals that she was also present outside the frame, in the studio, reading Hans Christian Andersen's fairy tales to him during long sittings.[1] These shared moments in Renoir's studio—often endured, more than anything, by this impatient child—become intimate moments, in his book, that shaped his relationship with his father.

M. D.

Fig. 28

49

Left:
Fig. 29 Mary Cassatt,
Mother and Child (Maternal Kiss),
1891.
Soft-ground etching, drypoint,
and aquatint, 19 × 12 in.
(47.8 × 30.9 cm).
Bibliothèque de l'INHA, Paris.

Below:
Fig. 30 Mary Cassatt,
The Barefooted Child, c. 1898.
Drypoint and aquatint, printed
in color, 12 × 17 in. (30 × 43.5 cm).
Indivision Petiet.

This blonde, curly-haired child held
in her mother's arms appears in
several drawings and lithographs by
Mary Cassatt, including *By the Pond*
(**fig. 155**, **vignette p. 247**) and *Under
the Horse Chestnut Tree* (**fig. 33**).
A pastel now held at the Baltimore
Museum of Art, *A Kiss for Baby Anne
(No. 2)* (c. 1896–1897), reveals the
child's name.

Facing page:
Fig. 31 Mary Cassatt,
Gathering Fruit (L'Espalier),
c. 1893.
Soft-ground etching, drypoint,
and color aquatint, 19½ × 17 in.
(49.9 × 42.7 cm).
Bibliothèque de l'INHA, Paris.

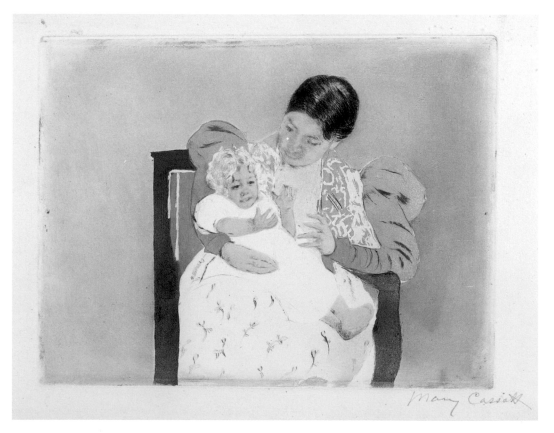

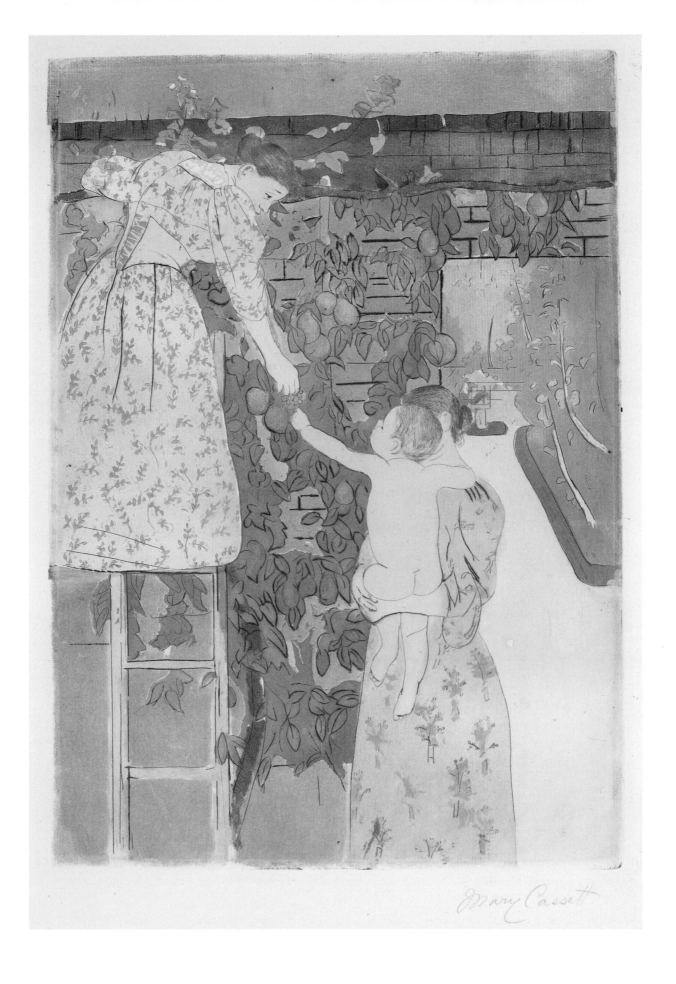

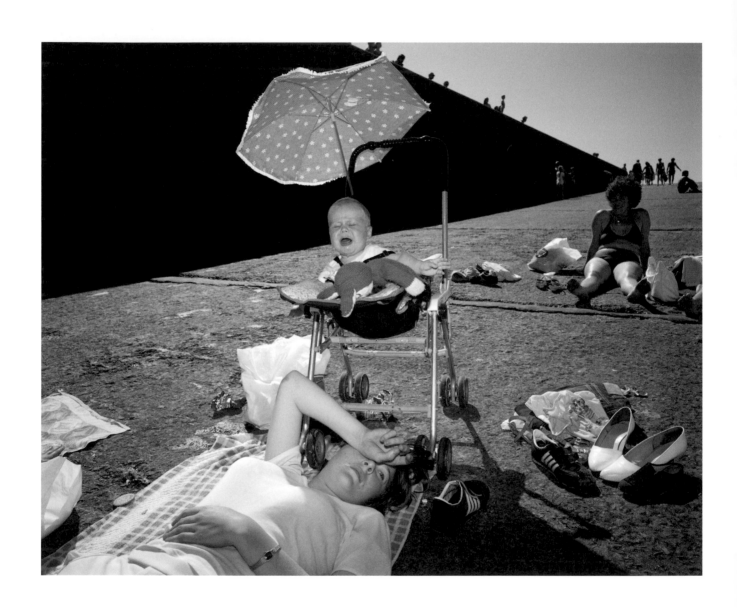

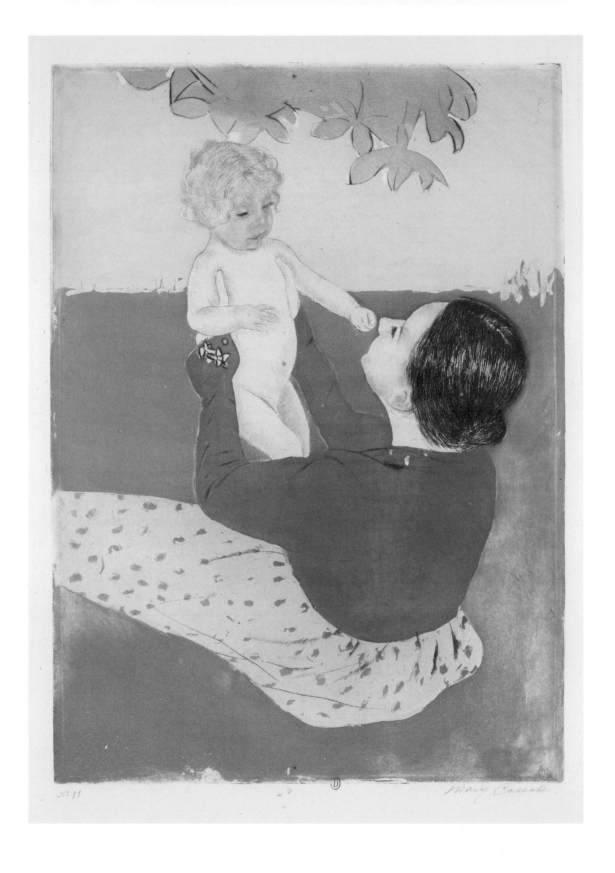

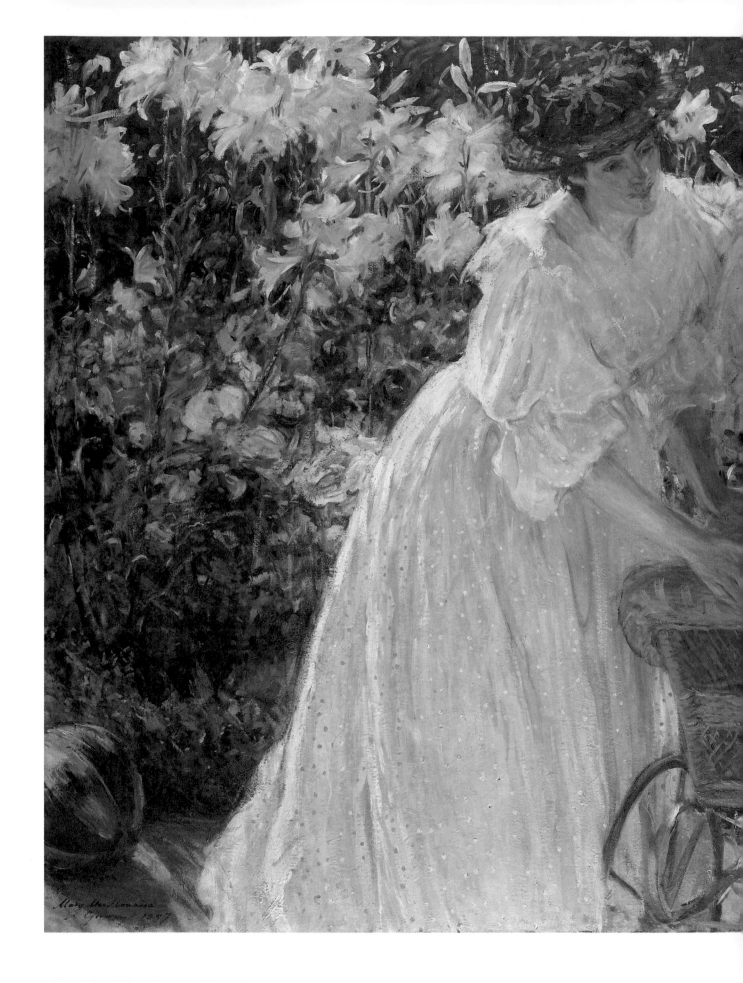

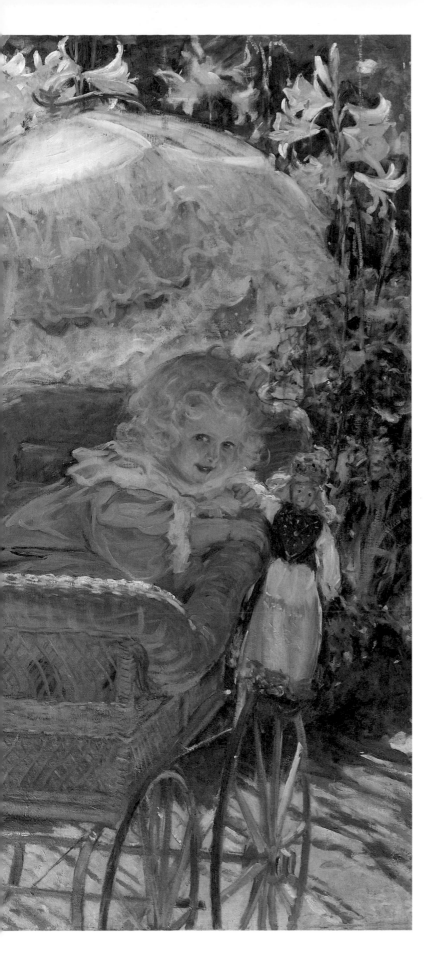

Fig. 34 Mary Fairchild MacMonnies,
Roses et lys (Roses and Lilies), 1897.
Oil on canvas, 4 ft. 4 in. × 5 ft. 9 in.
(1.33 × 1.76 m).
Musée des Beaux-Arts, Rouen.

The painter is depicted bending
over the wicker baby carriage,
in which her eldest daughter, Berthe,
known as Betty, born in Giverny in
September 1896, plays with a doll.

Camille Pissarro

1830–1903

Femme étendant du linge (Woman hanging laundry)

1887

Oil on canvas
16¼ × 13 in. (41 × 33 cm)
Musée d'Orsay, Paris

In 1883, Pissarro moved to Éragny-sur-Epte, near Gisors, a few miles from Giverny, where he explored subjects that celebrated rural life. He excelled at portraying scenes from the marketplace, apple picking, and harvests. This small-format work demonstrates his interest in domestic life. In a lush garden, a young woman hangs out the washing. At her feet, a young child watches her. The image is constructed along a long diagonal line that begins at the child and moves towards its mother; a wheelbarrow full of laundry is visible behind her. Pissarro's pointillist technique uses light brushwork to magnify this fleeting moment.

Yet beyond the image of a private scene, the painting also contains an observation about daily life in the nineteenth century: women were confined to the domestic sphere, occupied with laundry, gardening, and educating children. The young woman is clearly the child's mother. Pissarro had eight children from his marriage with Julie, including two girls: Jeanne-Rachel, known as Minette, who was born in 1865, and Jeanne, known as Cocotte, who was born in 1881 (Adèle-Emma, born in 1870, died prematurely). Given that the child depicted in the painting is possibly two or three years old, we can assume that it is Paul-Émile, who was born in 1884.

C. S.

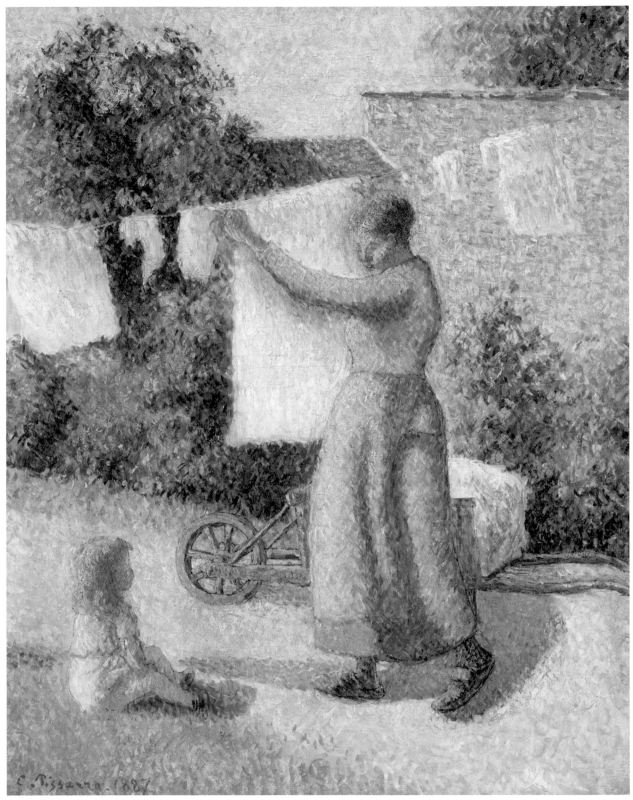

Fig. 35

Fig. 36 *The Debat-Ponsan Family in the Garden at Préousse*, c. 1888.
Musée des Beaux-Arts, Tours.

The birth of my brother Pierre was to cause a definite revolution in Renoir's life. Theories… were now made to seem unimportant by the dimples in a baby's bottom.

Jean Renoir, *Renoir: My Father*, 1962

ARTISTS' CHILDREN

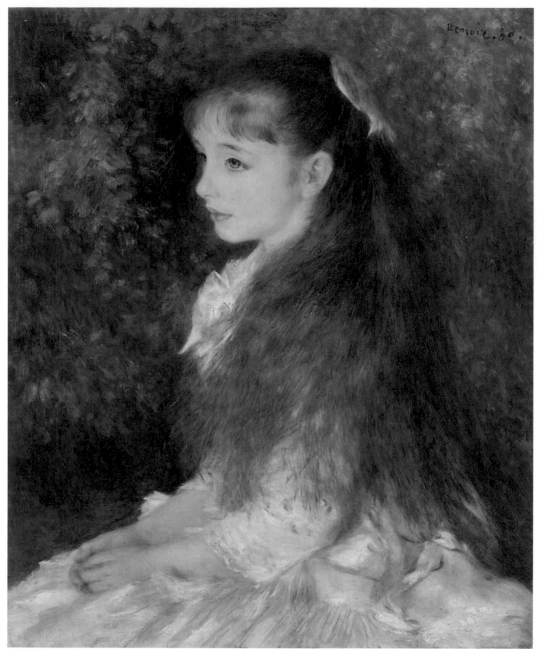

Fig. 37 Pierre-Auguste Renoir, *Irène Cahen d'Anvers* (*Irène Cahen d'Anvers [Little Irène]*), 1880.
Oil on canvas, 25½ × 21½ in. (65 × 54 cm).
Emil Bührle Collection, on long-term loan to the Kunsthaus, Zurich.

1

According to Dominique Lobstein, the child portrait "is only a circumstantial product in an artist's career. No one would ever think of building a career on this type of production." "Les portraits d'enfants dans les Salons parisiens," in *Carolus-Duran: Portraits d'enfants*, ed. Sandrine Duclos, exh. cat. on CD-ROM (Saintes: Musée des Beaux-Arts, 2003).

Standing before a reproduction of Renoir's portrait of Irène Cahen d'Anvers (fig. 37), Patricia, the heroine of Jean-Luc Godard's *À bout de souffle* (*Breathless*), played by Jean Seberg, declares, "Renoir is a truly great painter." In a beautiful sequence, Godard compares the actress's flawless profile with Renoir's depiction of Irène's. One of the film's promotional photos is taken from this scene, which places a child's portrait at the heart of the painter's legacy. Having produced several hundred paintings of children, Renoir was among those artists readily described in their day as painters of childhood—a group that included Carolus-Duran, Eugène Carrière, Jean Geoffroy, Joaquín Sorolla, and John Singer Sargent, to name just a few of his contemporaries. If our comparison is limited to impressionist painters, then Renoir, along with Mary Cassatt, was without a doubt the artist who most often drew inspiration from childhood, thereby overthrowing the traditional gendered division of subjects that, by definition, assigned children, motherhood, and the domestic sphere to female artists. Without actually forming a separate specialty in its own right,[1] the growing enthusiasm for portraying children, whether through portraiture or genre painting, was evident throughout the nineteenth century. It reflected a more widespread interest in the portrait, but also in what historians have identified as the invention of the very concept of childhood, considered from the late eighteenth century onward to be a period in life with very specific characteristics.

Children gradually came to be considered individuals in their own right. They also became the subjects of social, political, and cultural concerns. The nineteenth century, and particularly the last quarter of it, profoundly redefined the place that childhood held in society and the way in which society viewed this period. Those children who were born to each family—fewer in number, healthier, and better educated—became an essential element of domestic happiness, held up as something to strive for. For each stage of childhood, laws, studies, and debates emerged regarding education (the Duruy Law in 1867, the Jules Ferry Laws in 1881–1882); certain rights (the first legislation restricting child labor); health, as pediatric medicine developed; childcare; and, before long, psychology. Institutions and establishments were created, starting with public education, which was free and mandatory in France. At the same time,

Renoir's Depictions of Childhood

Sylvie Patry

2

Defining the end of childhood is an ever-changing and complex matter. In the nineteenth century, it most likely corresponded to the age of twelve or thirteen, when a school certificate was obtained.

3

Catherine Rollet, *Les Enfants au XIX^e siècle* (Paris: Hachette Littératures, 2001).

4

See the lovely portraits of Romaine Lacaux, 1864, The Cleveland Museum of Art, Cleveland, and of Marie-Zélie Laporte, 1864, Musée des Beaux-Arts, Limoges.

5

See Jean-Claude Gélineau, *Jeanne Tréhot: La fille cachée de Pierre-Auguste Renoir* (Essoyes: Éditions du Cadratin, 2007).

6

Ivan Jablonka, "La mort chez l'enfant au XIX^e siècle," L'Histoire par l'image (website), March 2016, accessed July 31, 2022, histoire-image.org/etudes/mort-enfant-XIXe-siecle

7

Jeanne Baudot, *Renoir, ses amis, ses modèles* (Paris: Éditions littéraires de France, 1949), 21. This episode is also mentioned in Jean Renoir, *Renoir: My Father* (Boston: Little, Brown, 1962).

a visual and material culture and economy developed around childhood, gradually entering bourgeois homes at the close of the century: painted, sculpted, and photographed depictions of childhood; images, books, and magazines for children; fashions for the most well-to-do; games and toys; and even specific furniture and decor for the bedroom. Every World's Fair—from London in 1851 to Saint Louis in 1904—included large educational exhibitions and sections for children, while the 1889 fair in Paris hosted a spectacular Palais des Enfants (Children's Palace). In 1873, a "universal and international exhibition of everything related to the child, from infancy to adolescence" was held at the Palais de l'Industrie in Paris.

Renoir seems to have recognized the new importance given to childhood. Throughout his career, and using different approaches (capturing his subjects alone or in groups, posing or in action), he painted each stage of childhood, from the newborn to the young adult;[2] he depicted both girls and boys, his own children along with the children of others. It could even be said that he acted as an advocate for childhood on two levels: as a father and as an artist.

At first glance, the image of childhood that he conveys is clearly one of a happy period, like Renoir's own childhood, and the models express humanity with an immediacy and a benevolence, just as Renoir liked to portray it. And yet the artist was no stranger to the disparate and contradictory conditions of childhood in the nineteenth century (labor, mortality, abandonment, etc.). His approach to childhood is no exception to this paradox, which historian Catherine Rollet examined in a major study, *Les Enfants au XIX^e siècle*.[3]

Children of the Salons and of the Montmartre Maquis

Renoir began painting children early in his career, in the mid-1860s. What began as a series of commissioned works led to sustained and almost exclusive production of portraits of wealthy children. This social element is often overlooked when considering Renoir's approach to the subject of childhood. Yet his first models were the daughters of successful entrepreneurs,[4] and the children of his friend the architect Charles Le Cœur (fig. 40). So, while Renoir's own childhood came to a fairly early end when he started working, most likely around the age of twelve or thirteen, as was the case in modest families like his, Renoir took no interest in children from his own background. However, he was sympathetic to the harsh social reality of childhood, and especially infant mortality, which remained very high throughout the nineteenth century. He was personally confronted with this widespread public health issue, which intensified with the obsessive fear of depopulation that developed in the aftermath of France's defeat in 1870 in the Franco-Prussian war. Renoir's first son, born in 1868 and whose existence only came to light twenty years ago,[5] probably lived a few short months. His fate was shared by many illegitimate children, whose mortality rate—between 50 percent and 90 percent in certain regions—was "appalling."[6] Renoir observed this reality again in the mid-1870s in Montmartre, where he worked and found his models: "He was moved and haunted by the deplorable living conditions of the children conceived in the wings of the Moulin [de la Galette]

8

Renoir, *Renoir: My Father*, 207.

9

The initiative was praised by Zola. "Aux mères heureuses," *Le Figaro*, April 18, 1891. See Virginie Serrepuy, "Georges Charpentier, 1846–1905: Éditeur de romans, roman d'un éditeur" (unpublished thesis, École Nationale des Chartes, 2005).

10

Baudot, *Renoir*, 21.

11

See Sylvie Patry, "Pierre-Auguste Renoir: Portrait de Madame Georges Charpentier et ses enfants," in *L'Impressionnisme et la Mode*, exh. cat. (Paris, Musée d'Orsay/Skira Flammarion, 2012), 99–105. Renoir painted two portraits of Paul (the one at the Salon in 1879), Georgette (1876), and Jane (1880).

12

Salon of 1879, two of four submissions, portraits of *Mme G[eorges] C[harpentier] et ses enfants* (Mme G[eorges] C[harpentier] and Her Children, fig. 85), and the portrait of *Paul Charpentier* (private collection). Salon of 1880, four of four submissions: *Pêcheuses de moules à Berneval* (Mussel Fishers at Berneval, fig. 38), *Jeune fille endormie* (Sleeping Girl; the Sterling and Francine Clark Art Institute, Williamstown), portrait of *Lucien Daudet* (pastel, private collection), portrait of *Marthe Bérard* (pastel, private collection). Salon of 1881, two of two submissions: Portrait of *Irène Cahen d'Anvers* (fig. 37), and of *Alice and Élisabeth Cahen d'Anvers* (Musée d'art de São Paulo Assis Chateaubriand). Salon of 1882: Portrait de *Yvonne Grimprel, dit au ruban bleu* (Yvonne Grimprel in a blue ribbon, private collection) was the only submission, but Renoir wanted to show the portrait of the Bérard sons, either André or Paul. Salon of 1883, no child portraits.

13

Les Filles de Catulle Mendès, 1888, The Walter H. and Leonore Annenberg Collection, The Metropolitan Museum of Art, New York, a gift of Walter H. and Leonore Annenberg, 1998, Walter H. Annenberg bequest, 2002.

14

1880, The Sterling and Francine Clark Art Institute, Williamstown.

and who must have sprouted like grass in the *maquis* [a euphemism for the slum housing] of Montmartre. Many of them died in early infancy. To save them, Renoir had the idea of founding a 'Pouponnat,' a childcare center."[7] He persuaded one of his most influential patrons, Marguerite Charpentier,[8] to lend her support, and even organized a dance at the Moulin de la Galette to benefit the project. Fifteen years later, Charpentier became the founder and director of the Pouponnière de Porchefontaine,[9] where children of working mothers were breastfed and cared for. The initiative, praised by French author and activist Émile Zola when it was created in 1891, later became a recognized institution known as the Société Maternelle Parisienne (Paris Maternal Society) and received a gold medal at the 1900 World's Fair in Paris. "So many people are unaware that they owe their lives to a great artist with a compassionate heart,"[10] pointed out Jeanne Baudot, a future student of Renoir's.

Renoir did not, in fact, depict the protégés of the enterprising philanthropist Madame Charpentier, except perhaps in the foreground of the crowd in *Bal au Moulin de la Galette* (*Dance at the Moulin de la Galette*; 1876, Musée d'Orsay, Paris). Instead, he painted her elegant children in *Madame Georges Charpentier et ses enfants* (*Madame Georges Charpentier and Her Children*, fig. 85). This masterpiece marked a turning point in Renoir's career and, more specifically, in his practice of child portraiture.[11] The painting of Charpentier's two children, Georgette and Paul (the eldest, Marcel, died prematurely), was shown to great acclaim at the Salon of 1879, earning Renoir praise and commissions. The mixed results of the impressionist exhibitions forced Renoir to find other opportunities and income, leading him to focus his efforts on portraits, and especially portraits of children. Their strategic role in this attempt to captivate and win over new audiences merits special attention here. Nine of the twelve works that Renoir sent to the Salon between 1879 and 1883 are images of children.[12] After a seven-year pause, his last contribution, in 1890, was another portrait of children—the daughters of his friend the poet Catulle Mendès.[13] In 1881, for the first time in his career, one of his works—a superb portrait of Irène Cahen d'Anvers—was reproduced in the highly respectable *Gazette des beaux-arts* as an "interesting portrait of a child." His submissions demonstrate the breadth of his abilities: he produced portraits in oil or in pastel (the preferred technique for children's portraits); large formal portraits, such as *Portrait d'Alice et Élisabeth Cahen d'Anvers* (*Pink and Blue—The Cahen d'Anvers Girls*), as well as closely framed, intimate portraits, like the vibrant and lesser-known Yvonne Grimprel; chubby babies (Lucien Daudet) and adolescents; children of the upper classes and, less often, poor children, such as the bohemians depicted in *Pêcheuses de moules à Berneval* (*Mussel Fishers at Berneval*, fig. 38), or, to a lesser extent, *Jeune fille endormie* (*Sleeping Girl*).[14]

Only rarely did Renoir take up these subjects made fashionable in the 1870s and 1880s by painters like Auguste Feyen-Perrin, Virginie Demont-Breton, and Francis Tattegrain. During the same period, and on the same shores, he turned his attention to both the ragged children of fishers or bohemians and to city dwellers dressed in the sailor suit characteristic of the bourgeoisie and emblematic of the growth of seaside tourism in the nineteenth century. The children of Yport's mayor, Alfred Nunès (fig. 39), and mussel harvesters are depicted against the background of a Normandy beach. However, there is no trace of social critique. Renoir

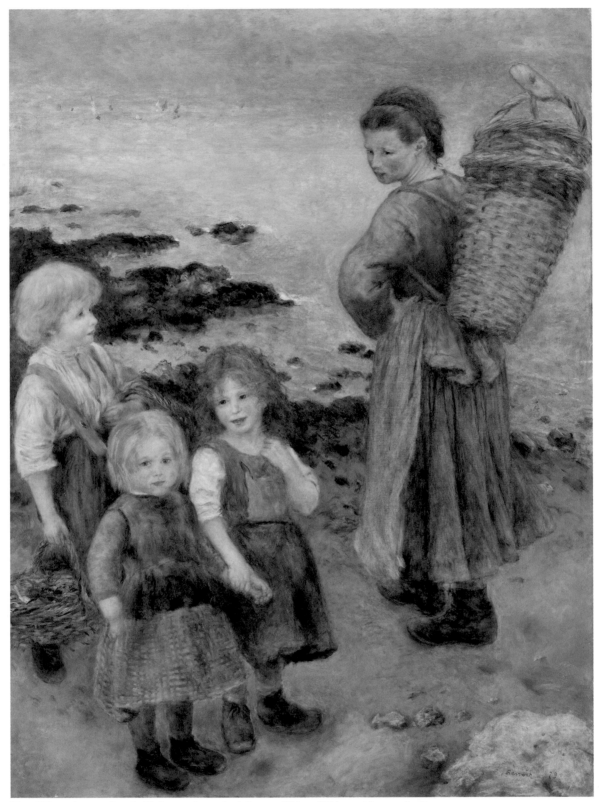

Fig. 38 Pierre-Auguste Renoir, *Pêcheuses de moules à Berneval* (*Mussel Fishers at Berneval*), 1879.
Oil on canvas, 5 ft. 9½ in. × 4 ft. 3½ in. (176.2 × 130.2 cm).
The Barnes Foundation, Philadelphia.

15
The little girl appears to be reinterpreted, beginning with *La Petite Bohémienne* (The little bohemian girl, 1879, private collection), even though the latter is not a study for *Pêcheuses de moules à Berneval* (Mussel Fishers at Berneval), but a work in its own right.

16
"One must know how to find beauty everywhere. That is what makes a poet.... Mirbeau is very talented, but ... he is, unfortunately, searching for truth," Pierre-Auguste Renoir, *Écrits et propos sur l'art*, ed. Augustin de Butler (Paris: Hermann, 2009), 241.

17
Michel Robida, *Renoir: Enfants* (Lausanne: International Art Book, 1959), 14.

18
The great critic, art historian, and collector Charles Ephrussi, who owned *La Petite Bohémienne* (The little bohemian girl) and *Les Deux Sœurs* (Two Sisters [On the Terrace], The Art Institute, Chicago), convinced the Cahen d'Anvers and Halphen families to commission Renoir for the portraits of their daughters and son. He particularly appreciated this aspect of Renoir's art. As for *Pêcheuses de moules à Berneval* (Mussel Fishers at Berneval), the painting was acquired by art dealer Paul Durand-Ruel and occupied a prime position in his salon.

19
Henry Havard, "Le Salon de 1881," in *Le Siècle*, May 14, 1881.

20
Renoir to Paul Bérard, July 1880.

21
Edmond About, *Le Décaméron du Salon de peinture pour l'année 1881* (Paris: Librairie des Bibliophiles, 1881), 97.

did not set one against the other: the Berneval fisherwomen are given the honor of a monumental format. The children, although they are likely to remain anonymous, are not reduced to stereotypes: they each have their own personality. Despite the baskets they carry, the difficult nature of their labor is not portrayed. They are posing—another job for which they were likely paid. Renoir is not trying to create a feeling of spontaneity, even if the composition appears to suggest a random group of figures. Although they are depicted as being fully integrated into the coastal landscape (unlike the portraits of the Nunès children, for example, in which the landscape acts as a backdrop), the composition is the result of a process of assembly and collage using children studied separately.[15] If not for the threadbare clothes and disheveled hair indicating the children's impoverished state, Renoir's treatment of the scene might pass for complete indifference to the harsh living conditions of those working in the fishing industry, which are clear in paintings by his contemporaries Demont-Breton and Tattegrain. But for Renoir, the purpose of art was not to reflect nor to contest the world—that would only add to its ugliness—but to "find beauty everywhere."[16] For Renoir, beauty and grace transcended social class, although this was more a case of indifference than any deeply held conviction on his part. From his perspective, young bohemians and fishers were every bit as worthy as the wellborn children he painted.

"These beautiful children who are said to be rich"[17]

This commercial strategy paid off, and those moving images of bohemian girls and mussel harvesters found buyers.[18] Most importantly, Renoir's portraits of children, commissioned by the Paris elite, earned him a new clientele: the Cahen d'Anvers, whose daughters' portraits were deemed "of exceptional interest" by the press at the Salon of 1881 (fig. 37);[19] the Nunès; and the Grimprels, whose patriarch was an associate of the banker Paul Bérard, one of Renoir's most important clients. Through a series of fourteen family portraits, Renoir painted all of Bérard's children, and he hailed the arrival of "[his] new model" when the youngest, Lucie, was born.[20] It seemed as though Renoir was finally on a par with popular portraitists Carolus-Duran, Paul Baudry, or Alexandre Cabanel. Like his contemporaries, Renoir emphasized the opulent interiors and clothing of his wellborn subjects, or depicted them against a dark red background, as in the portrait of Fernand Halphen (fig. 116). The young Nunès boy appears as self-assured (fig. 39) as Baudry's young *Louis de Montebello*, which was a success at the Salon in 1881 and declared worthy of the Louvre by an influential critic.[21] Renoir depicted the dresses of the Cahen d'Anvers girls with a precision and profusion of painterly effects that surpassed the work of Baudry, meticulous as he was. Like his popular contemporaries, Renoir embraced the codes of formal portraiture—stately bearing, large

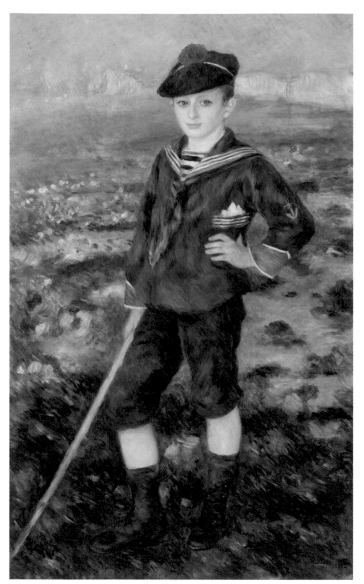

Fig. 40 Pierre-Auguste Renoir, *Portrait de Joseph Le Cœur*
(Portrait of Joseph Le Cœur), 1870.
Oil on canvas, 10½ × 8½ in. (27 × 21.5 cm).
Musée Unterlinden, Colmar.

Joseph Le Cœur was the son of the architect Charles Le Cœur,
older brother to Jules Le Cœur, who was a close friend of Renoir.

Fig. 39 Pierre-Auguste Renoir, *Robert Nunès*, or *Jeune garçon sur la plage
d'Yport* (Sailor Boy [Portrait of Robert Nunès]), 1883.
Oil on canvas, 4 ft. 4 in. × 2 ft. 7½ in. (131 × 80 cm).
The Barnes Foundation, Philadelphia.

22
Quoted in Renoir, *Écrits et propos sur l'art*, 167–168.

23
Renoir, referring to Manet's *Le Linge* (Laundry; 1875, The Barnes Foundation, Philadelphia), his favorite painting, in Renoir, *Écrits et propos sur l'art*, 203.

24
The Musée du Luxembourg, Paris, then known as the museum of living artists. Today, the painting is held at the Musée d'Orsay, Paris.

formats, full-length paintings, gleaming finishes, and expressions that, while touching, remain serious and reserved. The painter's little girls are just as admirable as the Velázquez *infantes* that Renoir so appreciated.

But a closer inspection reveals a mixed picture. In the nineteenth century, children's portraits remained less prestigious and fetched lower prices than others: representational stakes were not as high. That may explain why clients who had not previously demonstrated an interest in Renoir or in impressionism took the, albeit limited, risk to commission work from him. In some cases, this association was very short-lived. For instance, the Cahen d'Anvers were apparently dissatisfied with the beautiful portraits of their daughters. They consigned the paintings to the servants' quarters, whereas likenesses by Carolus-Duran and Léon Bonnat were displayed in rooms where visitors would see them. "As soon as a painter gets involved, there's nothing left, no resemblance. The family is impossible to please. They never understand the color of the hair or of the eyes; they don't see the tone these acquire from reflections, the surroundings, and the light at different times of the day,"[22] wrote Renoir several years later, attributing failures and misunderstandings to the fertile, creative tension between the importance of resemblance and the resulting, necessary divergence from reality—a deviation that any true artist must take. His portrait *Filles de Catulle Mendès* (*The Daughters of Catulle Mendès, Huguette, Claudine, and Helyonne*) was so poorly presented at the 1890 Salon—one critic described it as an "assassination"—that he stopped participating in the event altogether.

"A garden, a woman, and a child: I can think of nothing more beautiful."[23]

A few unfortunate commissions did not overshadow the success, central role, and growing importance of children's portraits in Renoir's work from the 1880s to the 1910s. It is worth noting that *Jeunes filles au piano* (*Young Girls at the Piano*)—a painting selected by Renoir himself—was the artist's first work to enter a museum collection, in 1892.[24] He still received requests from patrons and friends, including Paul Durand-Ruel, Caillebotte, and Morisot: these close relationships enabled Renoir to experiment and create a variety of often masterful pieces. This brings to mind the outdoor portraits of the Durand-Ruel children that vibrate with the flickering sunlight, or portraits of Julie Manet (figs. 89, 143), the Goujon children, or the Bérard daughters in the sitting room of Château de Wargemont (fig. 72), which all feature pure, precise brushwork that prefigures Derain in the 1920s and Balthus, although minus the latter's ambiguity. Most importantly, for the first time, beginning in 1885, fatherhood and painting went hand in hand in Renoir's life. It does not seem to have been a reflex, however: to our knowledge, he never painted his first two children, Pierre, born in 1868, or Jeanne, born in 1870, who was also a

25
"But it sometimes happens that a Raphael who only wished to paint nice girls with little children—to whom he gave the title of 'Virgin'—reveals himself with the most touching intimacy," Renoir, quoted by Jean Renoir in *Renoir: My Father*, 222.

26
Jean-Marc Rohrbasser, review of Catherine Rollet, *Les Enfants au XIX^e siècle* in *Population* 57, no. 1 (2002): 213–216.

27
Renoir, *Renoir: My Father*, 250.

28
These expressions come to us by way of Ambroise Vollard and Georges Besson. I analyzed this role of the model within the family sphere in Sylvie Patry, "L'invention du modèle," in *Renoir/Renoir*, exh. cat. (Paris: La Martinière, 2005), 26–37.

29
Jean Renoir en chasseur (*Jean Renoir as a Huntsman*; 1910, Los Angeles County Museum of Art, Los Angeles).

product of his relationship with Lise Tréhot, Renoir's lover and model in his youth. Renoir remained in contact with Jeanne, who died destitute, but she did not appear in his paintings. It was the birth of his third child, also named Pierre (the future actor), in 1885 that marked a turning point. When he was just months old, Pierre inspired mother-and-child scenes "with the most touching intimacy," so admired in the work of Raphael (fig. 41).[25] This was in stark contrast to Renoir's discretion regarding his private life: he informed only a few close relations about his companion, Aline Charigot, and their son. He married Aline in 1890: until his fifth birthday, Pierre was among those children born out of wedlock whose numbers doubled between 1800 and 1910.[26] Aline and Pierre pose outside of a house in the countryside, barely visible in the background. Through pure lines and sculptural figures, the artist's personal life acquires the same dignity as Raphael's Madonnas. "As he eagerly sketched his son [Pierre], in order to remain true to himself he concentrated on rendering the velvety flesh of the child; and through this very submission, Renoir began to rebuild his inner world,"[27] writes Jean Renoir. In the work that followed, the importance of painting scenes of childhood and of doing what Jean Renoir called "settl[ing] down to family life" cannot be stressed enough. This "settling" finally allowed for an intimacy and a closeness that enabled Renoir to capture his models, to make them "enter the paintbrush"—a process that was essential to the creative method of an artist who "could not work without a model."[28]

Jean, the filmmaker, born in 1894, and Claude, known as Coco, born in 1901, were represented in their father's work to an even greater extent than Pierre. The artist portrayed his younger sons in a series of portraits and genre paintings, first as babies and into late childhood, then as they became adults. Jean's relationship with Renoir was likely the most complex of them all—he would later portray his father in a book and, more indirectly, through his films. Renoir produced some sixty portraits of Jean as a child, starting when he was just months old (fig. 28) and concluding with a portrait of the boy in hunting attire, carried out in 1910, when he was sixteen years old.[29] It was both a lot and very little; contrary to what Renoir's body of work might suggest, Jean, like Pierre, spent little time with his parents as a child. The portraits, therefore, occupy these intervals. In 1902, Jean enrolled at the very chic Sainte-Croix private school in Neuilly, which he left in 1907 for other boarding schools. Convinced that children should not be educated before the age of ten, Renoir enrolled none of his own in the French public schools, whose architecture and strict, normative methods he deplored. His youngest son, Coco, probably had the most freedom, contact with nature, and hands-on learning, which Renoir felt were important for a child's natural development. Broadly speaking, the artist's approach to education was in tune with the new teaching methods that developed in the early twentieth century, although he was most likely unaware of them. Jean and Claude inspired a diverse artistic output, both in terms of the techniques Renoir used (painting, sculpture, etching,

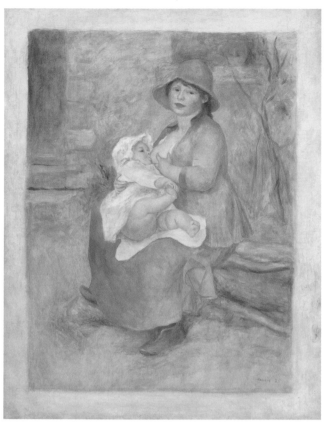

Fig. 41 Pierre-Auguste Renoir, *Maternité* (Motherhood), 1885.
Oil on canvas, 3 ft. × 2 ft. 4½ in. (92 × 72 cm). Musée d'Orsay, Paris.

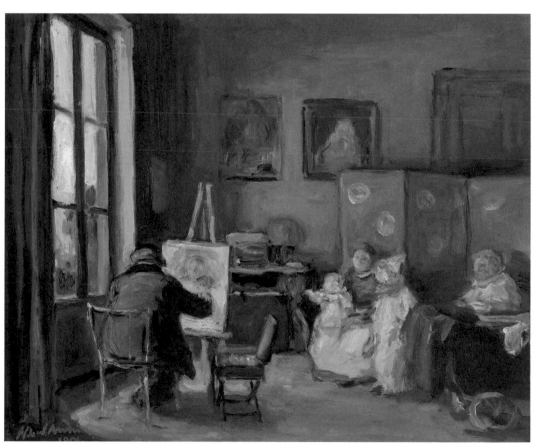

Fig. 42 Albert André, *Renoir peignant en famille* (Renoir painting his family), 1901.
Oil on hardboard, 21 × 24½ in. (53 × 62 cm). Musée d'Art Sacré du Gard, Pont-Saint-Esprit.

30
Marie Izambard (1885–1943). See Anne Distel, "Renoir, *The Artist's Family*," in *Renoir: Father and Son*, exh. cat. (Paris: Musée d'Orsay/ Flammarion, 2018), 272–277.

31
Edmond Renoir quoted in Renoir, *Écrits et propos sur l'art*, 25.

and drawing) and his ambitions, ranging from large, finished portraits of posed subjects, intended for sale, to intimate portrayals. These works were both a record of daily life and an idealized vision. With the children in the picture, an entire family, a "household" was captured in painting (fig. 42). In accordance with bourgeois custom, the boys—Jean and Claude—were educated by nannies and servants. Therefore, mother-and-child paintings are rare in Renoir's oeuvre, and in portrayals of the painter's own family, Pierre most often appears in these specific compositions. Renoir, like his friend Berthe Morisot, depicted his children more often in the company of the young women employed to look after them than with their mothers. The most important of these women was Gabrielle Renard, a cousin of Aline's, and Renoir's preferred model between 1894 and 1914. These nannies and models were also on hand to provide entertainment and distraction during sittings that many of the children would agree were grueling. Renoir's "inner world" and private sphere coincide perfectly through artistic practice and expression: the two crystallize in childhood. It is significant, then, that Renoir reserved a family portrait— the largest portrait he ever painted—for the Musée du Louvre (fig. 43). It includes Aline and Gabrielle, two maternal figures: one of biological motherhood and the other of caregiving. Pierre is wearing the aristocratic and bourgeois sailor suit, the topos of nineteenth-century portraits of boys. The lines of the composition converge where Jean can be seen in the foreground. Each boy is entwined with the woman who, in a way, acts as his mother. Jean has the stately, elegant bearing of royal offspring, but the position of his foot and the hand that can be seen grasping Gabrielle's sleeve betray the clumsiness of early childhood (he was two years old at the time). Above all, these details indicate Renoir's empathy. Gabrielle crouches at the child's level, a metaphor for Renoir's views on childhood. The group is joined by a little girl seen dropping by, like an interloper.[30] In a manner that seems both spontaneous and strangely artificial, she appears to be showing only the viewer the ball she is taking on what must be a walk in Montmartre. *La Famille de l'artiste* (*The Artist's Family*; 1896, The Barnes Collection, Philadelphia) is no longer quite true to its title. In fact, Renoir never painted his entire family together. This masterpiece seems to bring together the paradoxes and surprises contained within representations of childhood in his work: between the overtly stated and the merely suggested, closeness and absence, freedom and rules, but at the same time it is deeply human and alive, mischievous and on the verge of stepping out of the frame. If childhood occupied such an important role in Renoir's life and work, it is perhaps because, more than the world of adults, it contained this "impression of nature with all its surprises and intense harmony."[31]

Fig. 43 Pierre-Auguste Renoir, *La Famille de l'artiste* (*The Artist's Family*), 1896.
Oil on canvas, 5 ft. 8in. × 4 ft. 6 in. (1.73 × 1.37 m). The Barnes Foundation, Philadelphia.

Pierre-Auguste Renoir
1841–1919

Jean dessinant (The Artist's Son, Jean, Drawing)
1901

Oil on canvas
17¾ × 21½ in. (45.1 × 54.6 cm)
The Mellon Collection, Virginia
Museum of Fine Arts, Richmond

1
Jean Renoir to John Roberts, editor
at Ganymed Press in London, January 1,
1952, archives, Virginia Museum
of Fine Arts.

2
Renoir's Portraits: Impressions of an Age,
ed. Colin B. Bailey, exh. cat. (London:
Yale University Press/Ottawa, National
Gallery of Canada, 1997), 232.

A young Jean Renoir draws shapes on a sheet of paper under his father's gaze. As an adult, one of the greatest filmmakers of the twentieth century remembered this day spent posing for his father, recounting the anecdote in a letter to a British editor some fifty years later:

> I was myself exactly seven when the painting was done. I had caught a cold and could not go to school, and my father took the opportunity to use me as a model. To keep me quiet, he suggested that a pencil and piece of paper should be given to me and he convinced me to draw figures of animals while he himself was drawing me.[1]

Among the portraits of Jean as a child, the Richmond painting belongs to a series that depicts the boy with short hair, making reference to the minor domestic crisis that occurred in the fall of 1901. The Jesuits at the Sainte-Croix school in Neuilly had demanded that Jean cut his long hair—to the despair of his father, who was captivated and inspired by his lovely red curls, but to the great satisfaction of the boy, who was delighted that he would no longer be mistaken for a little girl at the park.[2] The composition illustrates the influence of rococo genre painting on Renoir around 1900. In this case, he was probably inspired by Jean Siméon Chardin's *La Petite Maîtresse d'école* (*The Little Schoolmistress*), which may put an aspect of the painting's provenance into perspective. Andrew Mellon acquired the Chardin work in December 1936, shortly before his death. It is likely that Mellon's son, Paul, still had the painting in mind when, much later, in 1962, the London art dealer Agnew suggested that Paul buy this painting of Jean drawing (in the meantime, the family had donated the Chardin to the National Gallery of Art in Washington, D.C.).

S. C.

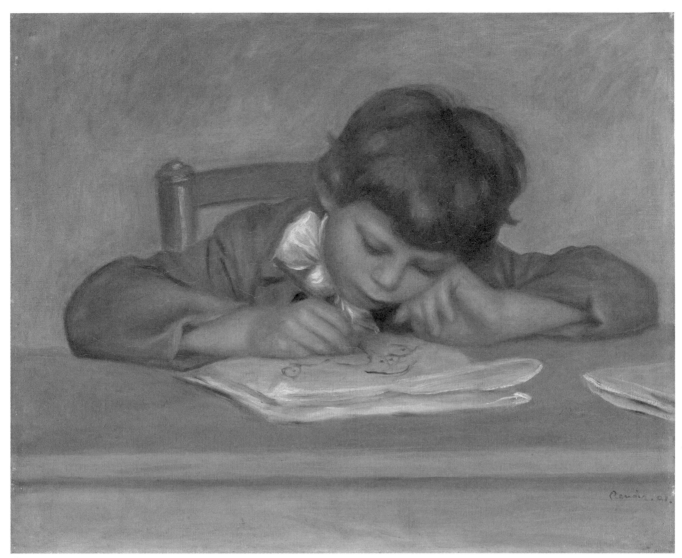

Fig. 45

75

Facing page:
Fig. 46 Camille Pissarro,
Paul-Émile Pissarro, 1890.
Oil on canvas, 16 × 13 in.
(41 × 33.6 cm).
Private collection.

Camille and Julie Pissarro's eighth
and last child—and the only one
born in Éragny—Paul-Émile is
probably between five and six years
old in this painting. Like the young
Jean Renoir, he still has the long
locks typical of early childhood.

Facing page:
Fig. 47 Camille Pissarro,
Jeanne Pissarro dite Minette
(Portrait of Minette), 1872.
Oil on canvas, 18 × 14 in.
(45.7 × 35.2 cm).
Wadsworth Atheneum Museum
of Art, Hartford, CT.

Jeanne-Rachel Pissarro was named
after both of her grandmothers.
Nicknamed Minette by her parents,
she was born in 1865, two years
after her brother Lucien. Her
younger sister, Adèle-Emma, born
in 1870, survived only three weeks,
making Jeanne-Rachel—in 1872—
her parents' only daughter. Minette
poses here in the Pissarro home
in Pontoise.

Below:
Fig. 48 Camille Pissarro, *Portrait*
de Jeanne dite Cocotte, au chignon
(Portrait of Cocotte with her hair
in a chignon), 1898.
Oil on canvas, 22 × 18½ in.
(56 × 47 cm).
Arp Museum Bahnhof Rolandseck,
The Rau Collection for Unicef,
Remagen.

Given the name Jeanne, like her
older sister who died at the age of
nine, Cocotte was the only Pissarro
daughter to outlive her parents.
Her mother endeavored to provide
her with a good education, in the
hopes of preventing her father from
making an artist of her. However,
Camille Pissarro's letters reveal the
painter's discreet attempts to give
his daughter an artistic education,
notably by urging her toward
tapestry and the textile arts.

Claude Monet
1840–1926

Un coin d'appartement (A Corner of the Apartment)
1875

Oil on canvas
32 × 26½ in. (81.5 × 60 cm)
Musée d'Orsay, Paris

This unusual work by Monet was carried out in Argenteuil, in the house where the artist was living with his young wife, Camille Doncieux, and his son, Jean, who was born in 1867. Monet positioned his easel at the entrance to a series of adjoining rooms: everything about the scene is theatrical. Lined with blue-and-white Chinese porcelain jars, which set off the tall palm trees, and framed by the window draped with imposing curtains, the space is viewed from a strange perspective. Positioned slightly to the right of the composition, Jean, wearing a schoolboy's uniform, is standing in the shadows with his hands in his pockets as he stares at the viewer. On the left, Camille, barely visible and seated near a large table, seems to have interrupted her work to observe the scene. An unlit chandelier hangs over the room, separating the child from his mother. Nothing seems clear in this "corner of the apartment": where are they? Is it an anteroom, a small sitting room, or a greenhouse? The residence in Argenteuil was not large, but several steps led directly from the sitting room into the garden. In this painting, Monet paints an image of childhood that is at once intimate and mysterious. Jean seems slightly lost, caught up in his daydreams in an adult world, a world that is a little too large for him. But he is also posing for his father and stares directly at the viewer. In a sort of mise en abyme, this beautiful, tender portrayal of a child wavers between portrait and genre painting within an unsettling atmosphere: therein lies Monet's strength and the power of his painting, which sought to achieve universal images. The work was acquired by his friend, the painter and patron Gustave Caillebotte, who lived for several years across the river from Argenteuil, in Le Petit-Gennevilliers.

C. S.

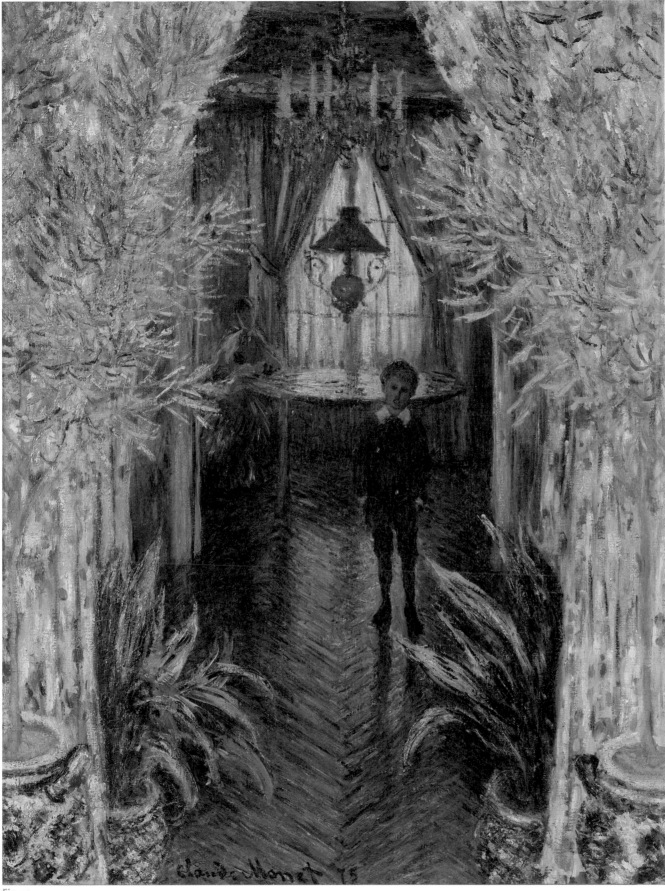

Fig.49

Monet:
A Family-Minded Man

Dressed in a simple canvas suit, a white shirt, leather ankle boots, and a hat, and, as always, smoking a cigarette, Claude Monet sits on the second step of the staircase leading to the terrace running along his house. He is not posing; he is taking a break. The photographer has captured him in a rare moment of domestic intimacy, in a natural, relaxed position, comfortably settled on both legs, his right arm on his knee. At his side, sitting on the same step, are Sissi and Lily, his two step-granddaughters, aged two and eleven, respectively. The painter and the older girl are looking at the younger one as she looks at the photographer. Her mouth is smeared with something, probably the candy Monet is holding in his other hand, which he has just offered her. The image that Monet projects here is not a common one (fig. 50): the artist makes way for the man. A brief review of Monet's life shows that the painter constantly maintained his relationships with children; what's more, they were precious to him. Not only was Monet family-minded, he nurtured this trait, as evidenced by the two periods of his married life. He had two sons from his first union, with Camille Doncieux: Jean, born out of wedlock in 1867; then Michel, in 1878. Camille died the following year. His family grew when Alice Hoschedé—who had separated from her husband— entered his life in 1880. She had six children, and Monet was likely the

father of the youngest. From that point on, and once they had all settled in Giverny in 1883, the artist began a new life within a blended family, with a total of eight children. At that time, Monet was forty-three years old—he had reached the midpoint of his life. Although the inventory of Monet's catalogue raisonné makes little mention of this family life, the first period is primarily illustrated by various portraits, such as *Jean Monet dans son berceau* (*The Cradle—Camille with the Artist's Son Jean*; 1867, fig. 25), *Le Fils de l'artiste* (*The artist's son*; 1868), *Jean Monet sur son cheval mécanique* (*Jean Monet on His Horse Tricycle*; 1872, fig. 20), *Germaine Hoschedé avec sa poupée* (*Germaine Hoschedé with her doll*; 1877), *Jean-Pierre Hoschedé dit "Bébé Jean"* (*Jean-Pierre Hoschedé, known as "Bébé Jean"*; 1878), *Michel Monet bébé* (*Portrait of Michel Monet as a Baby*; 1879). The second period provided Monet with opportunities to sketch in his notebook several scenes in which they all appear, such as studies of Germaine Hoschedé or Jean-Pierre Hoschedé and Michel Monet drawing; to make the pastel portraying Jacques, Suzanne, Blanche, and Germaine Hoschedé (c. 1880); and even to paint a work featuring Jean-Pierre Hoschedé and Michel Monet fishing (*Jean-Pierre Hoschedé et Michel Monet au bord de l'Epte* [*Jean-Pierre Hoschedé and Michel Monet on the Bank of the Epte*], 1887). Certain documents from these periods have remained in the family and provide a better understanding of the painter's relationship with the

children. "I saw Monet for the first time in 1876," writes Blanche Hoschedé. "I was eleven years old, but I remember his arrival at my parents' house in Montgeron. He had been introduced to me as a great artist with long hair. I was struck by this, and I took a liking to him right away, because it was clear he liked children. He had a teasing nature." From the first time she saw him, the image that Blanche paints of Monet was favorable. As a child, she immediately found him to be friendly; this feeling only grew over time and soon came to be shared by the entire troop of children, from the moment Monet became, as it were, the head of his blended family. In 1883, when they arrived in Giverny, the family included five teenagers—Marthe, Blanche, Suzanne, and Jacques Hoschedé, and Jean Monet—and three younger children, Germaine and Jean-Pierre Hoschedé, and Michel Monet. In the 1890s, following Suzanne's marriage to the American painter Theodore Butler, the family gained two new members when James, called Jim, was born in 1893, then Alice, known as Lily, the following year. Finally came Germaine's two daughters— Simone, known as Sissi, born in 1903, and Nitia-Dominique, called Nitou, in 1907.

A veritable tribe regularly descended on Monet's home in Giverny for periodic gatherings that the artist was particularly fond of, whether they were family Sundays, or other high days and holidays. "Every Sunday, and for celebrations, he liked to assemble

the whole family," writes Simone Piguet, "and there were about fifteen of us around the big table in the yellow dining room hung with many Japanese prints. After meals ... with my sister, six years my junior, I played in the garden and especially in the village, because Monet did not want us bringing friends to his house. Most of my time was spent at the farm across the way, with the Lecreux, who had several children." Essentially her only grandfather, the artist was "called simply Monet or, sometimes, papa Monet" by the children, and Piguet recalls a man who "was demanding in only two regards: don't disturb the flowers in the garden and respect mealtimes.... Lunch was at 11:30 a.m., since Monet always woke very early, and when I went to school in Giverny, in 1914–1915, we had to ask the schoolteacher to let me out at 11:15 a.m., a quarter of an hour before all of my classmates, and this greatly annoyed me." She also remembers that, every year, when Monet hosted the Académie Goncourt for lunch, no distinction was made between adults and children, who were allowed at the table, along with everyone else. It is well known that mealtimes were some of the most precious moments in Monet's life. They were as much a respite from work as they were an opportunity to enjoy being with his family.

Philippe Piguet

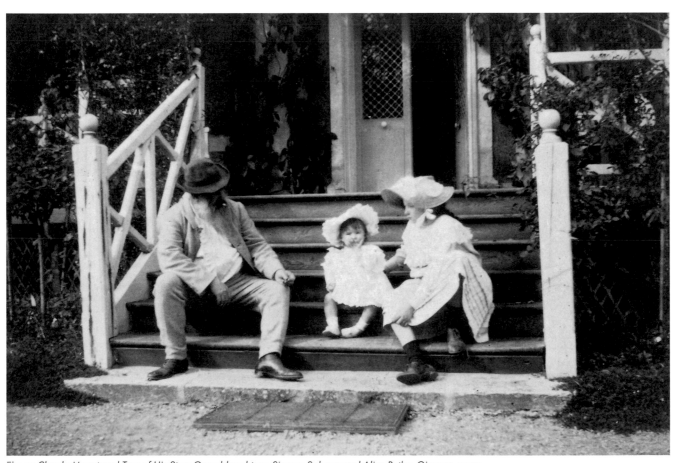

Fig. 50 *Claude Monet and Two of His Step-Granddaughters, Simone Salerou and Alice Butler, Giverny, 1905.* Philippe Piguet Collection.

This small portrait, painted the
year that Monet moved to Giverny,
depicts the artist's youngest son,
Michel, who was five years old at
the time.

Paul Gauguin
1848–1903

Intérieur avec Aline Gauguin (Interior with Aline Gauguin)
1881

Oil on canvas
20½ × 23¾ in. (52.4 × 60.3 cm)
Private collection,
on long-term loan to the Sheffield
Museums Trust, Sheffield

This strange painting depicts Aline, born on December 24, 1877. She was the daughter of Paul Gauguin and his wife, Mette Gad, who was Danish. They had five children together: Emil, Aline, Clovis, Jean, and Pola. Aline and Clovis died during the painter's lifetime. In 1881, Gauguin painted two works, *La Petite rêve* (*The Little One Is Dreaming*; Ordrupgaard, Copenhagen) and *La Petite s'amuse* (*Little Girl Playing*; private collection), that were in fact two versions of Aline's portrait—one thoughtful and the other mischievous. In this painting, Gauguin portrays her with short, cropped hair, sitting on a sofa before a large table. The room is plain, with a wood stove and bare walls. An orange sits in a fruit bowl, while two others sit on the table. The close framing truncates the edges of the furniture and creates an off-kilter image. The influence of Japanese art is evident. Aline holds an orange in her hands and seems lost in her thoughts. During this period, Gauguin, a wealthy stockbroker, was dabbling in painting, but had been exhibiting his work since 1876. He participated in the fourth impressionist exhibition in 1879. His radical decision to abandon his profession and become a painter caused his wife to leave, taking their children with her to Copenhagen. Gauguin had a close relationship with his children, and he was fascinated by their inner world and their dreams. He often painted them sleeping or escaping the watch of adults. In 1893, Gauguin dedicated *Le Cahier pour Aline* (The notebook for Aline), written in Tahiti, to his daughter. It is the journal of an exile who recounts his impressions of colonization on the island, but it also revisits texts by Poe and Wagner. Aline died of tuberculosis in 1897, at the age of nineteen, sending Gauguin into a state of deep distress. In a letter to Mette, the artist mourned his daughter: "Her grave is over there, with the flowers, it's only an illusion. Her grave is here, near me—and my tears are flowers, living flowers."

C. S.

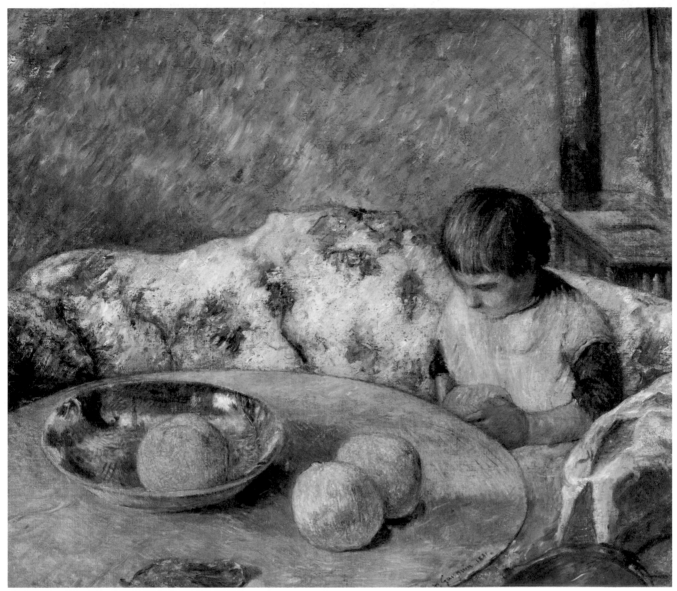

Fig. 53

Fig. 54 Émile Zola, *A Doll Sitting in a Child's Rocking Chair on the Left;*
Denise, Crouched Next to It, Caressing the Doll's Cheek, 1897.
Musée d'Orsay, Paris.

The children are delighted. I am to thank Mrs. Mirbeau for the nice playthings you sent them. They are happy, quite happy; if only all of life could be so.

Camille Pissarro to Octave Mirbeau, December 29, 1892

GAMES AND TOYS

Fig. 55 Catalog published by La Maison du Petit Saint-Thomas, Paris, 1880.
Bibliothèque Forney/Ville de Paris, Paris.

1

Far more factual and descriptive, Henry René d'Allemagne's *Histoire des jouets* (Paris: Hachette, 1902) was the first general history of the toy, published in the wake of the 1900 World's Fair in Paris.

2

The same definition is valid for games (swimming, climbing, and others) that require only space and a bit of freedom, and that can be found throughout European art, from Joaquín Sorolla's swimmers in the south, to Peder Severin Krøyer's in the north.

3

Some choices were more surprising, like the rat, the protagonist of Baudelaire's poem "The Poor Child's Toy," in *Paris Spleen* (New York: New Directions Pub. Co., Michel Lévy, 1988), 35.

Fig. 56 André Devambez, *Auguste a mauvais caractère, planche 4* (Bad-tempered Auguste) (Paris: Devambez Éditeur, 1913).
Bibliothèque Nationale de France, Paris.

4
A striking example is the role that toys and their makers played in documents related to the World's Fairs. In 1878, in section IV, consisting of fabrics, clothing, and accessories (category 42), trinkets and toys occupied a very small space. This had grown significantly by 1900, when toy makers had their own pavilion and were listed in category 100 (trinkets, group XV, various industries). The category change speaks volumes about the technological evolutions in toys.

5
Victor Hugo, "The Little One All Alone," chap. V, in *Les Misérables*, vol. 2: *Cosette*, book 3: *Accomplishment of the Promise Made to the Dead Woman* (New York: Fall River Press, 2012), 241–244.

6
But Cosette nonetheless informs him that these are "things with gold in them," in "The Unpleasantness of Receiving into One's House a Poor Man Who May Be a Rich Man," chap. VIII, ibid., 248.

7
Ibid.

8
"Entrance on the Scene of a Doll," chap. IV, ibid., 240.

9
Ibid.

A brief history of toys can be told in three parts, each defined by a different type of plaything.[1] First, there were natural objects, or toys found in nature:[2] a stone, twine, or a stick picked up by the player[3]—enough to provide ample entertainment. These were followed by unique, hand-made toys crafted by a father or craftsperson for a specific player. Finally, mass-produced toys appeared: several industrial processes were combined to make toys that no longer had a specific player in mind, but were standardized products for organized distribution. We will focus on this third phase, which dominated the second half of the nineteenth century,[4] although toys from earlier phases remained in less privileged rural and urban environments.

The most obvious example of this "industrial" shift can be found in Victor Hugo's *Les Misérables* when Cosette encounters Jean Valjean, in 1823, in the forest, and they return to the Thénardiers' inn, in Montfermeil.[5] The innkeepers' daughters, Éponine and Azelma, have a doll that Hugo barely mentions;[6] the third child, Cosette, whose mother sent her to board with the family, has "only a little lead sword, no longer than that … [it] cuts salad and the heads of flies."[7] Soon after, the escaped—and wealthy—convict gives Cosette the doll she had been dreaming of ever since she first caught a glimpse of it: "the merchant had placed, on a background of white napkins, an immense doll, nearly two feet high, who was dressed in a robe of pink crepe, with gold wheat-ears on her head, which had real hair and enamel eyes."[8]

Industrialization was synonymous with commercialization, and a distribution network for toys was soon established, as demonstrated by the description of "open-air boutiques" extending from the church to the Thénardiers' inn.[9] Cosette discovers her future doll here, on Christmas Eve, shortly before midnight mass. The department stores that developed in bourgeois cities could not display all the toys now available and so resorted to the *réclame*: a precursor to modern-day advertising. These were small pamphlets, illustrated with engravings and printed in black and white, some of which featured a colorful cover; pompously called

What Shall We Play?
Toys in Late Nineteenth-Century Painting

Dominique Lobstein

10
The largest catalogs produced by these stores were Parisian, published for the renowned department stores Le Printemps, Le Bon Marché, and Les Galeries Lafayette, but also for stores that have since closed, including Le Petit-Thomas, which opened in 1810 on Rue du Bac; the Grands magasins de Pygmalion, on Boulevard de Sébastopol, with premises on Rue de Rivoli and Rue Saint-Denis; À la Ménagère, on Boulevard de Bonne-Nouvelle, which had several branches outside of Paris, in Dijon, Niort, etc. Many of these store catalogs are held in the Forney library in Paris, where Martine Boussoussou helped me to locate them.

11
Sometimes called "Jouets et objets d'étrennes (Festive Toys and Objects)," these documents also offered luggage, cutlery sets, and liquor cabinets, which were obviously not intended for children but came under the category of possible Christmas gifts for adults.

12
Although sometimes—and this is true of the catalog we reference here—one of the first pages, containing no images, is dedicated to "festive books" and refers to the upcoming publication of a longer brochure.

13
Maison du Petit Saint-Thomas, Rue du Bac, Paris, *Tout le mois de décembre, exposition de jouets* (Paris: Imprimerie A. Lahure, 1880), 3.

14
Ibid.

15
Ibid., 5.

16
In the year 1880, ten years after the defeat of France in the Franco-Prussian War, it is worthwhile to note that no toys bear arms, only military costumes inspired by older uniforms.

17
In Courbet's painting *Pierre-Joseph Proudhon et ses enfants en 1853* (Pierre-Joseph Proudhon and his children in 1853; 1865, Petit Palais, Musée des Beaux-Arts de la Ville de Paris, Paris), his eldest daughter runs her finger along the letters of her alphabet book, while the youngest plays with a tea set. According to her father's theory, there were activities appropriate for each age.

"catalogs" (fig. 55), they were announced with great fanfare on posters. In spring, summer, and fall, they showcased seasonal clothing for adults and children.[10] These little pamphlets, which appeared shortly before winter, were intended for children anticipating a visit from Saint Nicolas or Santa Claus; they were widely distributed each year, often under the title *Articles pour étrennes* (Festive Gifts),[11] beginning in the late 1870s.

Further explanation is needed before considering the role of toys and games in the age of impressionist painting. These catalogs all adopted the same classification system: resellers appealed to what was probably a hierarchy defining children's preferences, and they appear to have promoted individual play, a fact reflected in the rare appearance of board games. Dolls always came first,[12] and, after "baby" dolls, they almost exclusively resembled little girls. The most popular were "unbreakable babies, with a fully-jointed body; an unglazed porcelain (bisque) head; enamel eyes; long, styled hair; and dressed in satin,"[13] which came in sizes from 11 to 22 inches (28–55 cm) and cost between 16 and 48 francs. These were followed by "rubber Bébé[s] dressed in a knitted wool baby, Punch, or soldier outfit,"[14] which measured 20½ inches (52 cm) and sold for just 34 francs. To accompany these "babies," a "basket containing an earthenware dish set" appears on the same page for 2.90 francs. The following page features primarily "kidskin dolls with fully-jointed bodies, heads that turn, and long, styled hair, wearing satin and velvet outfits," measuring 10½ to 23 inches (27–58 cm) and priced between 9 and 55 francs. The same dolls were also available without clothing or accessories for between 2.50 and 8.70 francs, and in a bare, sculpted wood version measuring 16 to 18½ inches (40–47 cm) that sold for 11.50 or 13.50 francs. The accessories featured on this page are "a Japanese cabinet with doll toiletries or a child's dish set," available in two sizes, for 18.50 or 32 francs; and a "basket filled with rubber toys" for 8.50 francs. The pages that follow feature other kinds of dolls—a baby Punch and a baby soldier available in a single size, priced between 3.90 and 12.75 francs; there is also an automaton in a single size (an equestrian acrobat) for 120 francs and mechanized toys (dolls that jump rope or play tennis) for 17 francs.[15] Eventually the catalog leaves aside babies and dolls to present a rather jumbled inventory: pages six to twenty feature a succession of small images depicting baby clothes and furniture for dolls, tenpin sets, costumes, musical instruments, animals made from leather, ball-toss games, and bagatelle tables.[16]

Let us now turn to the images of children and toys portrayed by painters in the last quarter of the nineteenth century, leaving aside those that relate to education; many artists during this period depicted children reading,[17] writing, or engaged in artistic or musical practice, but these do not appear to be presented as leisure activities.[18] Only children leafing through Épinal prints or illustrated books have been included here. Pierre-Auguste Renoir portrays Gustave Caillebotte's niece and nephew (his brother Martial's children) seated on a sofa: Geneviève turns the pages of an illustrated book as Jean looks at the images. A pile of other children's books rests at her side (1895, fig. 74).

18

This view may explain why the term *jouet* (toy) does not appear in *Dictionnaire de pédagogie et d'instruction primaire*, vol. 2, ed. Frederick Buisson (Paris: Librairie Hachette, 1888), which only mentions games for group play (pp. 1095–1096).

19

Expressly leaving aside the formal portraits that punctuate history, such as Velázquez's *Equestrian Portrait of Prince Baltasar Carlos* (1635, Museo del Prado, Madrid).

20

Several paintings convey the regret that urban children felt at being far from animals, such as Jean Geoffroy's *Les Animaux au marché de Belleville* (The animal market in Belleville; Sotheby's, live auction, May 22, 2018, lot 80, New York), from the Salon of 1909 in *Henry Jean Jules Geoffroy, dit Géo (1853–1924)*, ed. Maryse Aleksandrowski, Alain Mathieu, Dominique Lobstein (Trouville: Illustria—Librairie des Musées, 2012), 198 and 225–226. These compensations—goldfish (Berthe Morisot, *Les Enfants à la vasque* [The children playing at the basin; 1886, Musée Marmottan Monet, Paris]), canaries, and house dogs (Berthe Morisot, *Julie et Laërte* [Julie and her greyhound Laërte; 1893, Musée Marmottan Monet, Paris])—became increasingly common features of childhood.

21

This embryonic doll also appears in the foreground of *La Joie des petits* (Children's joy; private collection), presented by Jean Geoffroy at the Salon de la Société des Artistes Français in 1906 (in *Geoffroy, dit Géo*, ed. Aleksandrowski, et al., 192–194). His painting *Les Poupons à la crèche de Belleville* (The baby dolls at the Belleville crèche; Salon of 1910, discovered in a photo from the Druet-Vizzavona archive) illustrates a more evolved version of the doll, with wooden head, arms, and legs, and a body stuffed with sawdust.

22

No. 325, 6. These wooden dolls were easily improved with Épinal prints that could be cut out and pasted to them.

In the mid-nineteenth century, natural objects still predominated as toys, and several works illustrate children's capacity for appropriating and transforming a given object. Two examples, one from mid-century and the other from the turn of the twentieth century, demonstrate this well: in 1877–1878, Eva Gonzalès painted *La Nurse et l'enfant* (*Nanny and Child*, fig. 58). On the right, the nanny, facing the viewer, seems lost in her thoughts; on the left, the little girl stands in profile, wearing clothes that suggest she has just been released from school. She is looking down at her hands, which toy with the bars of a metal gate. She is holding what appears to be a handkerchief that she weaves in and out of the lattice-work, probably humming or making up adventures for her piece of cloth. The other example was painted in the early twentieth century by the British artist John Russell, who was living in France. He depicts his three sons, nude on a beach, intently observing a crab that has just washed up on the sand (1904–1906, fig. 134). These children are similar to the little girl that appears in Frédéric Bazille's *La Terrasse de Méric* (The terrace at Méric; 1866, fig. 93). In the lower left corner, a girl has abandoned her hat on the ground, a few steps away, and now turns her back to the family as she tries to make the acquaintance of a dog and a puppy. These representations,[19] focusing on outdoor scenes, were painted at a time when large numbers of the rural population were deserting the countryside and coastal areas for the cities; this probably explains why toy stores offered substitutes for animals like those found on pages ten to thirteen of the Petit Saint-Thomas catalog: a "hopping rabbit with natural hide" for 6.90 francs, a "bleating goat or sheep automaton covered in natural wool" for 26 francs; and a "Tibetan goat with a very long coat and a leather sidesaddle, richly decorated with blue or pink ribbons, three sizes" for 22.50 to 45 francs.[20]

Toys resembling animals rarely appear in impressionist painting. However, Monet's painting of his son *Jean Monet sur son cheval mécanique* (*Jean Monet on His Horse Tricycle*; 1872, fig. 20), in the garden at Argenteuil, is worthy of note. Although the child is pictured outdoors, his parents have substituted a toy for an animal. There are likely several reasons for this choice: the price and care required for a living animal and, no doubt most importantly, the rider's safety. The indoor equivalent to Jean Monet's plaything, the rocking horse, was often pictured in toy advertisements, and can be found, for example, in Swedish painter Carl Larsson's watercolor *"Murre." Portrait of Casimir Laurin* (1900, National Museum, Stockholm).

It is difficult to identify toys from the second category—"handmade" toys—in paintings from the years 1875–1900. We can probably mention, however, the worn sculpted doll painted with black hair, blue eyes, and red cheeks,[21] seen in his son's cradle in the painting by Claude Monet (1868, Ny Carlsberg Glyptotek, Copenhagen). The same model can be found in the *Journal amusant* dated March 22, 1862, in an article by G. Randon entitled "Les Bibelots d'un sou" ("Trinkets for a penny"), with this humorous description of a basic wooden doll's head and torso: "Woman! What do you want? For a penny, we can't exactly give you the Venus de Milo!"[22]

23
See, for example, Jacques Porot, *Poupées articulées: Brevets d'invention 1850–1925*, n.p., 1982.

24
In the collection *Les Musardises* (Paris: Fasquelle, 1911), 98 ff.

25
For example, Jean Aicard's poem "Valentine," from *La Chanson de l'enfant* (Paris, 1885), 76, expresses the relationship between a child and her doll: "Yesterday she told me: 'I am very busy! / Without me, who would entertain my doll?'"

26
See, for example, photos of Émile Zola's son and daughter posing with their dolls: *Denise, de face, portant une poupée* (Denise, face on, carrying a doll; between 1900 and 1902, Musée d'Orsay, Paris) and *Jacques, son lion et ses poupées* (Jacques, his lion and his dolls; 1897, Musée d'Orsay, Paris).

27
This toy can be paired with rolling animal toys in various sizes and at different prices, which appear, for example, in Édouard Debat-Ponsan's *Simone au bois de Boulogne* (Simone in the Bois de Boulogne; 1888, Musée des Beaux-Arts, Tours).

On the double-page spread of the *Journal amusant*, this wooden toy is surrounded by other playthings, in particular a Punch doll with a jointed body—a basic version of a nicer toy that appears, for example, in Renoir's *L'Enfant au polichinelle* (*Child with Punch Doll*; 1880, private collection) and Paul Gauguin's *La Petite rêve*, étude (*The Little One Is Dreaming*, study; 1881, Ordrupgaard, Copenhagen).

This articulated puppet brings us to one of the toys most loved by children: the doll. Its popularity grew considerably during this period, and patents that led to changes in the toys' components or assembly were regularly filed.[23] However, although this object was immensely popular with children, it was not the most appreciated by painters, nor the most depicted by impressionists. It does not seem to have been any more common in the works of the academic painters who soon came to be labeled "painters of childhood," such as Jean Geoffroy, known as Géo, Auguste Truphème, and Timoléon Lobrichon, whose painting depicted here (fig. 57) appears to be the transposition of Edmond Rostand's poem "Joujoux" (Toys).[24] This absence is all the more remarkable because, at the time, dolls were the protagonists of many novels, fairy tales, poetry collections,[25] and songs, and children readily posed with them for photographers (fig. 54).[26]

In toy catalogs, the doll brought in its wake a certain number of miniature objects, intended to create a small-scale replica of the children's environment. Toy furniture, dolls' clothes, and tea sets did not generally find their way into paintings, however, with the notable exception of Renoir's portrait *Geneviève Bernheim de Villers* (1910, fig. 61).

Although dolls make a rare appearance in a few of the works reproduced here (figs. 34, 59, 72), one unexpected object appears more frequently: the hoop, a circle of wood designed to be rolled along the ground using a stick. In Monet's depiction in *La Maison de l'artiste à Argenteuil* (*The Artist's House at Argenteuil*; 1873, fig. 92) and André Brouillet's in *La Petite Fille en rouge* (Little girl in red; 1895, fig. 62), the toy seems adapted to the play area. It is far more surprising to find this same object indoors, in Paul Mathey's painting *Enfant et femme dans un intérieur* (*Woman and Child in an Interior*; c. 1890, fig. 64), where the limited space would make it difficult to play with—unless the child has finished playing and has come inside from the garden to join his mother.

In summary, pictorial depictions of children and their toys remain rare—too rare, even, to attempt to determine their parents' financial situation. Julie Manet, Berthe Morisot's daughter, who came from a privileged background and often appeared in paintings, is rarely seen playing and, when she is, it is with relatively simple toys; the most original of these is a construction set she has placed on her father's knees in the painting *Eugène Manet et sa fille dans le jardin de Bougival* (*Eugène Manet and His Daughter in the Garden at Bougival*; 1881, Musée Marmottan Monet, Paris). At most, three paintings by Monet suggest an improvement in his financial situation; in 1867, he depicted his oldest son with a modest windmill and a rattle drum in *Jean Monet dans son berceau* (*The Cradle—Camille with the Artist's Son Jean*, fig. 25), which probably cost as little as the cheap wooden doll, previously mentioned, depicted in 1868. These two toys were much less expensive than the rocking horse from 1872, also mentioned above, which was similar to those that cost between 22 and 45 francs in 1880.[27]

Fig. 57 Timoléon Lobrichon, *La Vitrine du magasin de jouets* (The toy-shop window), n.d.
Oil on canvas, 3 ft. 8 in. × 2 ft. 9 in. (112 × 84 cm).
Private collection.

28
Maison du Petit Saint-Thomas, catalog, 12–13.

29
Sotheby's, live auction, April 20, 2005, lot 138, New York.

30
Devambez (Paris, 1913).

The children's toys rendered by the impressionist painters, and by some of their peers, represent a small fraction of those featured in the Christmas catalogs. No musical instruments appear in these selected works; Édouard Manet's *Le Fifre* (*The Fifer*; 1866, Musée d'Orsay, Paris) depicts a child, but not a child at play. Also absent are the tenpin sets that were available in a surprising variety of forms; the Maison du Petit Saint-Thomas catalog offers, among other things, a "marvelous cabbage containing animated vegetable tenpins," and a "choir of cats, a set of unbreakable tenpins, very light balls, presented in a silver oyster."[28] Absent, too, are the arms that might have been used by the "school battalions," established by Jules Ferry around 1880 and illustrated by Jean Geoffroy at the Salon in 1885, where he presented *Pour la France! Revue des bataillons scolaires*, with a text by Désiré Lacroix (*Cahiers d'enseignement illustrés* no. 34, July 14, 1884).[29] Finally, although our knowledge of toys and games is primarily drawn from Christmas publications, many other objects intended for vacationing children were also available and depicted in certain impressionist paintings: for example, buckets (Berthe Morisot, *Les Pâtés de sable* (The sand pies), 1882, private collection), shovels (Mary Cassatt, *Children Playing on the Beach*; 1884, National Gallery of Art, Washington, D.C.), and children's fishing nets, as well as beach balls.

At the Salon of 1897, Joseph Bail, a proponent of good-natured Realism, exhibited a painting of young kitchen boys sitting around a table and smoking in *Les Joueurs de cartes* (The young card players; 1897, Petit Palais, Musée des Beaux-Arts de la Ville de Paris, Paris), but he transgressed several of the precepts governing depictions of children in both academic and impressionist genre painting. His indolent, gambling, smoking, and probably lying and thieving children bear mentioning, even if they do not belong to the impressionist movement.

A final remark concerns other items missing from our selection: broken toys. Considered inappropriate for the ideal age that childhood was imagined to be, and no doubt, in most cases, for the model's social status, paintings did not depict children with damaged toys, although literature readily made mention of them. It was most likely educational illustrated children's books that would address the theme, for example, in *Auguste a mauvais caractère* (Bad-tempered Auguste), written and illustrated by André Devambez (fig. 56).[30] The idea of the naughty rascal became a common theme across the arts, including music, as in, for example, *L'Enfant et les Sortilèges* (*The Child and the Spells*)—the fruit of a collaboration between Colette and Maurice Ravel between 1919 and 1925. At the turn of the twentieth century, Hugo and Cosette once again became central figures in a way of thinking that had long been obscured by painting. The child and her sword that "cuts salad and the heads of flies" now illustrated the childish cruelty that the new century would allow itself to voice and to represent.

Fig. 58 Eva Gonzalès, *La Nurse et l'enfant* (*Nanny and Child*), 1877–1878.
Oil on canvas, 25½ × 32 in. (65 × 81.4 cm).
National Gallery of Art, Washington, D.C.

Berthe Morisot
1841–1895

L'Enfant à la poupée, or Intérieur de cottage (Young girl with doll, or Interior on Jersey)
1886

Oil on canvas
19½ × 24 in. (50 × 61 cm)
Musée d'Ixelles, Brussels

Painted while Berthe Morisot was vacationing on the Isle of Jersey, this work is reminiscent of the portrait *Eugène Manet à l'île de Wight* (Eugène Manet on the Isle of Wight; 1875, Musée Marmottan Monet, Paris), which she carried out several years before the birth of the couple's daughter, Julie. In it, the artist's husband contemplates a similar view of a lush garden, the harbor, and the sea. Here, the window has become a veranda, and sunlight pours in through the large patio doors, making the white of the fabric and dishes appear to vibrate. In the large pastel made in preparation for this composition, *Intérieur à Jersey* (Interior on Jersey; 1886, private collection), Eugène Manet sits in the armchair behind the table. In the painting, the same chair is partially hidden by the curtain and Julie becomes the only figure. The girl is standing by the window and appears to be showing the landscape to the blonde doll that she is holding. The wicker chair, the breakfast table, and the light-colored, slightly reflective parquet, isolate her in the background. Dolls held a prominent place in toy catalogs during that period, as well as in children's literature. What began as a toy that resembled a small woman had, by the end of the century, come to resemble a baby or a little girl, like the one in Julie's hands. The child–doll relationship came to mirror the mother–daughter relationship. The slight tilt of Julie's head suggests an imaginary conversation, or a few secrets whispered by the child to her toy—signs of an affectionate and attentive relationship that resembles the one perceptible in the discreet and loving gaze the artist casts on her daughter.

M. D.

Fig. 59

98

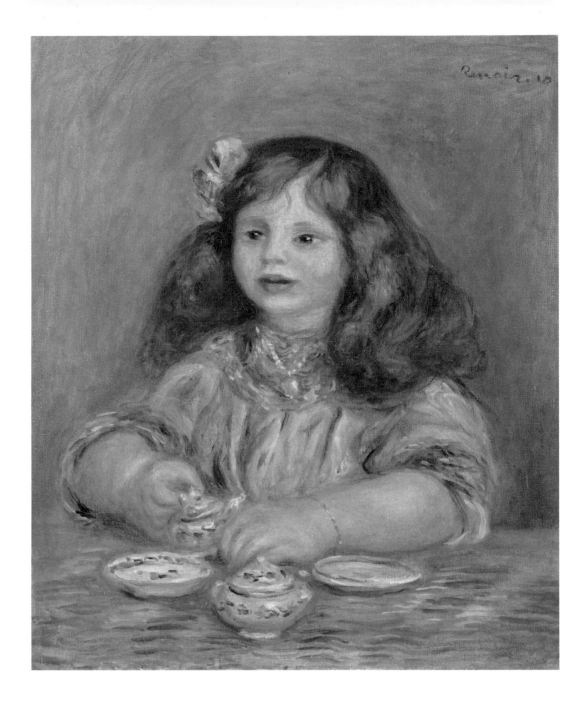

Above:
Fig. 61 Pierre-Auguste Renoir,
Geneviève Bernheim de Villers,
1910.
Oil on canvas, 21 × 17½ in.
(53 × 44.5 cm).
Musée d'Orsay, Paris.

Geneviève Bernheim de Villers was
the daughter of art dealer Gaston
Bernheim and Suzanne Adler. She
married Count Jean de la Chapelle
in 1928. Édouard Vuillard also
painted her portrait (1920, Musée
d'Orsay), when she was on the cusp
of adolescence.

Facing page:
Fig. 60 Édouard Debat-Ponsan,
Le Petit Bernard jouant dans l'atelier
(Little Bernard playing in the studio),
1912.
Oil on wood, 22 × 12½ in.
(56 × 32 cm).
Musée des Beaux-Arts, Tours.

Bernard Dupré was the artist's
grandson, from his eldest
daughter Simone's first marriage,
to Jacques Dupré.

André Brouillet
1857–1914

La Petite Fille en rouge (Little girl in red)
1895

Oil on canvas
6 ft. 6 in. × 4 ft. 3 in. (1.99 × 1.3 m)
Centre National des Arts Plastiques,
on long-term loan to the Musée
Sainte-Croix, Poitiers

This little girl dressed in red is Yvonne, born on June 11, 1889, in Constantine, Algeria, to Louise Travers and an unknown father. Ferdinand Isaac, André Brouillet's brother-in-law, acknowledged that he was the father following Travers's death in 1892. The painter and his wife, Emma, raised the girl as their adopted daughter. The couple had no other children, and Yvonne soon became Brouillet's favorite model— she may, in reality, have been his illegitimate daughter.

The painter was the son of Pierre-Amédée Brouillet (1826– 1901), a curator at the Musée de Poitiers, and a sculptor and archeologist, who initially urged him toward the École Centrale des Arts et Manufactures and the engineering profession. André Brouillet ultimately enrolled at the École des Beaux-Arts, where he studied under Jean-Léon Gérôme and Jean-Paul Laurens. He moved from subjects inspired by ancient history to more contemporary themes, leaving to posterity several famous depictions of the medical field: *Une leçon clinique à la Salpêtrière* (A clinical lesson at the Salpêtrière; 1887, Centre National des Arts Plastiques, Paris, on long-term loan to the Musée d'Histoire de la Médecine) and *Le Vaccin du croup à l'hôpital Trousseau* (The injection against croup at the Trousseau Hospital; 1895).

Brouillet was also a society portraitist, whose academic technique was at times colored by impressionism. In *La Petite Fille en rouge* (Little girl in red), the exuberant floral background behind the child reveals his appreciation for light colors and delicate brushwork. In the summer sunlight, the bright color of her hat and frills on her dress is striking against the soft green background of the vegetation, and brings out her delicate hands and face. The garden was located at the artist's home in Couhé-Vérac, in the Vienne department, which is recognizable by its pale roughcast, the rose beds, and the staircase protected by a fine metal railing.

M. D.

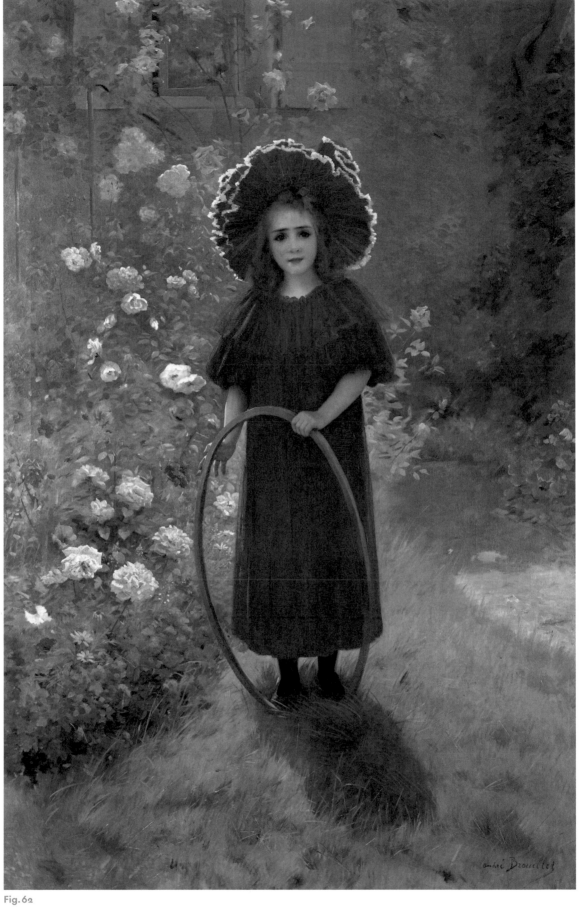

Fig. 62

Above:
Fig. 63 Laurence Reynaert,
Portraits, 2000–2003.
Black-and-white print on baryta
paper, 16 × 19½ in. (40 × 50 cm).
Frac Normandie Collection,
Sotteville-lès-Rouen.

Facing page:
Fig. 64 Paul Mathey,
Enfant et femme dans un intérieur
(*Woman and Child in an Interior*),
c. 1890.
Oil on canvas, 19 × 15 in.
(48.5 × 38 cm).
Musée d'Orsay, Paris.

Jacques Mathey, the artist's only son,
poses dressed in short pants, holding
a hoop behind his back.

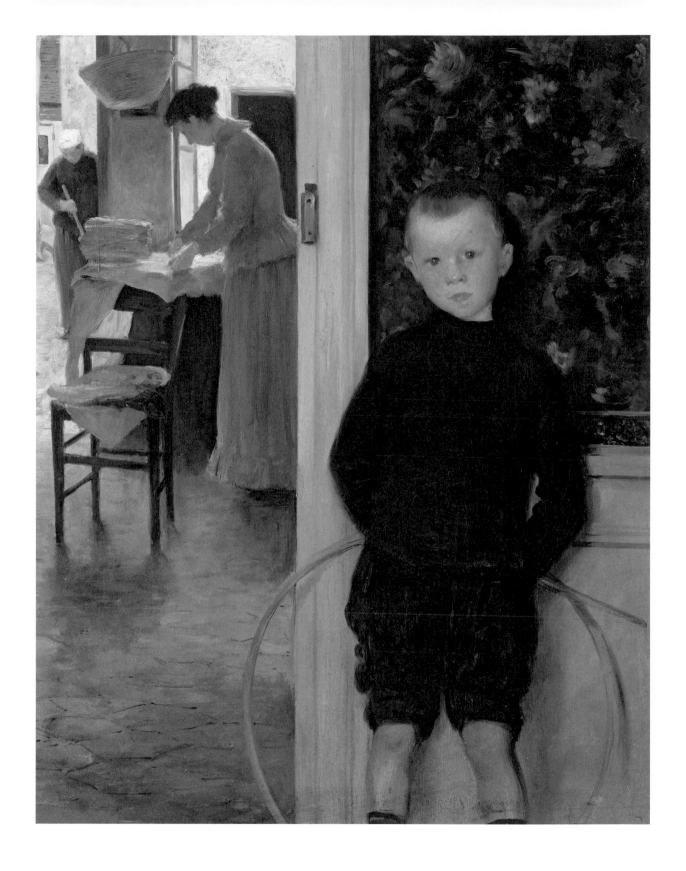

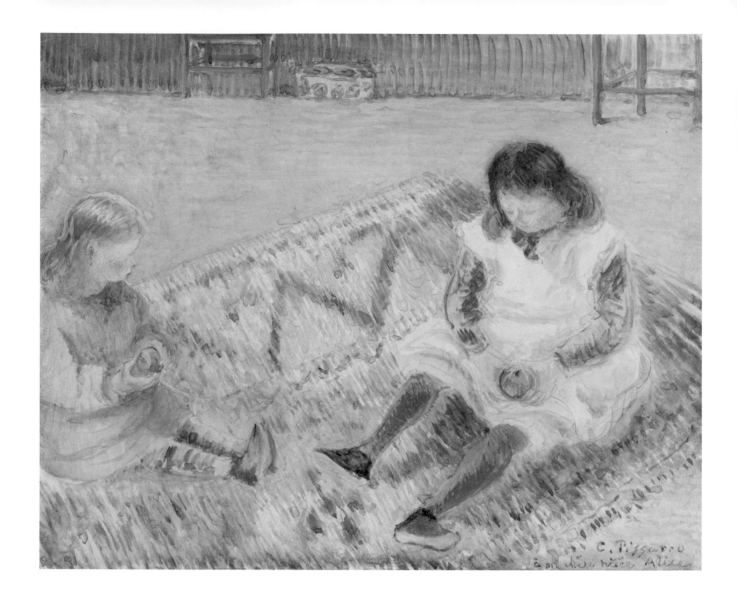

Facing page:
Fig. 65 Camille Pissarro, *Les Enfants jouant sur le tapis (Rodo et Jeanne)* (Children playing on the rug [Rodo and Jeanne]), 1883. Watercolor and gouache on paper, 9 × 11 in. (23 × 28 cm). Private collection.

Ludovic-Rodolphe and Jeanne were nicknamed Rodo and Cocotte. Rodo, wearing red stockings, is barely five years old and still wears a dress and his hair long. His sister Jeanne, aged three, is dressed in blue. The painting is dedicated "To my dear niece Alice": Alice Isaacson was the daughter of Emma Isaacson, née Petit, Camille Pissarro's older half-sister. The Isaacson family lived in London.

Below:
Fig. 66 Elaine Constantine, *Juliet on Swing*, 1998. Digital Lambda print, 23 × 31½ in. (58.56 × 80 cm). Elaine Constantine Ltd.

Fig. 67 Ferdinand du Puigaudeau,
Fête nocturne à Saint-Pol-de-Léon
(*Night Fair at Saint-Pol-de-Léon*),
1894–1898.
Oil on canvas, 23½ × 28½ in.
(60 × 73 cm).
Carmen Thyssen-Bornemisza
Collection, on long-term loan to
the Museo Nacional Thyssen-
Bornemisza, Madrid.

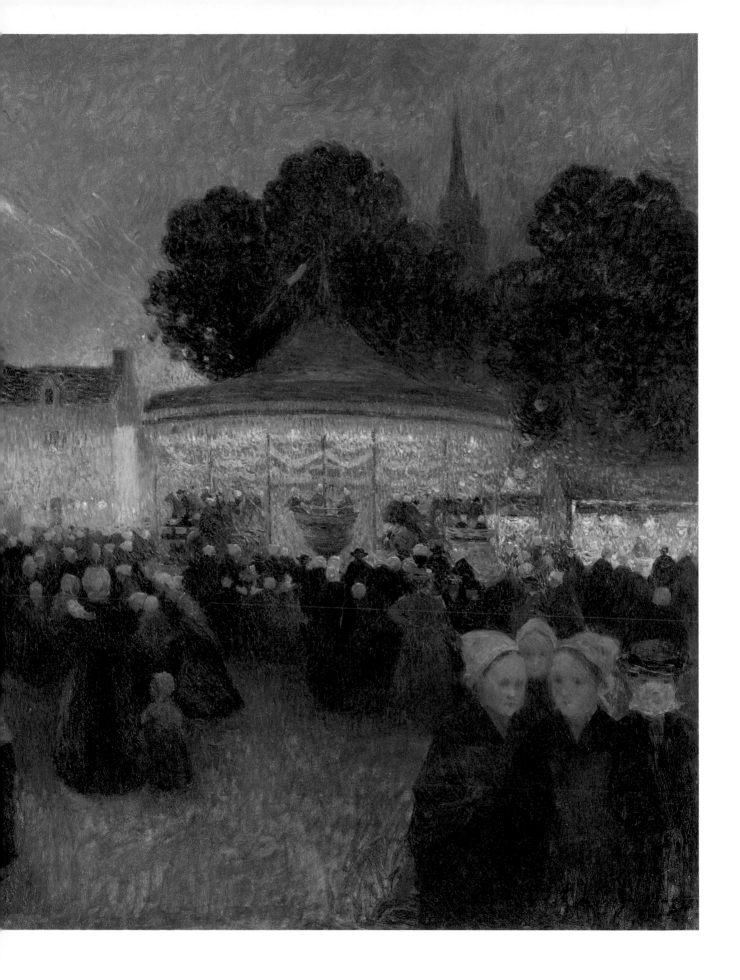

Fig. 68 *Rentilly, Man and Child on the Edge of a Pond, 1899–1900.*
Musée d'Orsay, Paris.

Today, little girls take five or six classes a week. They fidget and wriggle about; people have forgotten that nothing compares to two hours spent sprawled on a chaise longue. Dreams are life itself.

Berthe Morisot, *Carnet de Mézy*, 1891

EDUCATION

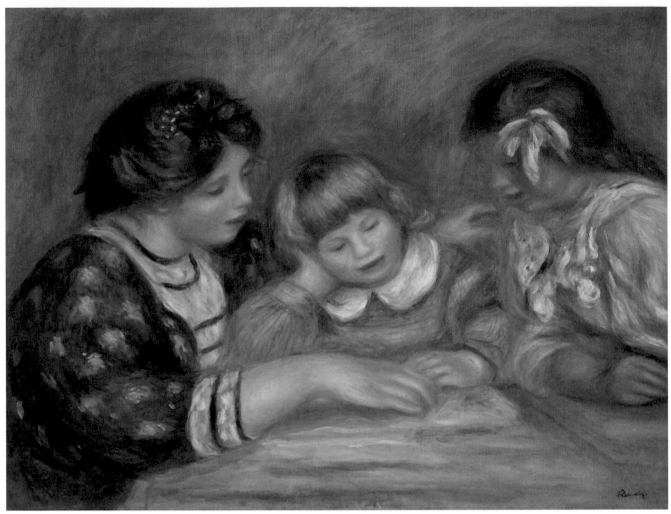

Fig. 69 Pierre-Auguste Renoir, *La Leçon (Bielle, l'institutrice et Claude Renoir lisant)*
(The lesson [Bielle, the teacher, and Claude Renoir reading]), c. 1906.
Oil on canvas, 26 × 33½ in. (65.5 × 85.5 cm).
David and Ezra Nahmad Collection.

Gabrielle, the Renoir family's nanny, may have been the model
for the teacher helping Claude with his lesson.

1

Excerpt from the author's inscription in a picture book by Randolph Caldecott, quoted in A. G. Gardiner, *Prophets, Priests and Kings* (London: A. Rivers, 1908), 327.

2

Between 1988 and 1990, the Musée d'Orsay produced three exhibitions and related documentation concerning childhood in the nineteenth century, which delivered a brilliant analysis of this relationship between child, book, and image. See Chantal Georgel, *L'Enfant et l'image au XIXᵉ siècle*, exh. cat., "Les Dossiers du musée d'Orsay," no. 24 (Paris: RMN, 1988); Nicole Savy et al., *Les Petites Filles modernes*, exh. cat., "Les Dossiers du musée d'Orsay," no. 33 (Paris: RMN, 1989); Ségolène Le Men and Anne Renonciat, *Livres d'enfants, livres d'images*, exh. cat., "Les Dossiers du musée d'Orsay," no. 35 (Paris: RMN, 1989).

3

Instructions relatives aux objectifs et aux programmes de l'école maternelle, March 16, 1908.

"Don't believe in anything that can't be told in colored pictures."[1]
G. K. Chesterton

Throughout the nineteenth century—and particularly in the second half, when technological progress afforded images an essential role in printed volumes—a fresh relationship between children and books emerged where new family rituals, debates about education, and the development of consumer society converged.[2] A product of modernity, books became omnipresent in bourgeois homes; they appear in many impressionist works and, to a lesser extent, in the writings of artists and their families, who lived during the advent of children's literature. Why and how did children in impressionist circles read? Were they obligated to or did they want to? Did they read alone or with their families? What kind of stories did they read and in what form? In light of the interrelated histories of education and publishing, the impressionists' paintings and correspondence, as well as the memories of their friends and family, provide insight into these questions, and a profile of children's relationship with books, which they gradually made their own.

Reading Lessons

Did the impressionists send their children to school? In the late nineteenth century, early education, and reading and writing in particular, was still a mother's responsibility and took place in the family home. *Salles d'asile*—precursors to present-day pre-schools, which the decree of August 2, 1881 renamed *écoles maternelles*—were open to children between the ages of two and six, and dispensed these lessons, but these institutions were intended for children whose mothers worked outside the home. The teaching methods used there were expected "to imitate as intelligently as possible the educational methods of an intelligent and dedicated mother."[3] When Monet wrote in 1884, "I see that upon my return I will have to garden with Bébé [Jean-Pierre Hoschedé] and Mimi [Michel Monet], that I will not want for help. I also think that if I come home to good gardeners, I will also find children who know how to write,

Children and Books in Impressionist Art

Marie Delbarre

4

Claude Monet to Alice Hoschedé,
February 15, 1884, quoted in Daniel
Wildenstein, *Claude Monet:
Biographie et catalogue raisonné*,
vol. 2, *1882–1886: Peintures*
(Lausanne/Paris: La Bibliothèque
des Arts, 1979), 238–239.

5

Henry Boulay de la Meurthe,
*Rapport sur la situation
de l'instruction primaire en France
et sur les travaux de la société pour
l'instruction élémentaire*, 1846.

6

Camille Pissarro to his son Lucien,
April 10, 1883, in *Correspondance
de Camille Pissarro*, vol. 1,
1865–1885, ed. Janine Bailly-
Herzberg (Paris: Éditions du
Valhermeil, 2003), 191–192.

7

Claude Monet to Alice Hoschedé,
October 4, 1886, quoted in
Wildenstein, *Claude Monet*, vol. 2,
1882–1886, 279.

8

Jean Renoir, *Renoir: My Father*
(Boston: Little, Brown, 1962), 321.

and they will make their teacher proud,"[4] he was referring to the letter's recipient: his partner, Alice Hoschedé. In the nineteenth century, women were considered "the first and most powerful of men's teachers,"[5] and this argument was put forward for the development of girls' education. The Jules Ferry Law of 1882 rendered elementary school education mandatory between the ages of six and thirteen, for girls and boys alike. This instruction could, however, be provided at home, by the child's father or anyone else of his choosing. The impressionists' letters and family memoirs suggest that the age at which children entered school varied greatly. On April 10, 1883, Pissarro told Lucien that his younger brother Georges, then eleven years old, would be going to school: "He left every morning at 7:30 and courageously walked the two miles (three kilometers); I hope that it will benefit him physically and intellectually."[6] In 1886, during his stay on Belle-Île, Claude Monet asked after the two youngest children in the Monet-Hoschedé home—Michel and Jean-Pierre, aged eight and nine, respectively—who were starting school, noting that their older sisters must be saddened by the departure of the "angels."[7] Jean Renoir was sent to school at the age of seven, when his brother Claude was born in 1901. Up until then, his father had "refused to allow [him] to learn anything at all. 'Not until he is ten,' he said," despite the advice of his cook, Mrs. Matthieu, whose son Fernand had been going to the local school for some time.[8]

Within impressionist families, education long remained a domestic affair. Lessons were an essential part of family life and were often depicted by artists: examples include Pierre-Auguste Renoir's *La Leçon (Bielle, l'institutrice et Claude Renoir lisant)* (The lesson [Bielle, the teacher, and Claude Renoir reading]; fig. 69), Mary Cassatt's *The Reading Lesson* (c. 1901, Pauline Allen Gill Foundation), and Berthe Morisot's *Miss Reynolds* (1884, Fondation de l'Hermitage, Lausanne). These compositions make use of the models' closeness to each other: a teacher who bears a strong resemblance to Gabrielle, his nanny, wraps her arms around a young Claude Renoir; little girls lean on the shoulders of the women posing with them, their faces close together and often turned in unison toward the pages of a book or notebook. Regardless of what these lessons may actually have been like (it is easy to imagine that they were sometimes a source of frustration for both the adults and the children involved), impressionist paintings invariably convey an image of harmony and ease.

Girls' schooling remained the responsibility of their mothers for longer, despite the various Jules Ferry Laws that were passed in an attempt to remedy the gap in education between boys and girls. Camille Pissarro's letters reveal that the painter withdrew to some extent from the education of his daughter, Jeanne, nicknamed Cocotte, although he had been so attentive to his sons' artistic development. This difference is likely rooted in the division of domestic responsibilities; the parents disagreed over their children's education, and Julie Vellay would have preferred to see her sons take up a more stable profession than artist. While

9
Camille Pissarro to Esther
Bensusan-Pissarro, November 13,
1895, in *Correspondance de Camille
Pissarro*, vol. 4, *1895–1898*,
ed. Janine Bailly-Herzberg (Paris:
Éditions du Valhermeil, 1989), 113.

10
Julie Manet, *Journal, 1893–1899*
(Paris: Scala, 1987), 114, entry dated
August 12, 1897.

11
Law concerning secondary
education for girls, put forward by
French politician and congressman
Camille Sée.

Pissarro had the final word, Julie's authority was harder to challenge in matters regarding their daughter. However, the painter did not entirely neglect Cocotte's artistic education: "I took her to the Musée du Louvre, to the Centenary of Artistic Lithography, the Musée du Trocadéro, etc., etc. I will try, little by little, to open her eyes without appearing to do so. In the Jardin d'Acclimatation, I showed her beautiful tapestry motifs."[9]

Born into an upper-middle-class family, Julie Manet was educated at home by a series of private instructors, including Miss Reynolds, her English tutor, who is depicted in the work mentioned above, and she occasionally attended private classes. In addition to the extraordinary artistic education that she received from her mother, Berthe Morisot, as seen in *La Leçon de dessin* (*The Drawing Lesson [Berthe Morisot Drawing with Her Daughter]*, fig. 142), and her acquaintance with other painters—friends of her mother who came to their Thursday evening salon— Julie also received an exceptional literary education. The poet Stéphane Mallarmé, a close friend of the family, took an interest in what she was reading and gave her books. The writer Camille Mauclair taught her literature for two years. There are many portraits of Julie immersed in a book (figs. 136, 141). When, in her journal, she laments reading very little,[10] she may be comparing herself to a high ideal. Julie reached the age of secondary education just as schools were opening their doors to young women, following the law of December 21, 1880.[11] However, like many girls from her social background, she did not attend *lycée*, or high school. Born several months after Julie Manet, Jeanne, the eldest daughter of the painter Édouard Debat-Ponsan, enrolled at the Lycée Molière in Paris, where she developed a taste for the sciences. She made the unusual choice for a young woman of her background to pursue higher education and become a doctor; she went on to become one of the first female interns and clinic directors within the Paris hospital system. Jeanne Pissarro, Julie Manet, and Jeanne Debat-Ponsan belonged to a generation for whom educational possibilities were multiplying, although the new horizons that were opening before them left few traces in impressionist art. Degas's *L'Écolière* (*Schoolgirl*, fig. 70) is one of the rare depictions of a young girl studying outside of the family home.

Children's Literature

Today, it is difficult to determine exactly what the children of impressionist artists read. While a few random titles are mentioned in letters or memoirs, they in no way provide a complete picture of the stories that captivated and fed their children's imaginations. We can only observe that the impressionists' children were contemporaries of the great shift away from the edifying tales that defined children's literature in its first incarnation. Along with classics adopted in the eighteenth century by children and their teachers—abridged editions of *Robinson Crusoe* or

12
See François Caradec's spirited description in *Histoire de la littérature enfantine en France* (Paris: Albin Michel, 1977).

13
"When I was a kid, I hated books by the Countess of Ségur, née Rostopchine.... I was appalled by the mindless cruelty, not so much of the children, but of the parents that inhabited those books.... When I reached the age of reason (around forty), my opinion regarding the merit of Ségur's books radically changed. I realized that this frank writer had described her own social background with a brutal lack of moral consciousness and that had its own greatness. I saw her as a kind of Balzac of high-minded society." Jean Renoir, *Écrits (1926–1971)* (Paris: Ramsay, 2006), 169.

Don Quixote, Perrault's fairy tales and La Fontaine's fables, in addition to the historical novels of Victor Hugo and Alexandre Dumas—and in the absence of books specifically written for young readers, children were offered moralizing, sentimental works by the likes of Arnaud Berquin, Madame de Genlis, Jean-Nicolas Bouilly, and Pauline Guizot. These were intended to form a body of literature suited to their age and needs, but were in reality quite bland.[12]

In 1856, Louis Hachette broke with tradition when he created the Bibliothèque Rose (The Pink Library), publishing first short stories, then novels, by Sophie Rostopchine, the Countess of Ségur. Rostopchine's stories were a breath of fresh air in children's literature: the countess had a talent for storytelling, her protagonists were active participants, and even her critics admitted that she had a keen power of observation.[13] The eldest of the impressionist children, Lucien Pissarro, was born in 1863, just after the publication of the Trim and Stahl collections of children's picture books, and the year editor and publisher Pierre-Jules Hetzel founded the book series *Voyages extraordinaires* (*Extraordinary Journeys*) written by Jules Verne; *Five Weeks in a Balloon*, *Journey to the Center of the Earth*, and *From the Earth to the Moon* appeared in rapid succession. In 1869,

Fig. 70 Edgar Degas, *L'Écolière* (*The Schoolgirl*), c. 1880. Plaster statuette, 11½ × 5 × 6 in. (29.3 × 12.7 × 15.6 cm). Musée d'Orsay, Paris.

14
Anatole France, *My Friend's Book* (London and New York: John Lane, 1913), 244.

15
Jean Renoir, *Renoir: My Father*, 315.

Lewis Carroll's *Alice in Wonderland* was published in French for the first time. In the meantime, Jeanne-Rachel Pissarro, Jean Monet, Pierre Sisley, and Alice Hoschedé's three eldest daughters—Marthe, Blanche, and Suzanne, Monet's future stepdaughters—were born. In 1874, the year the first impressionist exhibition was held and the year the Countess of Ségur died, Emil Gauguin and Félix Pissarro were born, followed soon after by Paul Cézanne's son, Paul (born in 1872), and Georges Pissarro (1871). In 1878, Michel Monet, Julie Manet, and Ludovic-Rodolphe Pissarro were born, and Hector Malot's *Sans famille* (*Nobody's Boy*) was published. In the 1880s, Pissarro's youngest children were born, Jeanne and Paul-Émile, as were Pierre-Auguste Renoir's eldest son, Pierre, and Jean Caillebotte, the nephew of painter Gustave Caillebotte. This decade also saw the first French translation of *Little Women* in Hetzel's adaptation of Louisa May Alcott's original, published under the pseudonym P.-J. Stahl, and Robert Louis Stevenson's *Treasure Island*, also adapted by Hetzel, in 1885. French readers would have to wait until 1899 to read Rudyard Kipling's *The Jungle Book* (published in France by Mercure de France). Jean Renoir was five years old at the time. Claude Renoir, born in 1901, the youngest of this lengthy generation, was a child when Hachette published a French edition of *Peter Pan in Kensington Gardens* in 1907, and when the first French comic book characters appeared: Bécassine in the pages of *La Semaine de Suzette* (1905), and the Pieds Nickelés in *L'Épatant* (1908).

"In the vast majority of cases, children display a marked antipathy to books 'for the young,'" wrote Anatole France in "Dialogues on Fairy Tales," which concludes *My Friend's Book*,[14] before going on to defend the magic of fairy tales as opposed to the magic of Jules Verne's science fiction. Which one was written "for the young"? The child's mind, a subject of great preoccupation, remained a material to be shaped by society through means that were continually debated; at the same time, children's innate capacities were admired and parents could imagine providing minimal direction—a paradox that Jean Renoir points out in his father's attitude: "Renoir was opposed to all efforts to train young children. He wanted them to make their first contacts with the world around them on their own.... But then he would contradict himself by insisting on a child's having just the right kind of colors and objects in its surroundings."[15]

Impressionist works reproduce the duality of children's reading experiences, as both family activity and individual practice, subtly revealing the shifting border between the necessity of transmitting values and knowledge, and an awareness of a child's inner life. *Mrs. Cassatt Reading to Her Grandchildren* (1880, private collection) shows Robert, Katherine, and Elizabeth—Mary Cassatt's nieces and nephew—pressed around the artist's mother. They are completely absorbed in the story, their eyes riveted on the pages of the book or on their grandmother's face. On the other hand, Cassatt's *Augusta Reading to Her Daughter* (1910, private collection) depicts a girl leaning back on her mother's knees, gazing somewhere off to the right of the composition. Is she listening to the story

16
Michelle Perrot, *La Vie de famille au XIXᵉ siècle* (Paris: Points, 2015), 115.

or is she letting her thoughts wander? Simone's expression, as she sits at her mother's feet in Édouard Debat-Ponsan's *Mère et fille dans un jardin breton* (*Mother and Daughter in a Breton Garden*; 1898, fig. 75), begs the same question: are the children attentive or bored? Either state could inspire daydreaming.

The tension between the glorification of the family and the advancement of individualism that ran through nineteenth-century society provided a wellspring of material for literature.[16] In impressionist depictions of reading, it is expressed not as a conflict, but rather as an enigma. What might the children portrayed be thinking? The stories chosen for these maternal reading scenes most often remain a mystery. Only on the rare occasion does the title of the painting reveal the contents of the book, as in James Jabusa Shannon's *Jungle Tales* (1895, The Metropolitan Museum of Art, New York)—likely a reference to Kipling's book, which had been published the previous year—or *The Fairy Tale* by Scottish painter Harrington Mann (1902, Tate, London). The young models' distant gazes suggest that daydreaming and escape were still possible even in the midst of domestic life. Reading silently, as Joaquín Sorolla depicts a young girl doing in the foreground in *Sobre la arena, Playa de Zarauz* (*On the Sand, Zarauz Beach*; 1910, Museo Sorolla, Madrid, fig. 130), also provides freedom. Some portraits seem to capture a child absorbed in reading, unaware they are being observed: for example, Berthe Morisot's pastel *Jeune fille lisant* (Young girl reading; n.d., Fondation Bemberg, Toulouse), in which Julie Manet is recognizable, and her *Lecture* (*Reading*; 1888, St. Petersburg Museum of Fine Arts); or American impressionist Daniel Garber's *The Orchard Window* (1918, Philadelphia Museum of Art). Others established a communication between the painter and the model: the latter holds the book in their hands, but directs their gaze at the artist, as in Lilla Cabot Perry's *A Rainy Day*, a portrait of her daughter Edith (1896, private collection), and Albert Besnard's *Matinée d'été* (*A Summer Morning*; 1886, Musée des Beaux-Arts, Reims). Impressionism captured the sensory world—it could not reveal the imaginary worlds to which books transported young readers. But the recurring association between windows and reading in the last few examples seems to confirm that books offered an opening of sorts.

Illustrated Books

The children's literature that was developing at this time featured stories composed of images as well as words. Illustration played a fundamental role in the history of children's books in the nineteenth century, in textbooks and novels, and in that remarkable creation, the picture book, which gave images unprecedented importance. Images are concrete and have the capacity to hold children's attention, to intrigue and entertain them, and these qualities were put to educational use. Illustration had

17

The precursor to educational illustrated books, Comenius's *Orbis Sensualium Pictus* was published in Nuremberg in 1658; a French edition appeared in 1666.

18

Julie Manet: La mémoire impressionniste, ed. Marianne Mathieu, exh. cat. (Paris: Musée Marmottan Monet/Hazan, 2021), 24.

19

The catalogue raisonné gives *The Picture Book* as an alternative title for the work: Adelyn Dohme Breeskin, *Mary Cassatt: A Catalogue Raisonné of the Oils, Pastels, Watercolors, and Drawings* (Washington, D.C.: Smithsonian Institution Press, 1970), 147.

been used for educational purposes prior to the nineteenth century,[17] but during this time it experienced unprecedented growth owing to advances in reproduction and printing technology. Illustrated textbooks were rare in the first half of the nineteenth century, but their publication increased under the Third Republic. *Le Tour de France par deux enfants* (Two children tour France), a very popular primer written by G. Bruno and published by Belin in 1877, included around two hundred black-and-white images. One highly unusual example, but one in keeping with contemporary views on education, was a reading primer that Berthe Morisot illustrated for her daughter in 1883.[18] Extending beyond educational objectives, illustration became an essential element of children's books in the nineteenth century. With the addition of images, books became accessible objects that children handled and could use without the assistance of adults. The posture of the child at the center of Mary Cassatt's *Family Group Reading* (1898, Philadelphia Museum of Fine Arts, fig. 71) is enough to suggest the illustrations that the viewer cannot see: although too young to have learned to read, the child attentively observes the book that the young woman holds open.[19]

Fig. 71 Mary Cassatt, *Family Group Reading*, 1898. Oil on canvas, 1 ft. 10½ in. × 3 ft. 8 in. (56.5 × 112.4 cm). Philadelphia Museum of Fine Arts, Philadelphia.

Fig. 72 Pierre-Auguste Renoir, *L'Après-midi des enfants à Wargemont* (*Children's Afternoon at Wargemont*), 1884.
Oil on canvas, 4 ft. 2 in. × 5 ft. 8 in. (127 × 173 cm).
Alte Nationalgalerie, Staatliche Museen zu Berlin, Berlin.

20
Julie Manet, ed. Mathieu, 27.

21
Joris-Karl Huysmans, *L'Art moderne* (Paris: P.-V. Stock, 1902), 211–233.

22
Correspondance de Camille Pissarro, vol. 1, *1865–1885*, ed. Bailly-Herzberg, 326.

Children's albums—the forerunners of comic books—were created in the nineteenth century and took off in France in the 1860s: in the Trim collection, released by Hachette in 1860, Louis Ratisbonne, aka Trim, adapted German psychiatrist Heinrich Hoffmann's *Struwwelpeter* (*Slovenly Peter*) into French, under the title *Pierre l'ébouriffé*; then, in 1862, the Stahl collection, created by Hetzel, launched with *La Journée de Mademoiselle Lili*, illustrated by Lorenz Froelich. The large-format, generously illustrated pages typical of this genre appear in Henri Evenepoel's *Les Images* (*Images*; 1895, Musée Fin-de-Siècle, Brussels), which is a portrait of Adolphe Crespin's son; Philip Wilson Steer's *Mrs. Cyprian Williams and Her Two Little Girls* (1891, fig. 73); and Renoir's *Portrait des enfants de Martial Caillebotte* (*The Children of Martial Caillebotte*; 1895, fig. 74). The latter composition also gives prominence to the brightly colored covers of the books piled between little Geneviève Caillebotte and the arm of the sofa on which she and her brother Jean are seated. From the red-and-gold covers of the Hetzel editions to the illuminated plates in catalogs of holiday gifts and student prizes, these colorful, lustrous book-objects found a quite natural place in late nineteenth-century bourgeois homes, such as the one Étienne Moreau-Nélaton depicts in *La Lecture* (*Reading*; 1903, Musée d'Orsay, Paris), a portrait of his son, Dominique, around the age of seven. Renoir's *L'Après-midi des enfants à Wargemont* (*Children's Afternoon at Wargemont*; 1884, fig. 72) illustrates the Bérard family's luxurious sitting room. Young Marguerite, seated on the sofa, holds an open book on her lap, its cover scattered with flowers. The volume is Maurice Boutet de Monvel's *Vieilles chansons françaises* (French folk songs), published the previous year. In it, among the main characters of traditional nursery rhymes, she could discover a troop of children dressed exactly like her. The elegant printed fabric covering the book echoes both the delicate motifs of Boutet de Monvel's illustrations—in fact, the artist had designed the cover himself—and the fabrics that cover the Bérard family's furniture and make up their clothes, which come alive with brightness and texture under Renoir's brush.

These illustrated books made their way not only into the paintings of the impressionists, but also, in all probability, into their homes. Stéphane Mallarmé gave Julie Manet a copy of Robert Browning's *The Pied Piper of Hamelin*.[20] Perhaps it was the edition illustrated by Kate Greenaway, published in France by Hachette in 1889. The art of illustration had made remarkable progress in the United Kingdom, and French novelist and art critic Joris-Karl Huysmans devoted several pages to the subject in his "Salon officiel de 1881."[21] The most specific references to contemporary illustrated works are found in the correspondence of Camille Pissarro, who had family living in London. In a letter dated January 1885 to his niece, Esther Isaacson, the painter writes, "The book you sent us arrived safe and sound. Lucien traded with Georges, it's really too beautiful for children; Caldecott's drawings in this book are superior to those in the previous ones."[22] The volume in question was probably one of the *Picture*

23

Ibid., 327 (note 6).

24

The project is described in detail
in Christophe Duvivier,
*Les Pissaro: Une famille d'artistes
au tournant des XIXᵉ et XXᵉ siècles,*
exh. cat. (Musées de Pontoise,
Pontoise, 2015), 44–49.

25

"That little devil Jean often makes
errors and is in great need of
dictations; would you believe, in his
last letter, he wrote *onze* [eleven]
with an h." Claude Monet to Alice
Hoschedé, October 4, 1886, quoted
in Wildenstein, *Claude Monet,*
vol. 2, *1882–1886,* 279; and
"I received two short letters from
Georges and Titi peppered with
spelling mistakes. Georges manages
to make extraordinarily colorful
faults. He writes, '*nous t'embrassons
tousse*'." Camille Pissarro to his son
Lucien, November 20, 1883,
in *Correspondance de Camille
Pissarro,* vol. 1, *1865–1885,*
ed. Bailly-Herzberg, 253.

Books that Randolph Caldecott began developing for Routledge in 1878. Georges, who was fourteen years old at the time, was relieved of the book by his older brother in the name of artistic and professional interest. Lucien later explained to Clément-Janin, "Enchanted with the children's books produced by English authors—Caldecott, Kate Greenaway, W. Crane, etc.—I developed a project to illustrate [the French folk song] *Il était une bergère.* It was presented to several different publishers who were little inclined to undertake its publication, which would have been too costly."[23] Lucien Pissarro's illustrated book projects finally materialized when Eragny Press, founded with his wife, Esther, published *The Queen of the Fishes* in 1894. In the meantime, he had enlisted his brothers and sisters to join him on an impressive project to produce an illustrated newspaper inspired by the many periodicals that were published for children; their large, loose pages can be glimpsed in Berthe Morisot's *Sur le balcon* (*On the Balcony*; 1893, fig. 141) and Henri Lebasque's *La Famille sous la lampe* (Family in lamplight; c. 1905, Musée d'Orsay, Paris).

Created in the spring of 1899, the Pissarro children's *Journal,* which was soon renamed *Guignol,* ran for twelve issues. It was the fruit of a concerted effort between Georges, eighteen; Félix, fifteen; Ludovic-Rodo, eleven; Paul-Émile, five; and Jeanne, eight, who probably produced the decorative embroidery on the binding.[24]

Considering the place that children's literature occupied in nineteenth-century culture, it ultimately left faint, although often intriguing, echoes in the writings of the impressionists and their families. In general, letters written by Claude Monet and Camille Pissarro seem more concerned with the children's spelling than with what they were reading.[25] In impressionist works, however, books are depicted as an integral part of family relations, in particular the relationship between children and the maternal figures around them: mothers, grandmothers, and nannies. In this regard, books are also depicted as objects invested with the domestic harmony that, time and again, gives impressionism its charm. Books were captivating consumer products that figured prominently in the bourgeois homes represented by the artists, but, in portraits of children, they also act as accessories that emphasize an inner world whose elusive nature impressionist painting is particularly adept at conveying.

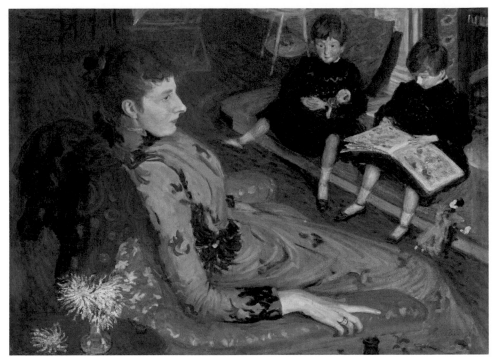

Fig.73 Philip Wilson Steer, *Mrs. Cyprian Williams and Her Two Little Girls*, 1891.
Oil on canvas, 2 ft. 6 in. × 3 ft. 4 in. (76.2 × 102.2 cm).
Tate, London.

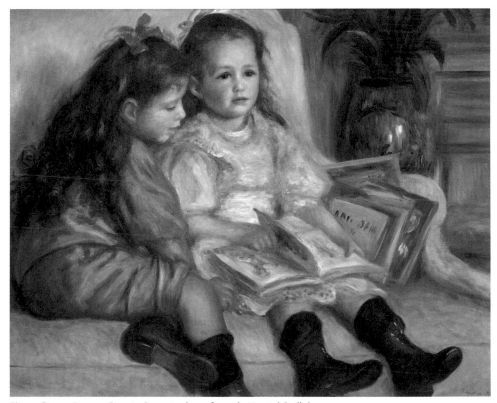

Fig.74 Pierre-Auguste Renoir, *Portraits des enfants de Martial Caillebotte*
(*The Children of Martial Caillebotte*), 1895.
Oil on canvas, 25½ × 32½ in. (65 × 82 cm).
Private collection.

Fig. 75 Édouard Debat-Ponsan,
Mère et fille dans un jardin breton
(Mother and daughter in a Breton
garden), 1898.
Oil on canvas, 19½ × 25½ in.
(49 × 65 cm).
Musée des Beaux-Arts, Tours.

The artist's wife, Marguerite,
is reading to their youngest
daughter, Simone, who was about
twelve at the time.

Étienne Moreau-Nélaton
1859–1927

Le Jeune Amateur (The young amateur)
1903

Oil on canvas
23½ × 19¾ in. (61.1 × 50.1 cm)
Musée des Beaux-Arts, Reims

The son of artist Camille Moreau, née Nélaton (1840–1897), and heir to the spectacular collection of Adolphe Moreau (1800–1859), his grandfather, and of the second Adolphe Moreau (1827–1882), his father, Étienne Moreau-Nélaton was a collector, painter, and art historian. He was a student of the historian Ernest Lavisse at the École Normale Supérieure from 1878 to 1881, and studied painting under Henri Harpignies in 1882, before entering the studio of Albert Maignan. In 1889, he married Edmée Braun (1864–1897), with whom he had three children: Étiennette (1890–1977), Cécile (1891–1977), and Dominique (1894–1918).

In 1897, Moreau-Nélaton's mother and wife died in the fire at the Bazar de la Charité film house. Deeply affected by his loss, Moreau-Nélaton found solace in art. In 1899, he published *Camille Moreau, peintre et céramiste*: a two-volume work dedicated to his mother's painting and ceramic work. He turned to landscape painting, abandoning figures for three years, and worked to modernize the family collection, which he generously opened up to include the impressionists.

The latter undertaking was in preparation for a donation to the Musée du Louvre, which was formalized in 1906. It was both a monument to the women of his family who had been lost and an active commitment to impressionism: his donation of works by Géricault, Delacroix, and Corot was dependent on the museum's simultaneous acceptance of impressionist canvases. *Le Jeune Amateur*, which he painted in 1903, shows his son, Dominique, dressed in clothes clearly intended for outdoor adventures; in the elegant interior space, he is pictured contemplating a canvas placed on an easel. The depiction casts the boy within the family's longstanding passion for art. This painting, with its delicate brushwork and rigorous construction, belongs, like *Enfants au piano* (Children at the piano; 1902, Musée des Beaux-Arts, Pau, **fig. 77**), to a series of intimate realist works carried out between 1902 and 1907 that all focus on the artist's children going about their daily occupations. In 1908, Moreau-Nélaton gradually began to abandon painting for his art history research. Unfortunately, fate had one more tragedy in store for him: his son was killed in the final days of World War I.

M. D.

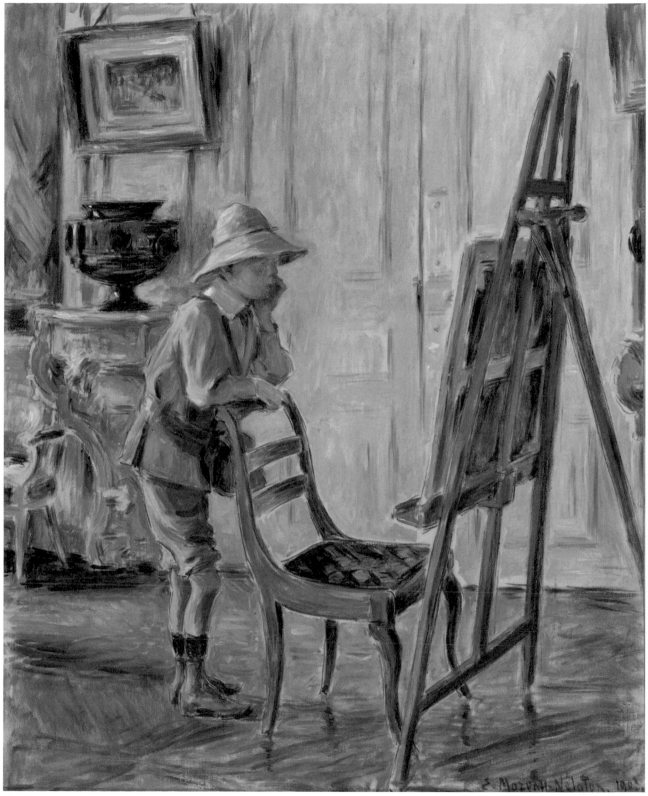

Fig. 76

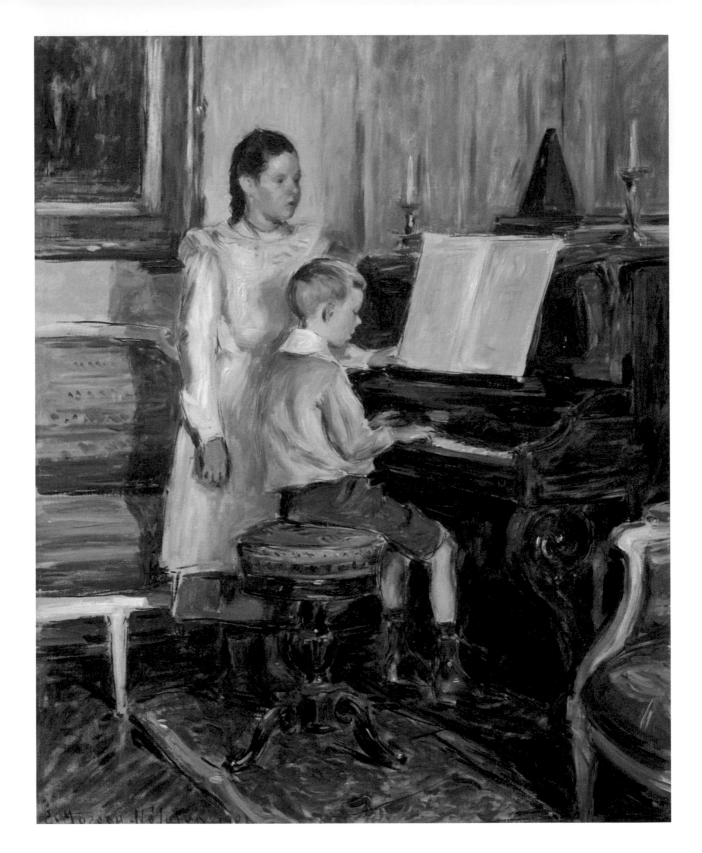

Above:
Fig.77 Étienne Moreau-Nélaton,
Enfants au piano
(Children at the piano), 1902.
Oil on canvas, 24 × 20 in.
(61.4 × 50.5 cm).
Musée des Beaux-Arts, Pau.

The artist's son, Dominique,
is practicing piano, assisted
by one of his older sisters,
Étiennette or Cécile.

Facing page:
Fig.78 Federico Zandomeneghi,
La Leçon de chant, or *La lezione
di canto* (*The Singing Lesson*), 1890.
Oil on canvas, 25½ × 21½ in.
(65 × 54.6 cm).
Intesa Sanpaolo Collection,
Gallerie d'Italia, Milan.

Camille Pissarro, "the charming, ideal father"

Today, a visit to the home and studio in Éragny-sur-Epte, in the Oise département, where Camille Pissarro settled in 1884 with his family, conveys none of the flurry of domestic and artistic life that went on there over a period of twenty years, a little more than a century ago. Silence reigns, in total contrast with the frenzy of activity that might have defined family life for the Pissarros, who had five sons,[1] all of whom took up painting, and a daughter;[2] a second daughter died in 1874 at the age of nine.[3] Many existing letters, photographs (figs. 12, 79), and various other accounts enable us to reconstruct this nonconformist lifestyle that made for a happy family, despite relatively precarious financial circumstances.

Camille Pissarro was an extremely paternal figure. Throughout his life, in addition to his own children, a number of artists from his generation and from his children's were drawn to him, and received his sound, uncompromising advice. He did not want to be their mentor; on the contrary, he invited them to look within to find their own creative élan: "you know, this question of education is the most complicated of all. You can't impose maxims, as each personality has different sentiments. All the schools teach art, which is a huge error. You can learn to execute, but never to make art, never!"[4] Julie Pissarro was more reluctant to see all of her children take up artistic vocations, but it was no use resisting. Camille expended considerable energy encouraging the children's creative impulses from an early age. Little by little, the house in Éragny

became an art school where drawing, painting, and metal and wood engraving were practiced. As a result of this patient and attentive education, Camille Pissarro's five sons all became artists, as well as several of his grandchildren and great-grandchildren. Was this a manifestation of the painter's Jewish cultural heritage? For generations, Camille's family had maintained a tradition of studying biblical texts and the accompanying commentary, but the young artist had broken with this practice. Submitting to a law, whatever it was, seemed to pose a problem for him—he eventually became an anarchist—and if this law came from a religious authority, submission became inconceivable. Camille cast off his parents' religion rather early in life. He described himself as a staunch atheist, but what he did not abandon—perhaps despite himself—was a concern for passing on knowledge to his children. And because he did not consider the biblical message worthy of this effort, he chose, in my opinion, to modify the message's content, so the biblical message was replaced by an artistic one. Camille channeled the same enthusiasm to accomplish this mission of transmission that fell to the "elders." But the members of Camille Pissarro's family should not be portrayed as "fanatics" of any such mission; the intention was not to make their artistic practice a religion, but to make transmission a vital part of life. Octave Mirbeau, who regularly visited the Pissarro family, enthusiastically observed, "An admirable family that reminds us of art's heroic ages! Five sons, all artists, all different, gathered around elders who are still young and revered! Each one follows his own nature. The father does not impose on any of them his theories,

doctrines, or ways of seeing and feeling. He lets them develop in their own way, according to their own vision and individual intelligence. He cultivates in them the flower of their own individuality."[5] In 1893, Mirbeau addressed these words to Lucien Pissarro: "I love your father as though he were my own—the charming, ideal father that I would have dreamed of having in my early years."[6] Paul Cézanne also wrote to Camille, telling him that he mattered more to him than his own father.

One can imagine how this family of nonconformists might have been viewed in the village of Éragny. Julie, who came from a family of farmers in Burgundy, had to help them to be accepted in a very rural environment. The children were by turns actors and spectators of the artistic and intellectual activity that surrounded them. As models for their father, posing for various portraits, they are almost always seen drawing, painting (fig. 81), reading, or writing (fig. 82). Unfortunately, the family library has since disappeared, but through letters we are able to reconstruct more or less what it might have contained: Flaubert, Zola, Huysmans, and Mirbeau among the novelists; Baudelaire and Mallarmé among the poets; and, of course, all of the anarchist theorists—Proudhon, Bakunin, Kropotkin, Élisée Reclus. The home had an open-door policy and regularly hosted visitors who belonged to these socially engaged artistic and intellectual circles. The young art critic Georges Lecomte was also enchanted by the atmosphere that reigned at the house in Éragny:[7] "His cherished village of Éragny remains his headquarters. In a series of perpetually renewed ambiances,

light, hours, and seasons,
it provides him with motifs that
captivate him with their truth and
grace. The works this region has
inspired him to paint all reflect a
deep connection rather than a new
beginning. Camille Pissarro would
never leave Éragny again. In the
history of French art, the name of
this village is inseparable from the
name Pissarro, much like Giverny is
now inseparable from the renown
of Claude Monet."[8]
Lionel Pissarro

1
Lucien (1863–1944), Georges
(1871–1961), Félix (1874–1897),
Ludovic-Rodolphe
(1878–1952), and Paul-Émile
(1884–1972).

2
Jeanne, known as Cocotte
(1881–1948).

3
Jeanne-Rachel, known as
Minette (1865–1874).

4
Camille Pissarro to Esther
Isaacson, May 5, 1890,
in *Correspondance
de Camille Pissarro*, vol. 2,
1886–1890, ed. Janine
Bailly-Herzberg (Paris:
Éditions du Valhermeil, 1986),
349.

5
Octave Mirbeau, "Famille
d'artistes," *Le Journal*,
December 6, 1897, reprinted
in Octave Mirbeau, *Combats
esthétiques 2, 1893–1914*
(Paris: Nouvelles Éditions
Séguier, 1993), 208.

6
Octave Mirbeau to Lucien
Pissarro, early March 1893,
in Octave Mirbeau,
Correspondance générale,
vol. 2, ed. Pierre Michel and
Jean-François Nivet
(Lausanne: L'Âge d'Homme,
2005), 739.

7
How can we explain the
strange destiny of this sincere
admirer of Camille Pissarro
and his family, an ardent
defender of Dreyfus, who
later compromised and
disgraced himself with the
Pétainists, while his son, who
signed his works under the
pseudonym Claude Morgan,
joined the Resistance in the
ranks of the communists?

8
Georges Lecomte, *Camille
Pissarro* (Paris: Éditions
Berheim-Jeune, 1922).

Fig. 79 *The Pissarro Family with Alice Isaacson and Tommy Pissarro.*
Pissarro Family Archives.

Left:
Fig. 80 Maximilien Luce,
Félix Pissarro, 1890.
Lithograph, 8½ × 5 in.
(21 cm × 12.8 cm).
Bibliothèque de l'INHA, Paris.

Born in 1874, Félix Pissarro was
nicknamed Titi. He followed his
brothers, Lucien and Georges,
to London when he was nineteen,
and began a promising artistic
career. He died of tuberculosis in
1897, at the age of twenty-three.

Facing page:
Fig. 81 Camille Pissarro,
Paul-Émile Pissarro peignant
(Paul-Émile Pissarro painting), 1898.
Oil on canvas, 21½ × 18 in.
(55 × 46 cm).
Private collection.

Like his older brothers, Paul-Émile
was encouraged by his father to
wield a pencil and a paintbrush from
an early age. In this painting, he is
fourteen and is working in his father's
studio in Éragny. After practicing
a few other trades, he eventually
became an artist like his brothers.

Left:
Fig. 82 Camille Pissarro, *Jeune homme écrivant (Portrait de Rodo) et Paul-Émile Pissarro* (Young man writing [portrait of Rodo] and Paul-Émile Pissarro), c. 1895. Original lithograph on zinc, 9 × 5 in. (23 × 13 cm). Musée des Impressionnismes, Giverny.

Ludovic-Rodo, often depicted by his father in a studious posture that was most likely second nature to him, published in the first catalogue raisonné of Pissarro's works in 1939.

Facing page:
Fig. 83 Ferdinand du Puigaudeau, *Fillettes de Bourg-de-Batz* (Little girls in Bourg-de-Batz), 1895. Oil on canvas, 21½ × 15 in. (55 × 38 cm). Musée de Pont-Aven, Pont-Aven.

Fig. 84 *Child Standing in a Garden*, 1906.
Musée d'Orsay, Paris.

I am happy to learn that you have a few flowers already. I see that upon my return I will have to garden with Bébé and Mimi, that I will not want for help.

Claude Monet to Alice Hoschedé, February 15, 1884

IN NATURE

1

For example, *Bronze Statuette of a Girl Holding a Dog*, first century BCE to second century CE, The Metropolitan Museum of Art, Rogers Fund, 1913, New York.

2

For more, see Éric Baratay, *Le Point de vue animal: Une autre version de l'histoire* (Paris: Seuil, 2012), 277–279.

3

Ibid., 278.

4

Ibid., 279–284.

5

Ibid., 303.

The impressionist painters, in endeavoring to depict everyday scenes, chose to abandon historical, religious, and mythological subjects in favor of the gestures and ordinary experiences of contemporary life. Animals, present in their homes and in the houses of their friends and patrons, are frequently represented, in particular with children, often emphasizing the close relationship between the child and their animals.

Throughout the history of art, cats and dogs have been given narrative, symbolic, or painterly roles within the scenes that they enliven, often with humor and spontaneity. Cats have pranced across large historical paintings and been enticed by the odors of elements in a still life, while dogs have been the subject of individual portraits and works that celebrate their hunting skills. This is not to suggest that the association of cats and dogs with childhood was a development specific to the nineteenth century; depictions of young girls with dogs have survived from as far back as antiquity.[1] Later, many portraits of children from royal or noble families portrayed the young model with their animal companion by their side or on their lap.

In the second half of the nineteenth century, the role of domestic animals began to change in artistic representations as well as in homes. Cats and dogs became common pets for a growing number of families from various social backgrounds, and were accepted in both bourgeois and more modest contexts.[2] Their position, and especially that of dogs, was significantly affected. While dogs had primarily been employed in modest or bourgeois households for their capacity to work, they now enjoyed the status of "family dog[s]" that "were not workers, but rather companions," no longer "left outside" but now "free to move about indoors."[3] Dog breed varieties expanded in Europe, following the latest fashions. Small dogs were particularly appreciated for their perceived attributes of loyalty and intelligence.[4] The friendship that certain breeds could develop with children was also sought after—the pitbull, strangely, belonged to this category[5]—while no aggressiveness was tolerated. Cats had been more generally accepted in homes for several centuries already,

A Child's Best Friend
Children and Pets in Impressionist Art

Elise Wehr

6

See Richard Sennett, *The Conscience of the Eye: The Design and Social Life of Cities* (New York: Knopf, 1990).

7

James H. Rubin traced the identity and breed of this dog and documented Georgette Charpentier's relationship with it. See James H. Rubin, *Impressionist Cats and Dogs: Pets in the Painting of Modern Life* (New Haven: Yale University Press, 2003), 90–94.

8

Ibid., 92–94.

especially as rodent hunters. The major shift concerning domesticated animals following the urban, industrial, and socio-cultural revolutions of the nineteenth century concerned this familiar, everyday relationship that developed between them and humans. In the same way that children were perceived and educated according to new approaches in the late nineteenth century, animals also acquired a different status at this time.

Impressionist portraits continued the established artistic tradition of depicting children with small, four-legged creatures who often shared a certain family resemblance. Used by painters in many different ways— to evoke the private sphere and intimacy, as ideal play companions, or to add painterly and symbolic value—these animals provoke different reactions in the viewer from one work to another. This leads us to a more general exploration of the position that children and animals occupied in impressionist homes and paintings.

In the Privacy and Comfort of Home

In the nineteenth century, an ideal of domestic happiness, of a comfortable home, and of private everyday life developed. The home was where the family gathered, and as such it was expected to provide an orderly refuge sheltered from the chaos and incessant activity that went on outside.[6] Certain animals, depicted alongside children in interior scenes, contribute to this impression of order, stability, and wellbeing, suggesting the privacy, calm, and tranquility that prevailed in the home. Consider, for example, Pierre-Auguste Renoir's famous portrait *Madame Georges Charpentier et ses enfants* (*Madame Georges Charpentier and Her Children*; 1878, fig. 85), shown with their dog, Porthos,[7] who lies in the foreground, imposing and imperturbable, with the six-year-old girl sitting on his back: James H. Rubin interpreted the position and posture of Mrs. Charpentier and the dog as compositional elements that point to their structuring roles in this lavish interior.[8] Renoir renders the dog's thick, abundant fur with the same care as the deep black silk and velvet fabrics of Mrs. Charpentier's attire; they echo each other, framing the comforting space that surrounds the two children.

Édouard Debat-Ponsan's painting *Mère et fille dans un jardin breton* (Mother and daughter in a Breton garden; 1898, fig. 75) also features a dog as the child's favored companion. In this more intimate work (here, the painter depicts his own family), a little dog with a blond coat sprawls in the grass, resting its chin on the knee of the painter's youngest daughter, Simone, aged twelve at the time. She is also resting her chin on her right hand, and she, like the little dog, stares off into the distance, without looking at her mother, who is reading. Simone and the dog share the same relaxed posture and air of daydreaming, and the way the two figures are intertwined suggests the affectionate relationship that connects them. The soft light bathing the garden and the harmonious pastel tones

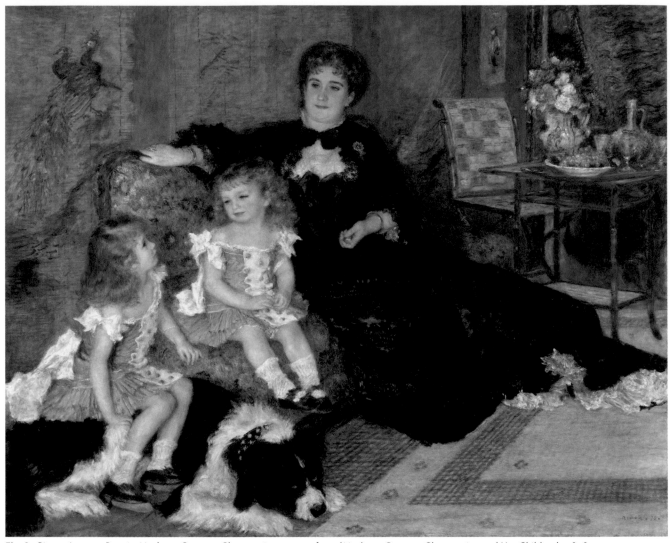

Fig. 85 Pierre-Auguste Renoir, *Madame Georges Charpentier et ses enfants* (*Madame Georges Charpentier and Her Children*), 1878. Oil on canvas, 5 ft. ½ in. × 6 ft. 3 in. (153.75 × 190.2 cm). The Metropolitan Museum of Art, New York.

9

Ibid., 90.

10

For example, Renoir's *Jeune fille endormie* (*Sleeping Girl*; 1880, oil on canvas, The Clark Art Institute, London), which Paul Durand-Ruel acquired directly from the artist in 1881. He sold it in 1883 before repurchasing it in 1891 and keeping it thereafter. See Monique Nonne in *Paul Durand-Ruel: Le pari de l'impressionnisme*, exh. cat. (Paris: RMN–Grand Palais, 2014), 184.

11

Working from Guy-Patrice and Michel Dauberville's catalogue raisonné, *Renoir: Catalogue raisonné des tableaux, pastels, dessins et aquarelles*, 5 vols. (Paris: Bernheim-Jeune, 2007–2015), we have established that 170 works from Renoir's graphic and painted repertoire depicting children or young girls passed through Durand-Ruel's hands. The works depicting young girls between childhood and adolescence make up a large majority of this body of work.

enveloping the three figures are suggestive of wellbeing and domestic harmony. Simone appears calm and obedient under her mother's authority, but, like her dog, her roaming imagination and thoughts are perceptible behind her compliant demeanor.

These two very different examples raise questions about the purpose of these family portraits and how they were received. The two paintings had very different lives. *Madame Georges Charpentier et ses enfants* met with great success at the Salon the year after it was painted, thanks to Monsieur Charpentier's emphatic recommendations.[9] The work offers up a very positive image of his family—one that meets all the criteria of the loving and comforting home, decorated with precious and exotic objects and materials, reflecting the couple's social, economic, and domestic success. In 1907, the work ultimately made its way into one of the world's major museums, the Metropolitan Museum of Art in New York, through funding made available by American philanthropist and art collector Catharine Lorillard Wolfe. Conversely, Debat-Ponsan's painting was created in a more private context. The canvas remained in the possession of the young model, the artist's third daughter, who bequeathed her collection to the Musée des Beaux-Arts in Tours, in 1981. Many impressionists, like Pissarro, Renoir, and Monet, had personal motivations for painting portraits of their children. However, it should be noted that a fair number of child portraits, including some portraits of children and animals together,[10] were acquired by the art dealers Paul Durand-Ruel and Ambroise Vollard; these included portraits of famous figures, portraits of a more private nature, such as those of Claude, Renoir's son, and portraits of fictional characters.[11] This is not very surprising, given that the clientele sought by these painters had a healthy appetite for these easy, light-hearted subjects, which chimed well with the bright colors and lively brushwork the impressionists had come to be identified with.

12

Many artists and critics expressed their admiration for Cassatt's aquatints. As for Manet's *Le Gamin* (*The Urchin*), the artist himself suggested it be reprinted in 1874, although he lacked the money to do so.

13

The animal appears to be the same dog being pulled by a little boy on the right side of the foreground in *Vue de l'Exposition universelle, 1867* (*View of the 1867 Exposition Universelle* [World's Fair]); 1867, Nasjonalmuseet, Oslo. The child in this work was identified by the Nasjonalmuseet in Oslo as Léon Koëlla Leenhoff, who was probably Manet's biological son. See Françoise Cachin, "Le gamin au chien," in *Manet: 1832–1883*, exh. cat. (Paris: RMN, 1983), 58.

14

Mary Morton mentions that decorative panels and scenes celebrating maternal love were popular with Durand-Ruel's European and American clients in "Against the Grain: Gustave Caillebotte and Paul Durand-Ruel's Impressionism," in *A Companion to Impressionism*, ed. André Dombrowski (Hoboken: John Wiley & Sons Ltd., 2021), 550–551.

15

Michelle Perrot, *La Vie de famille au XIXᵉ siècle* (Paris: Points, 2015), 100.

16

See a description of the work in *Frédéric Bazille (1841–1870): La Jeunesse de l'impressionnisme*, exh. cat. (Paris: Musée d'Orsay/ RMN, 2016), 235–236.

17

See Dianne W. Pitman, *Bazille: Purity, Pose, and Painting in the 1860s* (University Park: The Pennsylvania State University Press, 1998), 244, note 8.

18

Dianne W. Pitman compared the role of the dogs in *La Terrasse de Méric* (The terrace at Méric; 1866) with the dog that was first imagined in the sketch *La Réunion de famille sur la terrasse du château de Méric* (Family reunion on the terrace of the Château de Méric; 1867–1868, Musée d'Orsay, Paris, RF5257, recto). See Pitman, *Bazille*, 90–91.

Two quite successful prints were collected by famous art dealers: Édouard Manet's *Le Gamin* (*The Urchin*; n.d., fig. 87) and Mary Cassatt's *Feeding the Ducks* (c. 1893–1895, fig. 86), two representations that evoke a natural, unspoken connection between children and animals.[12] The little girl in Cassatt's aquatint, who is amused by the ducks approaching the small boat, their beaks outstretched in her direction, moves to feed them and smiles kindly. The boy and the dog in Manet's etching also appear united by an implicit connection; the pair poses together, their bodies turned toward each other but looking toward the viewer in unison. Françoise Cachin has suggested that this dog is the Manet family's griffon, which can be seen in other works the painter carried out in the 1860s.[13]

This close relationship between children and animals—be it deep or spontaneous, within the home or outdoors—was a subject appreciated by collectors and a wider public; both subjects belong to the domain of leisure and childhood, and mutually reinforce evocations of tender, domestic affection.[14]

Family Member and Ideal Playmate

As childhood was being redefined in the nineteenth century, animals were gradually becoming objects of deep tenderness and love that were expressed in the private sphere. "Animals are members of the family; they are spoken of as old companions, people ask after them,"[15] writes Michelle Perrot, confirming that cats and dogs became family members in their own right, playing a considerable role in children's lives. In Berthe Morisot's pastel *Dans le parc* (In the park; 1874, fig. 88), the little girl in the background seems to be waiting for the black dog at the center of the scene to come and play with her. A net, lying forgotten in the foreground by the little girl, suggests an interrupted butterfly hunt. In a work by Frédéric Bazille, a little girl kneels on a terrace in the foreground, near two dogs. She has also abandoned her hat, and the hoop that she must have been playing with is lying on the ground next to it. Situated far from the adults in *La Terrasse de Méric* (The terrace at Méric; 1866, fig. 93), the child hopes the animals will be her playmates. This part of the work had been covered up, perhaps by Bazille himself, after 1867, or when the canvas endured repainting and a fire shortly after the painter's death.[16] The little girl and the two dogs were only discovered in the 1960s, during restoration work carried out by the Musée de Genève.[17] In this scene, where the adults are all members of the painter's family, the animals draw the viewer's attention, in the same way that Bazille had intended in one of his sketches for *Réunion de famille* (Family reunion; 1877, Musée d'Orsay, Paris).[18] The animals and the children—probably all of them imaginary— were ultimately removed from both compositions, suggesting that they played similar roles as attractive, narrative elements within a more static group of adults.

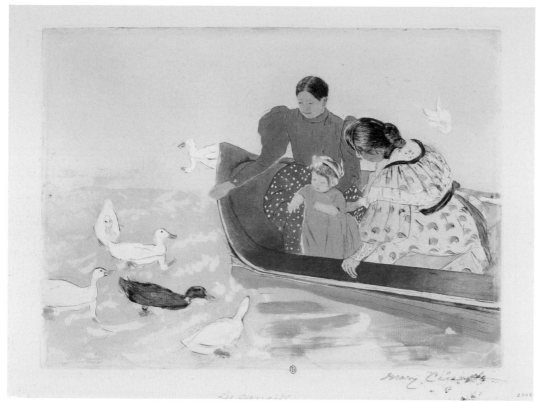

Fig. 86 Mary Cassatt, *Feeding the Ducks*, c. 1893–1895.
Drypoint, softground etching, and aquatint, 13½ × 20½ in. (34.7 × 52.4 cm).
Bibliothèque de l'INHA, Paris.

Fig. 87 Édouard Manet, *Le Gamin* (*The Urchin*), n.d.
Lithograph on violet-toned chine collé, 25 × 19 in. (63.8 cm × 48.5 cm).
Musée Carnavalet—Histoire de Paris, Paris.

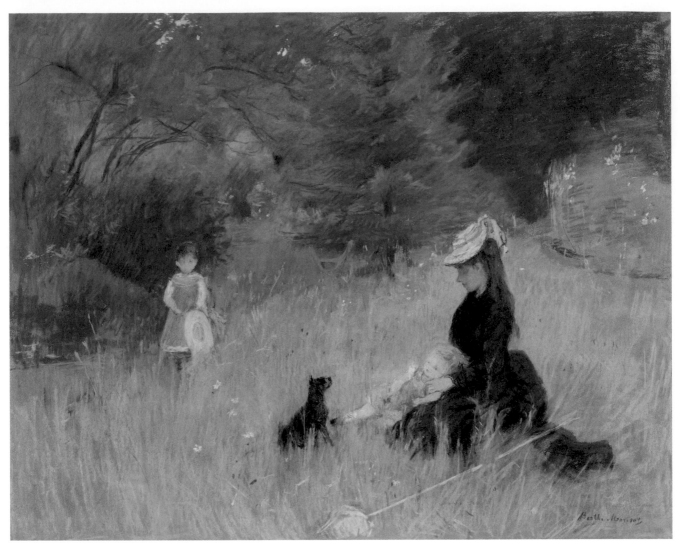

Fig. 88 Berthe Morisot, *Dans le parc* (In the park), 1874.
Pastel on paper, 2 ft. 4½ in. × 3 ft. (72.5 × 91.8 cm).
Petit Palais, Musée des Beaux-Arts de la Ville de Paris, Paris.

The dog belongs to the children's world; like them, it is a lively, playful, instinctive, and carefree creature. In Otto von Thoren's small oil painting on wood *Enfants jouant sur la plage de Trouville* (Children playing on the beach at Trouville; 1890–1900, fig. 128), three dogs play alongside the children. A little girl holds out a coin or some other object she has found in the hole that she is digging. Another dog sniffs at the sand, also looking for treasure, perhaps even working with the girl to his right, who appears ready to dig according to his instructions. They all seem to share an understanding and agreement in their search for fun and friendship. Indoors, and in less agitated contexts, small dogs and cats are often seen cradled in the arms of little girls in seated poses. The animal almost appears to be an alternative to the doll—the toy that most perfectly embodies the imitation of a mother's affection and gestures. Two fragments painted by Berthe Morisot in 1886, *Fillette à la poupée* (Young girl with doll) and *Fillette au chien* (Young girl with dog; private collection), depicting Julie Manet and her cousin Jeannie Gobillard, support this idea: the two girls—who faced each other in the first version of the work—hold in their arms, respectively, a little dog and a doll.[19] While the children face each other, the doll and the dog both look at the viewer with two brown dots that serve as eyes and give them a lifeless appearance.

Cassatt also made several portraits that convey the image of a child "playing mother," swaddling the little animal as she might have done with a baby, and gazing at it with tenderness and affection. Sara was a child model who lived near the artist's home in Mesnil-Théribus. Cassatt liked her very much and asked her to pose on multiple occasions (fig. 160), often using similar brushwork and colors for the girl's hair and the animal's pale coat. The pair also appears in a more complex painting, *Children Playing with a Dog* (1907, private collection). In it, the little girl wraps her arm around the animal and gazes tenderly down at him, exactly reproducing her mother's gestures and gentle way with her youngest brother. Unlike other scenes that more directly reference the traditional, timeless iconography of the Virgin Mother, here Cassatt suggests the notion of succession, of the little girl inheriting her mother's role, and a projection of the child in the social position that she will one day occupy. This is no longer a game for the girl, who sincerely hopes to feel a mother's tender love for her child. In this way, the dog no longer plays a supporting role in a performed simulation of reality, but becomes an accessory to the girl's dual projection of both her past and the future that awaits her.

Fig. 89 Pierre-Auguste Renoir, *Julie Manet*, 1887.
Oil on canvas, 26 × 21 in. (65.5 × 53.5 cm). Musée d'Orsay, Paris.

Fig. 90 Pierre-Auguste Renoir, *Le Garçon au chat*
(The boy with the cat), 1868.
Oil on canvas, 4 ft. ½ in. × 2 ft. 2 in. (123.5 × 66 cm).
Musée d'Orsay, Paris.

Berthe Morisot depicted this motif several times, notably on five occasions between 1885 and 1890. See numbers 173, 220, 237, 262, and 265 of Marie-Louise Bataille and Georges Wildenstein's catalogue raisonné, *Berthe Morisot: Catalogue des peintures, pastels et aquarelles* (Paris: Les Beaux-Arts, 1961).

Psychological and Visual Ambiguities

In impressionist portraits, the closeness and intimacy between children and their pets is evident, but certain associations between the two of them can also produce more ambiguous effects than simple friendship and familiarity. Most paintings depict the two figures with the same expression—the animal's facial features often mimic those of its child companion. This similarity creates the impression that both are inhabited by the same thoughts and emotions. In the portrait *Julie Manet* (1887, fig. 89), Renoir depicts the girl holding a cat on her lap. Julie and the animal share a similar sweet smile, almond-shaped eyes, and pale pink complexion; the highlights in the girl's hair echo the cat's fur. Both tilt their head slightly, and the intermingling of the white portion of the animal's body with the model's white dress, which Renoir renders in the same way, further accentuates the psychological and physical association between the two figures. Why this imitation? The cat's calm demeanor and contented expression might emphasize the painter's tender feelings for Berthe Morisot's daughter, as Renoir projects his own affection for his model onto the animal.

Birds, dogs, and cats can all be signs that indicate or reveal the child's mental state, standing in for a clear expression on the model's face. An animal's attitude or its way of reacting to the scene may divulge much more about the child's feelings than the latter's own expression. While the presence of a bird and a cage reinforces the melancholic appearance of a young girl in Morisot's paintings,[20] a dog's alert and protective stance can let a child's innocence and docility come through with greater force. Consider Maurice Boutet de Monvel's tender, humorous illustration of a woman bathing a child, *Le Bain de l'enfant* (The child's bath; n.d., fig. 91): kneeling before a large tub, she wrings out a sponge over the child's head as he raises his arms to shield his eyes. A little dog watches the scene with alarm, its body tense as it recoils and its muzzle open, and it is clearly startled by what is happening to the child. If not for the animal's presence and behavior, the scene would be altogether different: a relaxed, intimate depiction of a child's bath. The dog's narrative, emotional, and visual contribution conveys the reluctance that a young child might feel toward this unpleasant experience, which is what makes Boutet de Monvel's work so original.

Cats create particularly ambiguous effects in some of Renoir's most famous paintings; they may be unsettling or, conversely, considerably enhance the subject's sensuality. Two works, carried out twelve years apart, illustrate this well. *Le Garçon au chat* (The boy with the cat; 1868, fig. 90) depicts a nude young boy cuddling a cat, seen from the back. The boy leans his head against the cat's, and this juxtaposition reveals similarities in their faces, such as their pink mouths and the expression in their eyes. The painting is destabilizing, inasmuch as the cat further blurs the scene's possible meaning and context; it evokes a familiar environment—

Fig. 91 Maurice Boutet de Monvel, *Le Bain de l'enfant* (The child's bath), n.d.
Pen ink, ink wash, and white gouache highlights on paper, 10 × 13 in. (25.5 × 33.6 cm).
Musée des Beaux-Arts, Reims.

21

See, for example, James H. Rubin's interpretation: "The delicate softness of Renoir's brushstrokes is paralleled by the downy fur they represent.... The generosity and subtlety with which Renoir applied his paint appeals to appetite and desire as much as do the objects such pictures introduce to the imagination." (Rubin, *Impressionist Cats and Dogs*, 112).

the home—with no reference to historic or literary iconography, or the simple academic nude. The child's position is unsettling, and his physical and psychological proximity to the cat encourages the viewer to project the animal's docile manner and sensuality onto the boy. Renoir's rendering of various textures has led this work to be interpreted as a metaphor for the sense of touch: a reading that uses the animal to add nuance and reduce the painting's ambiguous quality. Another smiling cat—this one dozing comfortably on the lap of a young girl, who is also asleep and holding the animal's front paw—creates a similar effect. The erotic import of Renoir's *Jeune fille endormie* (*Sleeping Girl*; 1880, The Clark Art Institute, Williamstown) is undeniable: the strap of the girl's undergarment has slipped from her shoulder as she sleeps deeply, leaving a large part of her upper body visible to the viewer, while she seems unaware that she is being observed. The viewer's attention then moves to the cat: it is almost invisible against the model's skirt, which stretches from mid-thigh to her belly. Here, too, the cat, and the scene as a whole, can be interpreted in a variety of ways.[21] It seems clear that Renoir projects the insouciance and docility attributed to domesticated animals onto his young models. More than a well-defined symbol or attribute, the cat appears to be a sort of substitute that allows the artist to convey an ambiguous vision of childhood. The animal leads the viewer to confer a certain sensuality on these developing individuals, but also a protective impulse, while the children are depicted in the most innocent state of unconsciousness.

Whether used as narrative, charming, or inspiring elements, dogs, cats, and birds enable artists to accentuate evocations of intimacy, and domestic and affectionate feelings. As allegories of the fantasy world of childhood, pets crystallize and impart the way in which artists and adults understand this unfamiliar universe—this world of play, tenderness, and daydreams.

Claude Monet
1840–1926

La Maison de l'artiste à Argenteuil (The Artist's House at Argenteuil)
1873

Oil on canvas
23¾ × 29 in. (60.2 × 73.3 cm)
The Art Institute of Chicago, Chicago

Monet's move to Argenteuil in 1871 ushered in a period of stability for the artist. Significant acquisitions by Paul Durand-Ruel ensured Monet relative material comfort until 1874, when the art dealer's own financial troubles put an end to this situation. After his exile in London and a short stay in the Netherlands, Monet was drawn to Argenteuil—a pleasant town close to Paris with a wealth of motifs ideally suited to impressionist experimentation: the lush banks of the Seine, sail boats and barges traveling up and down the river, and metal bridges built to replace the structures that were destroyed in the war of 1870. The house, which belonged to the Aubry family, and which the Monet family rented until the summer of 1874, was located in a street near the station. It was a comfortable home where Monet often hosted his painter friends: Manet, Caillebotte, Sisley, and Renoir, as well as journalists and collectors. It was surrounded by ample grounds, which became the artist's first private garden.

Here, under the radiant sky strewn with wispy white clouds, the property is bursting with flowers: in dense beds that surround the garden, in the windows of the house, on the tree that conceals the horizon, and in the blue-and-white ceramic vases that would later accompany the artist to Giverny. At the top of the front steps, between the plants climbing the façade, appears a woman's figure dressed in a blue dress: Camille, the painter's wife. At the focal point of the composition, in the center of the stretch of light-colored gravel, cloaked in the house's mauve shadow, a child in a white gown with a dark grey sash tied in a bow is standing with his back to the viewer. This is Jean, Monet's eldest son, who was born in 1867 and would have been aged five or six. He wears a hat and holds before him a hoop. Interrupted in his game, he faces the glowing spectacle of the garden—just like the viewer and his father.

M. D.

Fig. 92

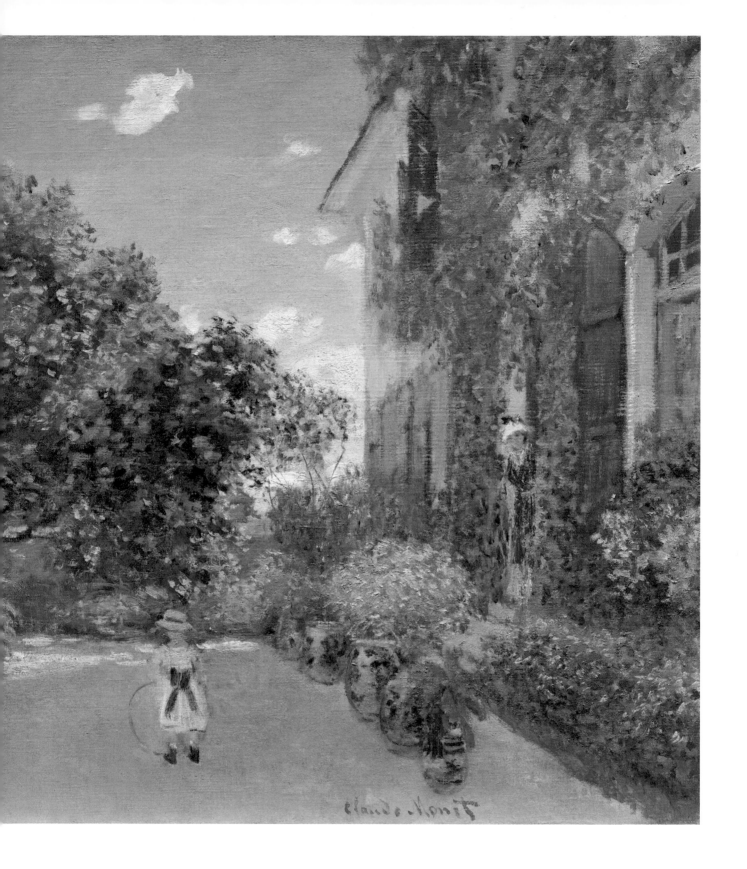

Fig. 93 Frédéric Bazille,
La Terrasse de Méric (The terrace
at Méric), 1866.
Oil on canvas, 3 ft. 2 in. × 4 ft. 2½ in.
(97 × 128 cm).
Musée du Petit Palais, Geneva.

Méric was a family estate that the
artist's mother, Camille Vialars, had
inherited with her sister Adrienne
(the wife of Eugène Des Hours).
The female figures might be Bazille's
mother and, according to a letter
from the artist to his parents written
in January 1867, his Des Hours
cousins, Camille and Pauline, then
around fifteen and twenty years old.
The identity of the little girls and the
male figures is more uncertain.

Facing page:
Fig. 94 Ernest Marché, *Le Jeune Pêcheur* (The young fisherman), n.d.
Oil on canvas, 16 × 13 in.
(41 × 33 cm).
Château-Musée, Nemours.

Above:
Fig. 95 Rineke Dijkstra,
*Parque de la Ciudadela,
Barcelona, June 4, 2005,* 2005.
Ink-jet print, edition 9/10,
2 ft. 6 in. × 3 ft. 1 in.
(75.5 × 94 cm).
Artist's collection.

Above:
Fig. 96 Eugène Boudin,
Paysage avec personnages
(Landscape with figures), c. 1880.
Oil on mahogany panel,
10½ × 14 in. (26.4 × 35.2 cm).
Musée Eugène-Boudin, Honfleur.

Facing page:
Fig. 97 Eugène Boudin,
Portrait de fillette
(Portrait of a young girl), c. 1880.
Oil on mahogany panel,
11½ × 8½ in. (29.3 × 21.7 cm).
Musée Eugène-Boudin, Honfleur.

Above:
Fig. 98 Berthe Morisot,
Bergère nue couchée
(*Reclining Nude Shepherdess*), 1891
Oil on canvas, 22½ × 34 in.
(57.5 × 86.4 cm).
Carmen Thyssen-Bornemisza
Collection, on long-term loan to
the Museo Nacional Thyssen-
Bornemisza, Madrid.

Inspired by the bucolic ambience
of Mézy (Yvelines) and likely by
Renoir's *Bathers*, this *Reclining Nude
Shepherdess* can be compared with
two other works by Morisot featuring
the same model in the same pose,
but wearing clothes. The girl is
Gabrielle Dufour: a twelve-year-old
who lived in the area and who took
her first communion with Julie.

Facing page:
Fig. 99 Berthe Morisot,
Le Cerisier (*The Cherry Tree*),
begun in 1891.
Oil on canvas, 5 ft. 1 in. × 2 ft. 9 in.
(154 × 84 cm).
Musée Marmottan Monet, Paris.

In Mézy, Julie posed as the young
girl on the ladder and her cousin
Jeannie as the girl holding the
basket. When she finished the
work in Paris, Berthe Morisot had
to use another model in place of
Julie: Jeanne Fourmanoir, who had
been recommended by the painter
Federico Zandomeneghi.

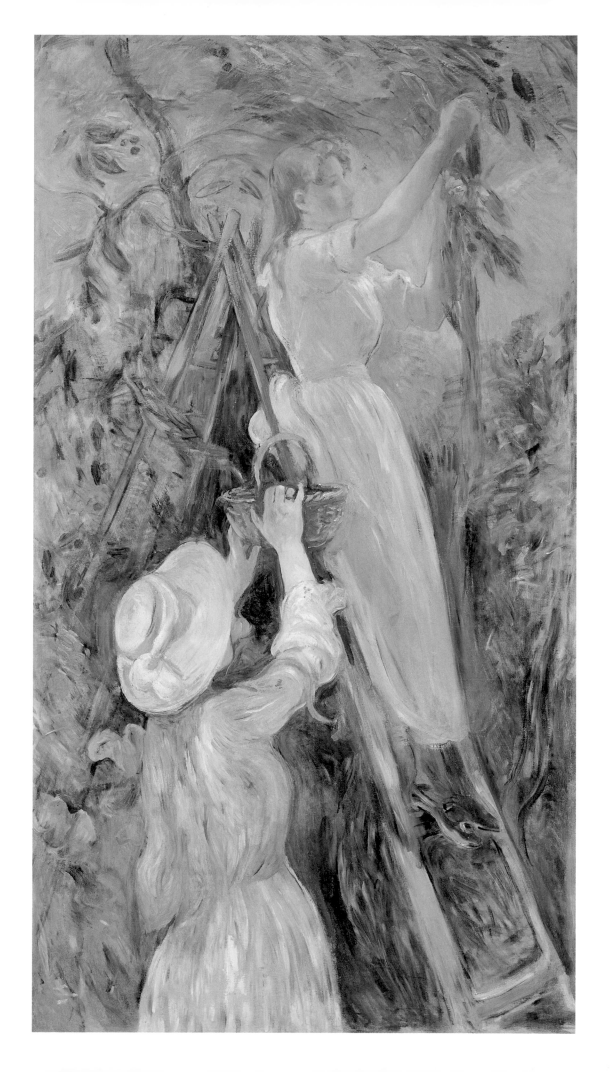

Above:
Fig. 100 Henri Martin,
Étude pour l'été
(Study for "The summer"), c. 1905.
Oil on canvas, 2 ft. 11 in. ×
3 ft. 11 in. (89 × 120 cm).
Musée de Grenoble, Grenoble.

Facing page:
Fig. 101 Émile Claus, *Les Glaneurs*
(Gathering Corn), 1894.
Oil on canvas, 15 × 22 in.
(38.5 × 55.8 cm).
Museum voor Schone Kunsten,
Ghent.

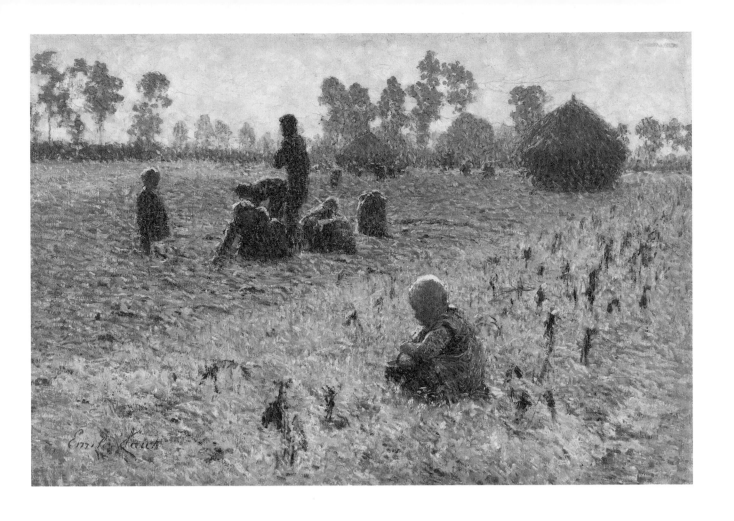

Fig. 102 Pierre Laprade,
*Vue de Paris; D'un balcon du quai
Henri IV* (View of Paris: From
a balcony on Quai Henri IV), c. 1919.
Oil on wood, 20 × 27 in.
(50.6 × 69 cm).
Musée de Grenoble, Grenoble.

Jean-Paul, the only son of Pierre
Laprade, was about five years old
when this painting was made. The
small, solitary figure may well be him.

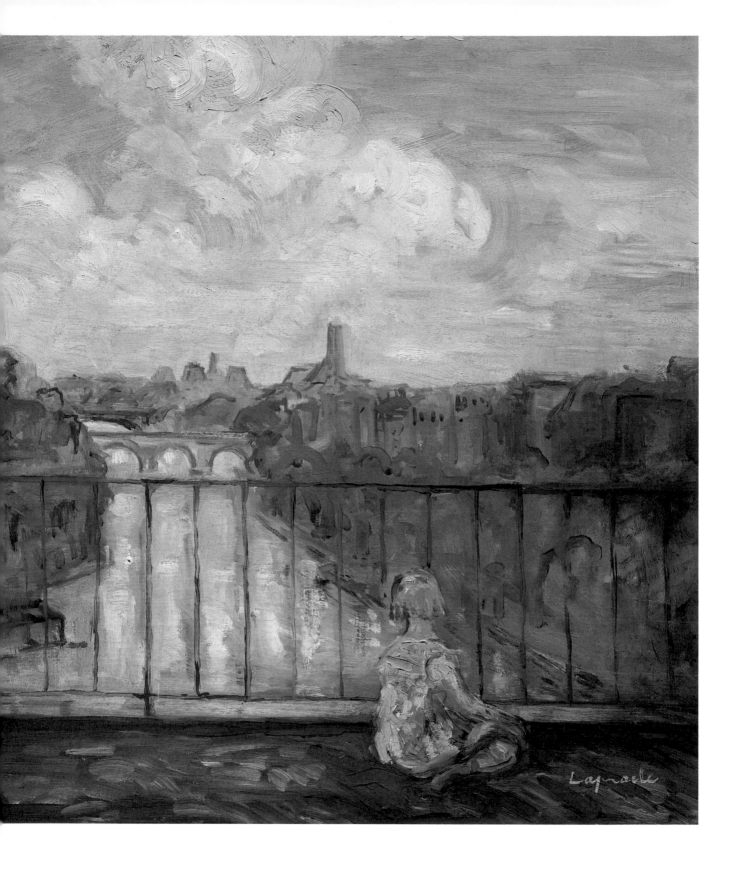

Fig. 103 Séeberger Frères (photographers), *The Jardin du Luxembourg: Photo Taken from Terrace E, 6th Arrondissement, Paris*, detail, August 1906. Musée Carnavalet—Histoire de Paris, Paris.

I never buy a hat without asking myself if Monsieur Renoir will like it.

Julie Manet, *Journal*, January 8, 1898

FASHION

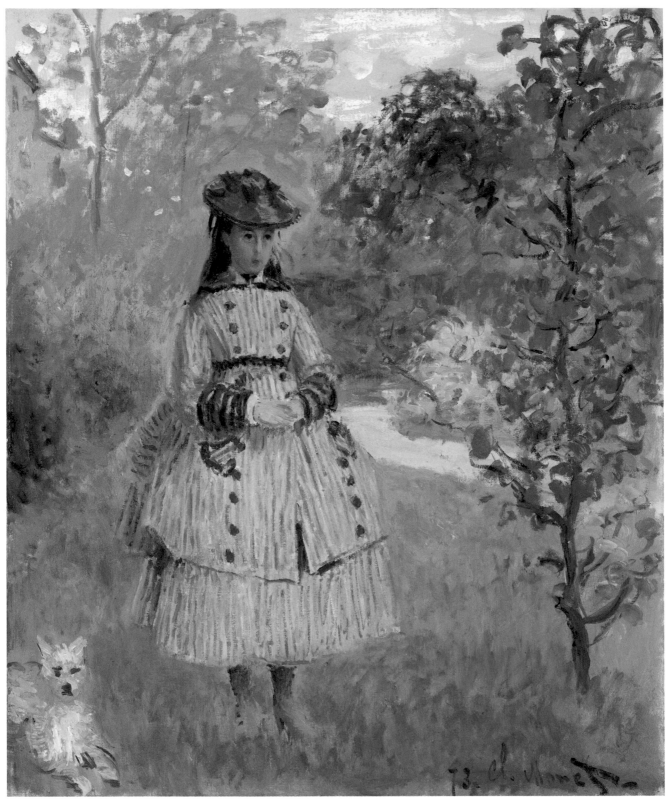

Fig. 104 Claude Monet, *Fille avec un chien (Girl with Dog)*, 1873.
Oil on canvas, 21½ × 18 in. (55.2 × 45.7 cm).
The Barnes Foundation, Philadelphia.

1

Claude Monet, *Femmes au jardin* (Women in the garden; 1866–1867, Musée d'Orsay, Paris).

2

Ambroise Vollard, *Auguste Renoir* (Paris: G. Crès et Cie, 1920), 74.

3

Édouard Manet, *La Famille Monet au jardin à Argenteuil* (*The Monet Family in Their Garden at Argenteuil*; 1874, The Metropolitan Museum of Art, New York); Pierre-Auguste Renoir, *Madame Monet et son fils* (*Madame Monet and Her Son*; 1874, National Gallery of Art, Washington, D.C.).

4

Claude Monet, *Les Coquelicots à Argenteuil* (Poppy field near Argenteuil; 1873) and *Le Déjeuner* (The lunch; c. 1873), both held at the Musée d'Orsay, Paris.

5

Claude Monet, *La Promenade, la femme à l'ombrelle* (*Woman with a Parasol—Madame Monet and Her Son*; 1875, National Gallery of Art, Washington, D.C.).

In July 1874, three months after the first impressionist exhibition was held, Manet, Renoir, and Monet met in the garden of the house in Argenteuil where Monet had moved in 1871, upon his return from England. Manet was living nearby at the time, across the Seine in the family estate in Gennevilliers. He had not wanted to join Renoir, Monet, and the other artists who had gathered in the studio of photographer Nadar to exhibit outside the official Salon, but he did develop a friendship with Monet. In the summer of 1874, Manet often visited him and they painted together. On one particular day, captivated by the light and the effect of color on the figures in the garden, Manet set out to depict the Monet family (fig. 109). Camille, Monet's wife, wears an elegant white dress topped off with a white hat adorned with pink flowers and black ribbons. In the nineteenth century, it was frowned upon to go out bare-headed. She is seated in the grass, striking more or less the same pose as she does in *Femmes au Jardin* (Women in the garden),[1] but this time, their son, Jean, appears at her side. Claude gardens in the background. At this point, Renoir arrives, delighted at "such a wonderful opportunity to have models at hand,"[2] and borrows Monet's palette to paint the charming pair (fig. 108). In this way, seven-year-old Jean Monet was immortalized in a pair of paintings carried out in the open air by two geniuses of "the new painting."[3] He probably posed in his summer clothes, rather than dressing up for the occasion. He wears a blue-and-white-striped sailor suit with dark-blue contrasting elements and a straw cloche hat with a red border on the brim. The same hat protects him from the sun in his father's outdoor scenes, such as *Les Coquelicots à Argenteuil* (Poppy field near Argenteuil), *Le Déjeuner* (The lunch),[4] *La Promenade* or *La Femme à l'ombrelle* (*Woman with a Parasol—Madame Monet and Her Son*),[5] and *La Maison à Argenteuil* (*The Artist's House at Argenteuil*; 1873, fig. 92). Manet pursues this red line executed in fluttery brushstrokes from the hat down to Jean's shoes, to Camille's fan, the rooster's comb, and the flowers that Monet—who is a secondary figure here—attends to. Manet was a tall, elegant bourgeois man who enjoyed fashion. After all, he once said, "The latest fashion is absolutely

Boys in Princess Gowns and Girls in Suits

Marie Simon

6

Fashion was a key concern in modern painting; see Marie Simon, *Mode et peinture* (Paris: Hazan, 1995) and the exhibition catalog *L'Impressionnisme et la mode* (Paris: Musée d'Orsay/Skira Flammarion, 2012).

7

Franz Xaver Winterhalter, *King Edward VII (1841–1910), when Albert Edward, Prince of Wales* (1846, Her Majesty Queen Elizabeth II's collection). Bertie wears a middy top and drop-front trousers made by the tailor of the royal yacht crew's uniforms, and also sports the royal beret.

8

Françoise Tétart-Vittu explains the sailor suit's ubiquitousness by the extension of men's clothing to boys, and its distribution in specialized sections of department stores, which added a girls' department around 1880. See *La Mode et l'enfant 1780–2000*, exh. cat. (Paris: Paris Musées, 2001), 166, 184, and 185.

9

Julie Manet, *Journal, 1893–1899* (Paris: Mercure de France, 2017), 135; Thursday, November 14, 1895. Julie and her cousins are lunching at Renoir's: "he showed us the portrait of a model wearing an Arabic-style hat made of white muslin with a rose on it that he made himself, and a white dress with a green belt. It is very pretty, the clothes are delicate and light, and so is the brown hair, which is very beautiful." Ambroise Vollard, in "Renoir fait mon portrait," from 1925, recounts the painter's words: "When you have a suit in a shade of blue that speaks to me: you know, Vollard, that metallic blue, with silver reflections," or "Your hat is amazing. I must do something about it," *En écoutant Cézanne, Degas, Renoir* (Paris: Grasset, 1938), 266.

10

Michel Florisoone, "Renoir et la famille Charpentier," in *L'Amour de l'art* (Paris, 1938).

necessary for a painting. It's what matters most."[6] Here, he provides an incontestably accurate rendering of the sailor suit, which was an outfit comprising several pieces: a pair of short trousers (either loose-fitting below the knee in the style of knickerbockers, or cut straight); a blouse or V-neck middy-style top; a large collar trimmed with braid and squared in the back; a removable shirtfront; and sometimes a belt and a knotted tie.

The sailor suit was initially worn as vacation attire: a fashion sparked during the Second Empire by Queen Victoria's eldest son, Albert Edward ("Bertie" to his family), who had been dressed by his mother in a replica of the Royal Navy uniform.[7] Available in primary colors—white, sky blue, navy blue, red—solid or striped, and enhanced with graphic stripes, the sailor suit was the latest fashion for sea swimming. Summer versions were made of cotton or drill and winter versions were available in jersey, serge, broadcloth, and Cheviot wool. From the 1870s onward, the sailor suit was an essential element of any boy's wardrobe, and ten years later girls adopted the fashion. Inspiration knew no borders: there were middy tops modeled after the uniforms of the English, Russian, or American navies; quartermasters' jackets over pleated skirts for girls; blouses and long pants for young men; dresses for babies; and berets and "Jean Bart" straw-boater hats. During the Belle Époque, the sailor suit invaded wardrobes everywhere to become the uniform of childhood. Children's fashion, which until then had consisted of nothing more than small-scale replicas of adult styles, was born. This remarkable change was made possible by the development of children's clothing manufacturing,[8] and the fashion press. Just as the impressionists were casting off the strict rules and limited distribution opportunities offered by academic painting (as embodied in the Salon), children's fashion was laying the groundwork for its own emancipation: two simultaneous revolutions, as it were. But, of course, they were not understood in this way at the time. Who could have imagined such a future for the sailor suit?

Manet and Renoir each applied their own pictorial style to the same subject. To compare the two paintings is like playing a game of spot-the-difference, in which Manet bests Renoir when it comes to fashion: he is perfectly in keeping with the style, and the stripes and the socks slipping down the boy's little legs are exquisite. In Renoir's version, the stripes on the suit disappear in brushwork that creates the impression of a sky-blue fabric. However, unlike Manet, Renoir depicts the boy's navy blue cuffs. He adopts a more allusive approach to the suit than the older painter. But as Julie Manet writes in her *Journal* and art dealer Ambroise Vollard in his memoirs,[9] Renoir was attentive to fashion: his father, a tailor, and his mother, a dressmaker, had introduced him to it. He was particularly fond of fabrics and hats, going so far as to suggest to Marguerite Charpentier that he develop and illustrate a fashion column for the last page of the review *La Vie moderne*,[10] founded by her husband, the publisher Georges Charpentier. Renoir's relationship to children's fashion is illuminating: he was careful to accurately depict the clothing worn by the children he

Figs. 105, 106, 107 Maurice Boutet de Monvel, *La Civilité puérile et honnête, expliquée par l'oncle Eugène*
(Plain good manners for children, explained by Uncle Eugène; Paris: Plon-Nourrit et Cie, 1887).
The Musée des Impressionnismes library, Giverny.

11

The filmmaker Jean Renoir in his book *Renoir: My Father* (1962) recounts the pleasure his father took in painting his long hair. He asked him to wait as long as possible before cutting it. The custom was to cut boys' hair when they started school.

12

Pierre-Auguste Renoir, *Madame Georges Charpentier et ses enfants* (*Madame Georges Charpentier and Her Children*; 1878, The Metropolitan Museum of Art, New York).

13

Julie Manet et Jeannie Gobillard (Julie Manet and Jeannie Gobillard; c. 1887, Musée Marmottan Monet, Paris).

14

Between 1890 and 1920, baby clothes became gendered, first through slight differences in fabrics, patterns, and cuts, then ultimately through the use of pink and blue.

was commissioned to paint, while he simplified that of his own children. When painting his sons, Pierre, Jean, and Claude, known as Coco, he rarely depicts more than a collar or a knotted ribbon; the rest of the clothing is rendered in solid colors, admittedly in shimmering tones that harmonize with the silky highlights in their hair. How he loved their long hair! His five-year-old nephew Edmond Renoir (1889, fig. 112) had locks down to his buttocks. His own children were eager to be rid of theirs.[11]

On the other hand, however, he produced brilliant renderings of the clothing worn by young models such as the Charpentier children, and the Cahen d'Anvers and the Bérard girls, among others. Renoir's success had grown ever since the Salon in 1879, where his portrait of Mrs. Charpentier and her children had been exhibited (fig. 85),[12] and he began a career as a painter of children's portraits. He excelled at rendering the effects of light on fabrics and accessories, not to mention the details of cuts and finishes; the young Fernand Halphen (fig. 116), wears the white cord and red embroidered insignia of the Royal Navy on his high-quality blue serge sailor outfit, complete with striped shirtfront. When Renoir painted Julie Manet with her cat sitting on her lap (fig. 89)—a portrait commissioned by Berthe and Eugène Manet—he faithfully, although without lapsing into Ingrès-like precision, rendered the ocher-yellow embroidery that seems to add a slight stiffness to the bust, collar, and cuffs of her dress. Julie poses in the same dress in a photograph taken of her with her cousin.[13] Neither the photograph, which has unfortunately suffered heavy damage, nor the painting allows us to identify the origin of the embroidery: was it inspired by the traditional Breton costumes that came into fashion in the 1870s? Did Berthe Morisot order this neo-folk dress—to use a neologism—from her dressmaker? Did she consult her friend Renoir about the choice?

For the moment, let us return to Jean Monet, Claude's son. Half reclining, with one leg bent and the other outstretched, he gives the impression of having momentarily curbed his youthful impatience. His visibly relaxed air and nonchalant attitude are quite unusual in depictions of children. At that time, young men were supposed to "carry themselves well," especially once they reached the age of reason. He has indeed cast off the dresses of his early childhood; until the age of about five, boys wore dresses and kept their hair long, like girls. With his back to the viewer and wearing a white dress tied with a wide sash, the five- or six-year-old Jean pictured in *La Maison de l'artiste à Argenteuil* (*The Artist's House at Argenteuil*; 1873, fig. 92) could easily be mistaken for a little girl, if viewed through modern eyes. In Renoir's painting, Georgette and Paul Charpentier wear exactly the same low-cut princess gown in blue faille, and shoes with a mid-foot strap; a single detail sets them apart: Georgette's have small heels. Fashion magazines and department store catalogs offered baby models for children aged two to six. Dressing siblings in identical clothing took precedence over maintaining gender distinctions, and in fact the colors pink and blue had not yet acquired their gendered status.[14]

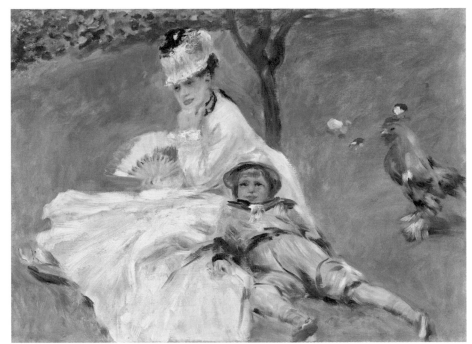

Fig. 108 Pierre-Auguste Renoir, *Madame Monet et son fils (Madame Monet and Her Son)*, 1874.
Oil on canvas, 20 × 27 in. (50.4 × 68 cm).
Ailsa Mellon Bruce Collection, National Gallery of Art, Washington, D.C.

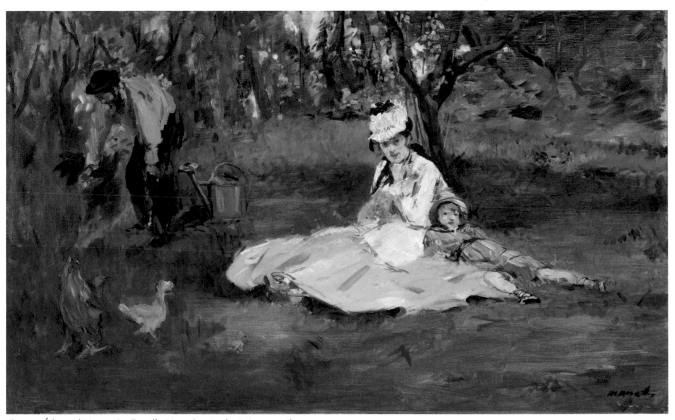

Fig. 109 Édouard Manet, *La Famille Monet au jardin à Argenteuil*
(*The Monet Family in the Garden at Argenteuil*), 1874.
Oil on canvas, 2 ft. × 3 ft. 3 in. (61 × 99.7 cm).
Joan Whitney Payson bequest, 1975, The Metropolitan Museum of Art, New York.

15
Petit Bateau underwear was invented in the following century, in 1913, by the hosier Pierre Valton, who shortened pant legs.

16
Pierre Mornand, *Souvenirs 1884–1905* (Paris: Arts et Mémoires, 2017), 18.

17
Journal des dames et des demoiselles, June 1871, column "Modes," 95.

18
Mornand, *Souvenirs*, 153, regarding a classmate at the Lycée Condorcet who, although he came from a very good family, was "poorly dressed, dirty, and more than unsophisticated.... Adrien was nice, but he looked as though he'd just come back from plowing. He had *aucun monde*, as we used to say."

In Mary Cassatt's *Little Girl in a Blue Armchair* (1878, fig. 110), the child sprawled on an armchair with only a dog for company—probably the Brussels griffon that Degas had given to Cassatt—assumes a posture similar to Jean's. Like the boy, she doesn't actually appear to be posing. This little girl has clearly forgotten the decorum of a proper young lady. What is to be made of the Scottish plaid fabric that matches her head-band and socks, tied rather sloppily around her embroidered dress and rumpled behind her? Her appearance is rather unkempt. Has this brazen girl forgotten that even children must sit up straight with their legs together, or risk revealing their undergarments?[15] Is she surrendering to profound ennui after a society outing? In his *Souvenirs 1884–1905*, Pierre Mornand, deputy curator at the Bibliothèque Nationale de France, art critic, and man of letters, recalls being suddenly torn away from his playthings by a zealous maid, dispatched by his mother, who submitted both him and his brother to energetic "scrubbing" and "primping" to make them presentable. It was their mother's day for receiving visitors and they were expected in the sitting room. "She washed our hands, and combed, brushed, and tugged on our long hair. How we cried 'ouch!' when the comb encountered a 'knot.' We also had to exchange our slippers for elegant, polished, English-style buckled shoes, and pull up our stockings that were corkscrewed around our legs."[16] For these young members of a respectable family from the Plaine Monceau neighborhood, preparing to make an appearance in "society" was quite an ordeal.

These elegant children were constrained, figuratively and literally—just consider their narrow ankle boots. Their wardrobe included overlapping layers of undergarments and outer clothes. Many items fastened at the back, further complicating the task of dressing. The chest had to be kept straight. Despite disapproval by certain doctors, corsets were made in large quantities and in every size, available for children as young as a year old in the form of unboned undershirts; they were sold in the lingerie section of department stores, as were corset-like vests for little boys. Boys wore short trouser suits until their first communion or when they entered secondary school—both rites of passage for young men. Girls had less freedom of movement; they more or less adopted their mother's fashions. In 1871, a columnist for the *Journal des dames et des demoiselles* called for "a simpler bodice form & skirt" to give them a "younger appearance."[17] This wish for simplicity went unfulfilled: girls did not escape the profusion of ruffles, pleats, bows, and ruching that was characteristic of the extravagant "tapissier" style (fig. 104). Hats and gloves were de rigueur; during the Belle Époque, the former were excessively large, cumbersome, and often too heavy for children's heads (fig. 121).

Within the new urban bourgeoisie, being dressed to the nines ensured that children did not look like they had "just come in from the fields."[18] Dress codes were extremely complex; etiquette guides and fashion magazines took it upon themselves to instruct mothers who did not naturally master them, unlike their counterparts on the aristocratic

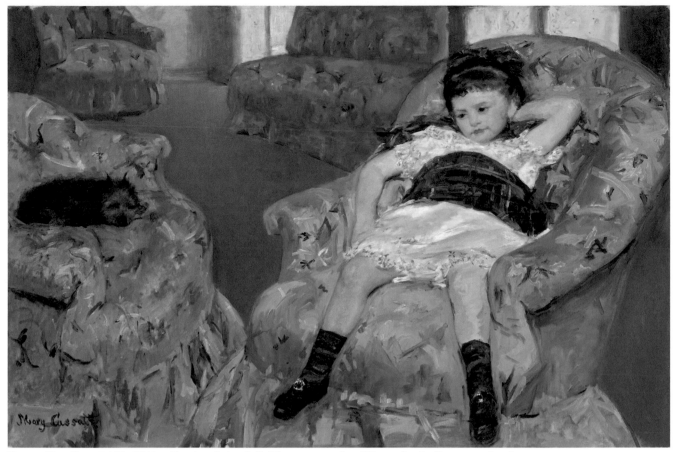

Fig. 110 Mary Cassatt, *Little Girl in a Blue Armchair*, 1878. Oil on canvas, 2 ft. 11½ in. × 4 ft. 3 in. (89.5 × 129.8 cm). Mr. and Mrs. Paul Mellon Collection, National Gallery of Art, Washington, D.C.

19

Ibid., 73 and 74, the children illustrated by Boutet de Monvel in Anatole France's book, *Nos Enfants*, had "the same occupations, the same outfits as us: big red pinafores with sleeves, protecting the 'Russian blouse' or sailor suit. Grandma cut and sewed these Russian blouses and sailor suits, or had them sewn by her maid."

20

L'Enfant first appeared in 1878 as a series in the newspaper *Le Siècle*, before being published as a novel in 1879 by Charpentier.

21

Degas admired Mary Cassatt's aristocratic appearance. He sketched her at the Louvre and depicted her in a hatmaker's workshop. He was even more enthusiastic about the American artist's pictorial output; he worked on the background of *Little Girl in a Blue Armchair*, and the model is the daughter of one of his friends.

22

Pamela Todd, *Impressionists at Home* (London: Thames & Hudson, 2005), 97.

23

Julie Manet, *Journal*, 159, in reference to the Berthe Morisot painting *Les Pâtés de sable* (The sand pies; 1882, private collection, Boston).

24

Baronne Staffe, *Le Cabinet de toilette* (Paris: V. Havard, 1891), 269.

25

Charles Baudelaire, *The Painter of Modern Life and Other Essays* (London: Phaidon Press, 1965), 31.

26

Berthe Morisot, *Le Berceau* (The Cradle; 1872, Musée d'Orsay, Paris).

27

Claude Monet, *Impression, soleil levant* (Impression, Sunrise; 1872, Musée Marmottan Monet, Paris).

Boulevard Saint-Germain. Serious as the matter was, fortunately there was still room for humor: the delightful album for children who are "good as gold," *La Civilité puérile et honnête expliquée par l'oncle Eugène* (Plain good manners for children, explained by Uncle Eugène), written by Eugène Plon and illustrated by Maurice Boutet de Monvel (figs. 105, 106, 107), met with great success when it was published in 1887. Boutet de Monvel provides invaluable observations of the fashion and customs of his day.[19] He illustrates what was still, at the time, a distinct separation between city children and country children: the former in true chic Parisian style, wearing ankle boots, hats, and urban outfits; the latter in "country attire," as the young Jacques Vingtras, Jules Vallès's character in *The Child*,[20] called it—in other words, pinafores, headscarves, and little clogs. It was partly because of the child's irreverent posture in *Little Girl in a Blue Armchair* that the painting was turned down by the American pavilion at the Paris World's Fair of 1878. Yet Cassatt, an American artist who was accustomed to high society, was perfectly aware of the codes and concerns of representing fashion.[21] But she loathed the affectation and stiff postures of academic painting. She sought to portray the truth of childhood. She told her friend Louisine Havemeyer, "I love to paint children. They are so natural and truthful. They have no *arrière-pensée* [ulterior motive]."[22] Berthe Morisot felt similarly. "It looks so much like a child!" declared Julie Manet, in response to the painting her mother made of her wearing a pink dress and little brown bonnet, making sand pies on a beach in Bougival.[23] Julie was Morisot's favorite model; the artist, breaking with the conventions of her own social background, successfully combined her work as an artist with the "sacred maternal duties" to which women were systematically assigned.[24] She participated in every impressionist exhibition (except for 1878, the year that Julie was born), and provided financial support for the events. And yet her death certificate, dated March 2, 1895, describes her as having no profession.

Morisot painted her cherished daughter playing and engaged in everyday activities: reading, playing music, daydreaming. Julie grew up under the watchful gaze of mother and artist. She was never dressed in superfluous accessories, and she never resembles a doll. In intellectual and artistic upper-middle class circles, children were dressed tastefully, without the ostentatious luxury of the demimonde. When Julie was little, she wore a white pinafore, dresses (fig. 59), and then skirts paired with blouses featuring an officer's collar, a fashionable style in the 1880s. As a young woman, she wore long dresses (fig. 99). During the entire nineteenth century, only little girls were allowed to reveal their legs; women would have to wait until the Roaring Twenties. Morisot refused to render clothing in meticulous detail: she wanted to capture a figure's essence, an "indivisible unity" between dress and wearer, using the keen understanding of fashion that a "painter of modern life" must possess as defined by Baudelaire.[25] When she exhibited *Le Berceau* (The Cradle),[26] alongside Monet's iconic *Impression, soleil levant* (Impression, Sunrise),[27] in 1874,

28

André-Théodore Brochard, *La Jeune Mère ou L'Éducation du premier âge*, an illustrated journal of childhood, no. 9 (September 1880), 138.

29

Casual wear is a basic trend in children's wear that appeared with the development of more comfortable clothing in the 1960s.

30

Joris-Karl Huysmans, *L'Art moderne* (Paris: UGE 10/18, 1975), 50.

31

Stéphane Mallarmé (*alias* Marguerite de Ponty) on children's fashion in the short-lived publication *La Dernière Mode, Gazette du monde et de la famille*, issue 7 (Sunday, September 26, 1874). He created the journal in 1874 and wrote all eight issues himself.

she paved the way for a new subject: maternity and young children—a theme of special interest to Mary Cassatt.

In the intimacy of the nursery, Cassatt's babies are lightly clad in thin, spotlessly white shirts. There are no vests, swaddling clothes, long dresses, or coverups, let alone padded gowns, bonnets, knit caps, stockings, or slippers—all the accoutrements that swamp newborns in a mountain of linens. In 1880, Dr. Brochard, who was vehemently opposed to swaddling and sartorial customs that posed a threat to babies' health, recommended "a light shirt, a sleeveless canvas dress" for summer. Observing a group of infants from all social classes during a vaccination session at the Académie de Médecine, he noticed that they were all dressed as though for winter in "flannel cardigans, wool vests, and on top of that, head and neck scarves. And," he continued, "the state they are in! They are soaked in sweat. I need not add that almost all of these children are pale and weak. Nothing weakens children like this incessant sweating."[28] Wool was the most common fabric used for underlayers. The impressionists were ahead of their time in terms of fashion. They favored light cottons, stripes, and fabrics that would produce the most interesting effects of light. Their attention to intimate family and domestic life led them to paint white undershirts (fig. 146) and baby gowns in the sun, which had rarely been represented in the past. Were impressionist children the forerunners of casual wear?[29]

Seated in the grass, under the watchful eye of his mother as she hangs out the laundry (1887, fig. 35), Pissarro's infant son—perhaps the youngest, Paul-Émile—soaks up the sun. He appears to be bare-bottomed, dressed simply in a short-sleeved gown to which Pissarro has added a small bluish shadow just above the waist: is it the boy's little vest? He is playing outside, which, if Dr. Brochard is to be believed, was far from common.

From babies in gowns to young girls in flowers, the children of impressionist artists certainly had pretty clothes and elegant style. In their endeavor to capture these children in moments of daily life, to reproduce the fleeting brightness of light on their figures, their parents repudiated the photographic precision of paintings that were as flat as fashion plates, as seen in the depictions of children exhibited at the Salon by the "couturiers" of painting, as Huysmans called them.[30] Contrary to the conventions of academic painting, the impressionists portrayed the spontaneity of children and the marvelous life force that inhabits them. Instead of showy colors, they preferred the infinite variations of white and pastels; instead of society fashion, they favored light, outdoor fashion with the "tender, naïve harmony" that the poet Mallarmé called for in his fashion magazine *La Dernière Mode*.[31]

Below:
Fig. 111 Berthe Morisot, *La Petite Marcelle*
(Portrait of Marcelle), 1895.
Oil on canvas, 25 × 18 in. (64 × 46 cm).
Musée Marmottan Monet, Paris.

Marcelle was one of the child models to whom
Berthe Morisot turned when her daughter and
nieces entered adolescence. She posed for
several paintings in 1894 and 1895. According
to Julie Manet, this was the last painting her
mother worked on.

Facing page:
Fig. 112 Pierre-Auguste Renoir,
Enfant assis en robe bleue
(Portrait d'Edmond Renoir fils)
(Seated child in a blue dress [Portrait
of Edmond Renoir, son]), 1889.
Oil on canvas, 25½ × 21½ in.
(65 × 54 cm).
David and Ezra Nahmad Collection.

The young Edmond Pierre Auguste
Renoir was the son of the painter's
younger brother, Edmond Renoir,
a journalist and art critic who
supported the impressionists.

Fig. 113 Jacques-Émile Blanche, *Enfant couchée; Le réveil de la petite princesse* (Reclining child: The awakening of the little princess), 1890. Oil on canvas, 3 ft. 6½ in. × 2 ft. 8 ½ in. (107.5 × 209.5 cm). Musée de Dieppe, Dieppe.

This child is Lucie Esnault, the daughter of Jacques-Émile Blanche's Parisian locksmith. The artist painted her many times between 1887 and 1892, wearing dresses from the collection in his studio. Here, Lucie is probably wearing a corset under her dress, forcing her into an unnatural pose.

Above:
Fig. 114 Armand Guillaumin,
Portrait de petite fille
(Portrait of a young girl), 1894.
Pastel, 19 × 22½ in. (48 × 57.5 cm).
Musée d'Orsay, Paris.

This little girl is probably Madeleine,
the artist's eldest daughter, around
the age of six. In 1886, Guillaumin
married Marie-Joséphine Gareton,
a literature teacher at the Lycée
Fénelon in Paris. They had four
children: Madeleine, Armand,
Marguerite, and André.

Facing page:
Fig. 115 Camille Pissarro, *Jeanne
Pissarro dite Minette, au bouquet*
(Portrait of Jeanne Pissarro), 1872.
Oil on canvas, 28½ × 23½ in.
(72.7 × 59.5 cm).
Yale University Art Gallery,
New Haven.

Facing page:

Fig. 116 Pierre-Auguste Renoir,
Fernand Halphen enfant
(*Fernand Halphen as a Boy*), 1880.
Oil on canvas, 18 × 15 in.
(46.2 × 38.2 cm).
Musée d'Orsay, Paris.

The composer Fernand Halphen,
born in 1872, was the youngest son
of the banker Georges Halphen.
This portrait was given to the boy's
governess by the Halphens, before
being purchased by Jos Hessel,
who sold it to the collector Charles
Pacquement. Pacquement then
gifted it to Fernand Halphen's widow
after Halphen died in World War I.

Above:

Fig. 117 Alfred Stevens,
René Peter enfant
(*René Peter as a child*), 1880.
Oil on canvas, 11 × 9 in.
(27.5 × 22.5 cm).
Musée d'Orsay, Paris.

René Peter, the son of professor
Michel Peter, was a childhood friend
of Marcel Proust, whose father was
also a doctor. In 1880, Peter cured
Stevens of bronchitis. The artist
thanked him by painting a portrait
of Peter's son.

Daniel de Monfreid

1856–1929

Portrait de la fille de l'artiste, or L'Infante (Portrait of the artist's daughter, or Infante)

1906

Oil on board
25½ × 21½ in. (65 × 55 cm)
Musée d'Orsay, Paris

On May 1, 1899, Agnès de Monfreid was born. She was a product of the artist's relationship with Annette Belfils, who had been his companion since 1892.

Daniel de Monfreid began his career in the late 1870s at the Salon des Artistes Français (Salon of French Artists). He entered the Académie Julian in 1876 and developed ties with the Nabi artists Ker-Xavier Roussel, Édouard Vuillard, and Maurice Denis, and he became a close friend of Paul Gauguin in 1887. He participated in the exhibition at the Café Volpini (1889) with the synthetist group and developed friendships with members of the avant-garde, including Aristide Maillol, Louis Valtat, Paul Verlaine, and Odilon Redon. He painted landscapes but also Breton subjects, still life compositions, and Mediterranean seascapes. Settled in Saint-Clément, in the Pyrénées-Orientales, he continued to give Gauguin his unwavering support; he was a close observer of Gauguin's artistic production and contributed to honoring the artist's memory, notably with a publication of *Noa Noa: Voyage to Tahiti* in 1924.

Monfreid had two children: Henri (born in 1879) and Agnès. He painted them often, from childhood to adulthood. In this preliminary work carried out in 1906 in Saint-Clement, Monfreid paints a melancholy portrait of the little girl. She wears a blue dress with billowing sleeves, her hair is pulled back, and she is shown in three-quarter profile, with her hands crossed on an immense armchair that resembles a throne. This difference between the size of the model and the size of the accessory likely explains the title *Infante*, the name for Spanish princesses. Following her engagement in 1918 to Louis Huc, a military doctor from Béziers, she posed for her father in more bourgeois settings, with the same placid face in the grip of private, inaccessible dreams.

C. S.

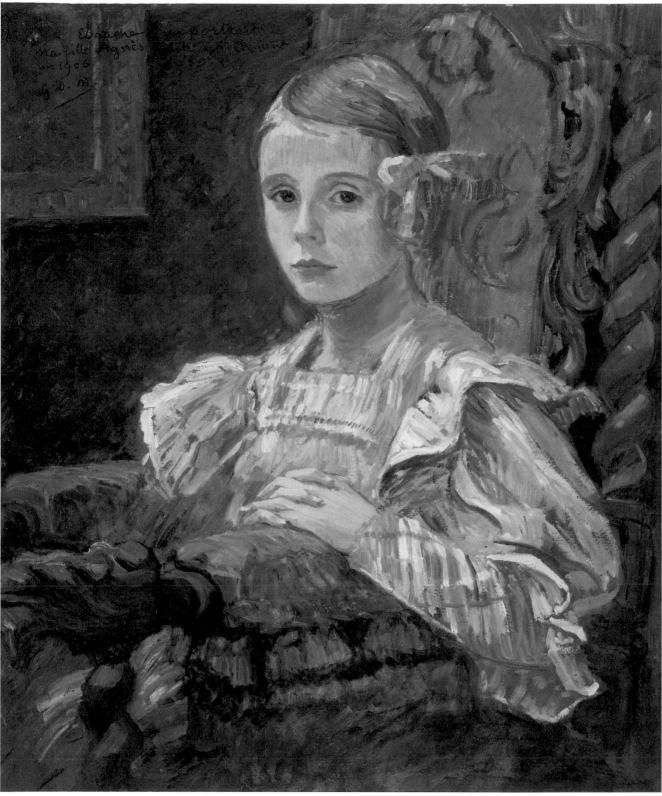

Fig. 118

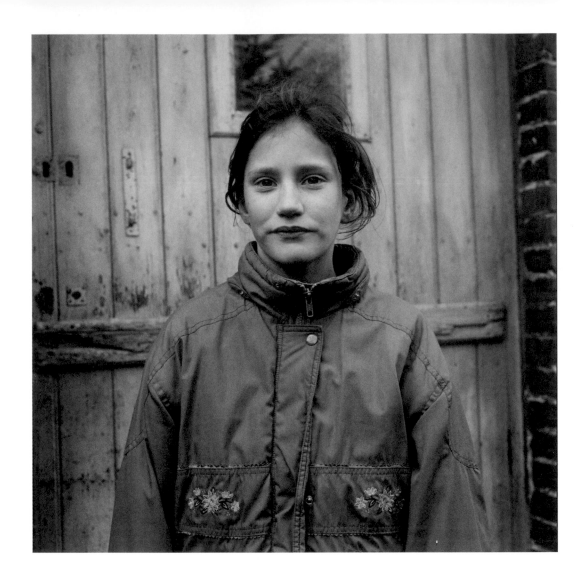

Above:
Fig. 119 Laurence Reynaert,
Portraits, 2000–2003.
Black-and-white print on baryta
paper, 16 × 19½ in. (40 × 50 cm).
Frac Normandie Collection,
Sotteville-lès-Rouen.

Facing page:
Fig. 120 Henry d'Estienne,
Portrait de fillette
(Portrait of a young girl), c. 1913.
Oil on canvas, 4 ft. 5 in. × 2 ft. 9 in.
(135 × 85 cm).
Musée d'Orsay, Paris.

Henry d'Estienne presented
many portraits of his wife
and his daughter, Suzanne,
at the Salon. In this painting,
Suzanne is around ten years old.

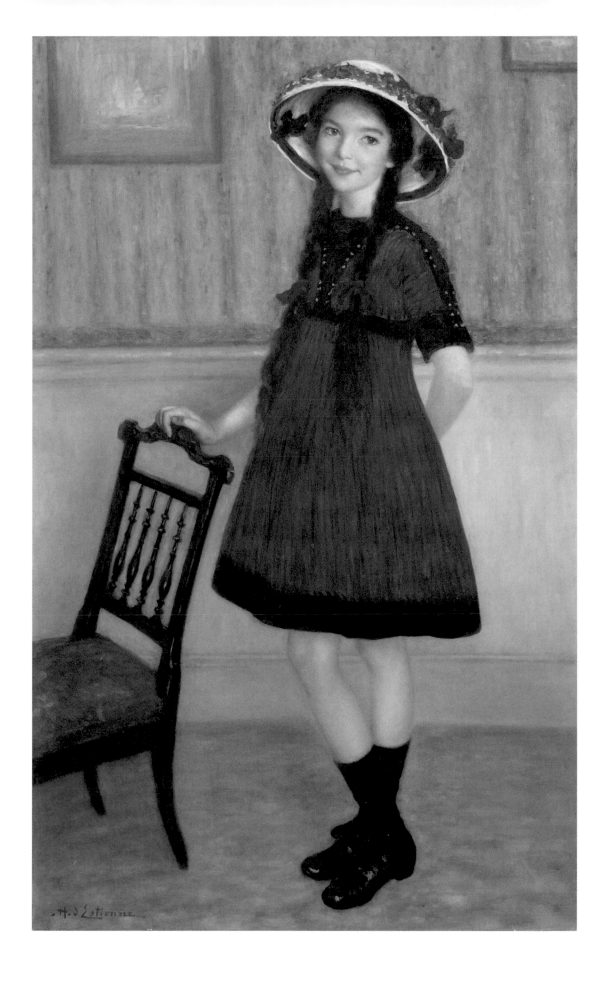

Facing page:

Fig. 121 Maurice Boutet de Monvel, *Mademoiselle Rose Worms*, c. 1900. Oil on canvas, 27½ × 16 in. (70 × 40 cm). Musée des Impressionnismes, Giverny.

Rose Worms was the daughter of Blanche Barretta and Gustave Worms, both members of the Comédie Française. A writer, she recounted her childhood memories in *Le Nid: Un foyer d'artistes à la Belle Époque* (The nest: A home of artists during the Belle Epoque).

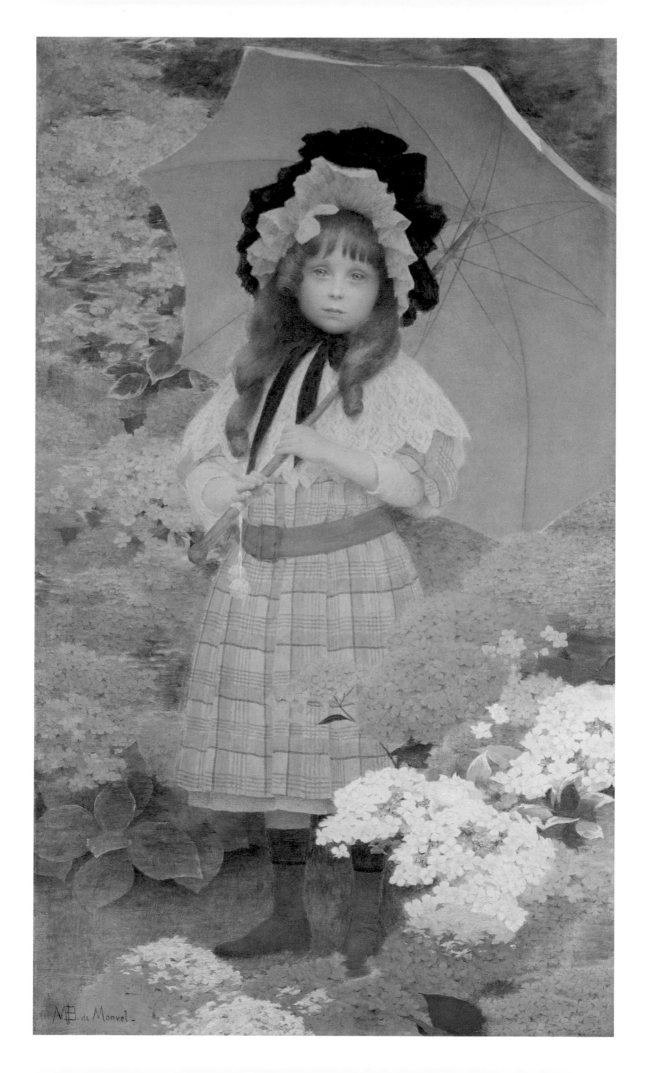

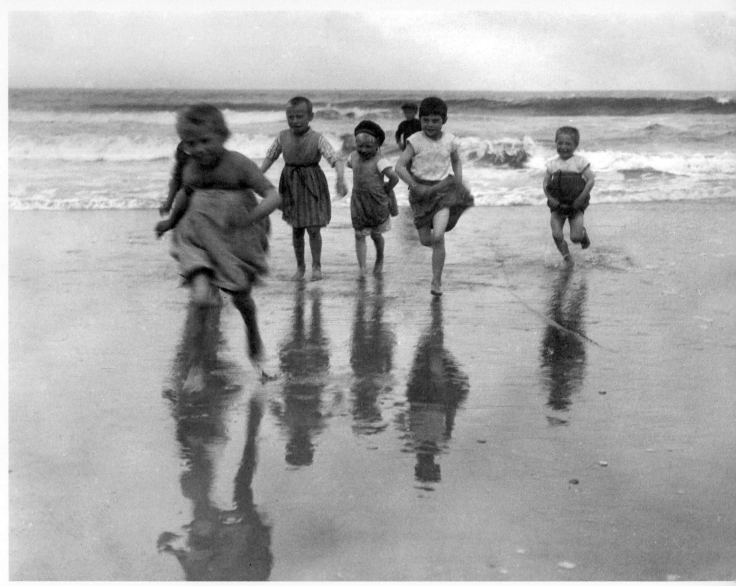

Fig. 122 *Seascape: Children Running out of the Water, 1890–1915.*
Musée d'Orsay, Paris.

It's Paris—with all its qualities, its absurdities, and its vices—transported to the seaside for two or three months.

Adolphe Joanne, *La Normandie,* 1867

AT THE BEACH

1
Dr. Antoine Roccas, *Traité pratique des bains de mer et de l'hydrothérapie marine fondé sur de nombreuses observations* (Paris: Victor Masson et Fils, 1862), 42. The edition cited here is the second edition, which contains numerous additions to the information presented five years earlier in the first edition.

2
Ibid.

3
Ibid., preface.

4
Dr. Gustave Drouineau, foreword, *Des bains de mer: Guide médical et hygiénique du baigneur aux plages de l'Ouest* (Paris: Victor Masson et Fils, 1869), III.

5
Ibid., 62–63.

6
Dr. André-Théodore Brochard, *Sea-Air and Sea-Bathing for Children and Invalids*, trans. and ed. William Strange (London: Longman, Green, Longman, Roberts, & Green, 1865). In France, the book received an award from the Académie de Médecine.

7
Dr. Brochard, son, *Guide des enfants aux bains de mer* (Paris: J.-B. Baillière et Fils, 1885), VII. The 1885 edition was the ninth edition.

"Childhood is certainly the period in an individual's life best suited to *experiencing the sea*. I purposefully use the word *experiencing* and not *bathing*, because the latter is not appropriate for all phases of childhood, while children of all ages almost always receive healthful effects from the marine air."[1]

Thus wrote Dr. Antoine Roccas in 1862. Among his other functions, he was "deputy medical inspector for sea-bathing in Trouville."[2] At the time, seaside activities on the Normandy coast were at their height, promoted by the Duke of Morny, among others, with the financial support of the banker Armand Donon and the British doctor Joseph Francis Olliffe. It was precisely the growing popularity of sea-bathing that had encouraged Roccas, who believed the activity should be medically regulated, to write a treatise.[3] His approach and recommendations were not an isolated phenomenon. Under the Second Empire, doctors who turned their attention to the issue of children and non-therapeutic sea-bathing advised extreme caution. For example, Dr. Gustave Drouineau declared the following in the introduction to his work, which was published several years before Dr. Roccas's: "In this case, the latest fashions should be completely disregarded. And while it is true that sea-bathing owes its current popularity to them, we may now, while being thankful for this revelation, heed them with great moderation and accept its dictates with reserve."[4] He explains in the chapter on exposing children to water, "this must be done with caution. When sudden immersions frighten [children], causing them to cry out, when they cling in terror to the necks of their guides, or when they must be dragged along the shore, it is better to give up swimming than to force them under such conditions.... On sandy beaches where the ocean washes up a gentle slope, children may be left to play as they like. Nothing benefits them more than free activity that promptly familiarizes them with bathing and removes any fear they may have."[5] A monumental work by Dr. André-Théodore Brochard had been published in France on the subject in 1864,[6] but given the difficulties in consulting voluminous works of this kind at the beach, the son of Dr. Brochard, also a doctor, had the wise idea to publish the shorter *Guide des enfants aux bains de mer* (A guide to sea-bathing for children):[7] a handbook for mothers who frequented the highly popular beaches, "where distractions are so great and

Children on the Beach: Urban and "Natural"

Philippe Thiébaut

8

Brochard, *Sea-Air and Sea-Bathing*, 42, 157–159, and 167.

9

Ibid., 96.

10

Ibid., 162.

11

Ibid.

12

Ibid., 164.

13

Adolphe Joanne, *La Normandie* (Paris: Librairie Hachette, 1867), 204.

14

On this subject, see in particular Robert L. Herbert, *Impressionism: Art, Leisure, and Parisian Society* (New Haven: Yale University Press, 1988) and *Origins of Impressionism*, ed. Henri Loyrette and Gary Tinterow, exh. cat. (New York: Harry N. Abrams, Inc./The Metropolitan Museum of Art, 1994). Specifically regarding the seafront, see *Impressionists by the Sea*, ed. John House and David Hopkins, exh. cat. (London: Royal Academy of Arts, 2007).

15

See the discerning analysis in Bruno Delarue, *Boudin à Deauville– Trouville* (Fécamp: Éditions Terre en Vue, 2015).

so varied [that] no one has time to read a serious work." This fifty-page booklet, which was sold for sixty centimes, was intended to summarize advice taken from his father's tome. The Brochards advised families to opt for sandy, level beaches, to bathe at high tide, and to limit baths to no more than two or three minutes.[8] This immersion, brief though it might be, was not to be hurried. They recommended letting children play at the beach at their leisure for two or three days,[9] and then suggested, once children had donned their bathing suits, "promenad[ing] for some minutes upon the sands, in order to bring the temperature of their bodies nearer to that of the surrounding air,"[10] while being careful "not to wait until a sensation of cold has arrived, before entering the water."[11] Finally, specific instructions were given as to how the child should do this: "The best plan for children to observe is to *run* into the water, and to splash it about them as they proceed. After having got a short way in, they should bend their knees, and so bring the trunk of the body forward, and then plunge two or three times overhead. At the same time, they should beat their breasts with the palms of their hands.... If the child or youth can swim,... instead of the much-dreaded *dips*, he can boldly launch himself *upon* the waves."[12] Admittedly, this medical literature was intended for professionals, but primarily concerned the affluent classes, who had turned sea-bathing into a new form of sociability rather than a medical therapy. The Joanne guide of 1867 includes this charming commentary about Trouville: "It's the meeting place for invalids in good health. It's Paris, with its qualities, its absurdities, and its vices, transported to the seaside for two or three months."[13]

It is highly useful, if not essential, to consult these publications, and others like them, in order to better understand the presence of children in pictorial representations of the urban population's new leisure activity. This is especially the case in works produced by followers of the New Painting who, as we know, were in search of modern subjects with an aesthetic suited to their artistic approach.[14]

It is evident that until the late 1870s, bathing itself did not feature prominently in these seascapes, starting with paintings by Eugène Boudin (fig. 123). A native of Honfleur—a quaint Normandy harbor town—he was a prime observer of the transformation that took place along the coast following the arrival of summer vacationers, most of them from Paris.[15] In the majority of his horizontal, panoramic compositions, the compact groups of figures in the foreground only rarely allow for a glimpse of possible bathers frolicking in the waves. Children are scarce within this elegant crowd. Might the painter have focused his attention on little girls in an effort to emphasize this elegant quality?

The girls' figures—always near their mothers—are often seen from the back, whether depicted standing, seated, or crouching, and they are usually dressed in light-colored dresses with wide belts or colorful short capes, depending on the temperature and wind. Depicted with a few brushstrokes, they contribute vibrant, colorful markings that play a role in

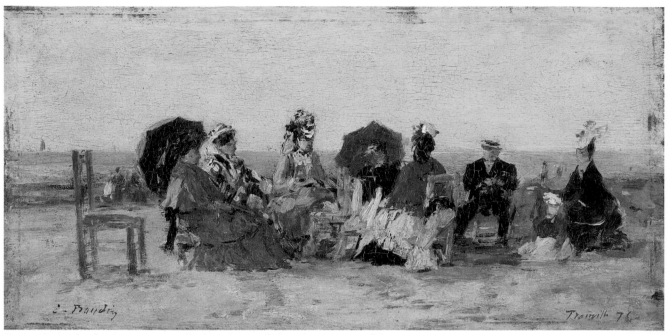

16
Wadsworth Atheneum Museum of Art, Hartford.

17
National Gallery of Art, Ailsa Mellon Bruce Collection, Washington, D.C.

18
"Very young children ... are to be lightly dabbed over with lint or a very soft towel (not rubbed)."
Brochard, *Sea-Air and Sea-Bathing*, 168.

the painting's visual construction. When, in the summer of 1870, Monet depicted Trouville's society life, he painted a distinctly more dynamic picture of the beach and seafront than Boudin's. In compositions organized around the figure of his wife, Camille Doncieux, an open view of the water provides a glimpse of a child's figure, notably a little boy in a navy-blue shirt and light-colored pants. The beach is similarly uncrowded in *La Plage à Trouville* (*The Beach at Trouville*);[16] among the people who have left the boardwalk to stroll in the sand, three toddlers can be seen. They appear to be crouched on the beach, playing with a bucket, although the object itself is not depicted, unlike in Mary Cassat's *Children Playing on the Beach*,[17] painted several years later. On the other hand, there are a few more people in the water at the beach in Boulogne-sur-Mer in Degas's 1869 painting *Petite fille peignée par sa bonne* (*Beach Scene*; fig. 124). Here, contrary to Monet's depiction, forms do not dissolve in the shimmering light: in the upper left corner of the painting, two children wrapped in white linens are distinctly visible,[18] trailing behind their mother and a nanny. The group is returning from the section of water reserved for women, evoked in the upper right corner by a few dark brushstrokes representing ladies in bathing suits. The subjective and arbitrary framing creates a feeling of immediacy comparable to that which emanates from

Manet's masterpiece painted a year earlier, *Sur la plage de Boulogne* (*On the Beach, Boulogne-sur-Mer*; fig. 125). There are no bathers in the water or on the horizon—just isolated groups that share a desire to drink in the sea air. Children are present in larger numbers in Manet's painting. Dressed in elegant daywear, they are seen accompanying or in conversation with their mothers, while others have gathered to make sandcastles as they wait, perhaps, for a donkey ride—the animal's rump is visible in the lower right corner of the painting. Despite certain details characteristic of contemporary seaside activities, seascapes by Monet, Degas, and Manet cannot be considered picturesque. They are slices of modern life that represent a total break with the convention of genre painting, which was replete with the picturesque. For this very reason, its practitioners leapt at the spectacle afforded them by the summer population. Consider, for example, *Les Bains de mer à Honfleur* (Bathing at Honfleur; fig. 127) by Louis-Alexandre Dubourg—who, like Boudin, was a native of Honfleur[19]—which was produced at the same time as the paintings by Degas and Manet. The various activities of summer vacationers are depicted on one single canvas: couples walk arm in arm down the beach toward the viewer; others are seated, contemplating the sea; while ladies are sitting and chatting together. These different groups determine the canvas's vanishing points, liberating a space at the center of the painting occupied by two elegant little girls. They have been drawn there by the spectacle of the sea, or perhaps by a young boy in a bathing suit following his mother toward a group of bathers under the watchful gaze of a *maître du nage*, or lifeguard. The composition is based on an artificial grouping of figures depicted with stereotypical attitudes, and features similarities with images of bathers that appeared in the press. Indeed, Otto von Thoren's *Enfants jouant sur la plage de Trouville* (Children playing on the beach at Trouville; fig. 128), painted in 1876, resembles a fashion print. Everything here is an illusion, too. The children are from the same social class as those represented by the impressionists, but their demeanors and carefully rendered gestures, their well-made clothes, meticulously depicted, and the near total absence of adults likens the scene to a page torn from a garment maker's or a department store catalog (fig. 126). In contrast to these staid, model children, Winslow Homer's excited young Americans exude a refreshing energy. Composed, like Boudin's painting, of superimposed horizontal bands—the sky, the sea, the children, and their reflections on the wet sand—*Beach Scene*, painted in 1869 (fig. 132), features only children, but they are children overflowing with life before the sight of the Atlantic Ocean on a beach in Cape Ann, Massachusetts. Extremely excited little boys jump and gesticulate as they shout in the surf, while the more prudent little girls, after removing their boots and hiking up their skirts, content themselves with getting their feet wet. The clothing of both sexes suggests that they belong to the class of summer vacationers, comparable to the holidaymakers who frequented the Normandy beaches during the same period.

20

Regarding the practice of separate areas reserved for men, women, or families at seaside resorts, see Philippe Thiébaut, "Baigneurs du XIXᵉ siècle: Caleçons, costumes et slips," symposium *Cultures physiques & Cultures visuelles*, INHA, 2021 (https://journals. openedition.org/apparences/2682).

21

Brochard, *Sea-Air and Sea-Bathing*, 159.

22

Ibid., p. 160.

23

Dr. Auguste-Frédéric Dutrouleau, "De l'hygiène des bords de mer," *Gazette hebdomadaire de médecine et de chirurgie*, no. 22 (1862): 337.

24

Drouineau, *Des bains de mer*, 59.

25

Musée d'Art et d'Histoire, Lisieux.

26

Hamburger Kunsthalle, Hamburg.

27

Wallraf-Richartz Museum & Fondation Corboud, Cologne.

The local population is conspicuously absent from these scenes. Were local residents and their children unfamiliar with sea-bathing? Surely not: they would have been familiar with bathing, but unfamiliar with seaside resorts. There were two distinct communities, with summer vacationers on one side, and fishers and farmers on the other. And it is likely that the locals felt—at least at first—a certain bafflement as regards the new trend, not to mention the rules enforced by the bathing police that were intended to define areas reserved for men, women, or families, and which called for specific attire depending on the area in question.[20] These regulations must have provoked some astonishment, if not hilarity. Indeed, the custom among coastal residents was to swim nude and let children come and go on the beach as they wished, free of the bathing suits required of urban children. For the latter, and according to Dr. Brochard Senior, the most practical bathing suit comprised "a short pair of pantaloons, with a little blouse, fastened together by a strap at the waist … or the two garments may be made all in one piece. The materials should be composed of wool, thin, porous, and light. If the dress be made to button in front, children will be able to dress and undress themselves."[21] The doctor went on to attack, on the one hand, his colleagues who wanted to see the suit replaced by "simple drawers,"[22] and, on the other, the most radical of them all, Dr. Auguste-Frédéric Dutrouleau—the French Navy's first Chief Medical Officer—who was an outspoken proponent of reducing the bathing suit as much as possible, claiming that in reality "it should be possible to do without it."[23] In an attempt to end the growing debate, Dr. Drouineau concluded the following in 1869: "Useful or not, the swimsuit is an absolute necessity in our bathing establishments and we cannot avoid this rule of decency."[24]

These considerations obviously escaped the notice of the local population—though, in fact, they were never intended for them—whose children, from an early age, swam nude not only in the sea, but also in the nearby rivers. There is ample pictorial evidence of this widespread practice, which is also confirmed in postcards. Two paintings in particular represent opposing aesthetic choices. In 1851, Pierre Duval Le Camus painted *Trouville, les bains de mer* (Trouville, sea-bathing).[25] The main subject is a group of women fishers and their children gathered around baskets containing their catch. But on the right, several nude bathers are clearly visible, including children. They pay no attention to the vacationers, whose presence is indicated by the white canvas of their tents in the background. Thirty years or so later, Paul Gauguin made a small series of paintings featuring young Breton boys bathing. *Jeunes baigneurs bretons* (Young Breton bathers),[26] painted in Pont-Aven in the summer of 1888, and *Petit Breton nu* (*Breton Bather*),[27] carried out the following summer in Le Pouldu, were both painted en plein air and reflect Gauguin's quest for a "primitive" truth, which he perceived in the boys' nudity. Several years earlier, Renoir had also discovered the freedom of nude bodies, during a stay on Guernsey in late summer 1883. In his exchanges with his two art

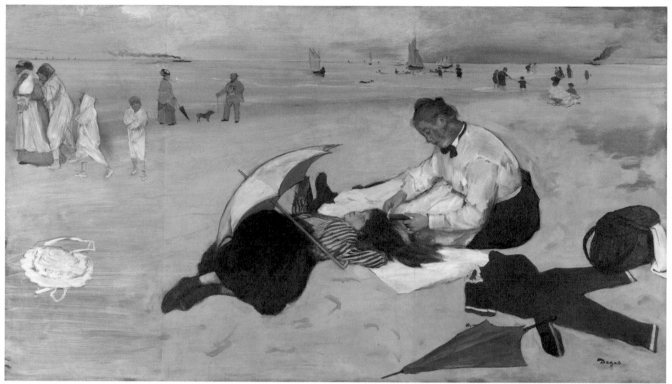

Fig. 124 Edgar Degas, *Petite fille peignée par sa bonne*, or *Scène de plage (Beach Scene)*, c. 1869–1870.
Oil on paper on canvas, 18½ × 32½ in. (47.5 × 82.9 cm). The National Gallery, London.

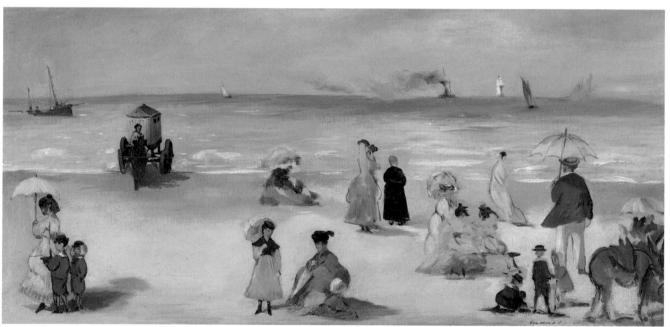

Fig. 125 Édouard Manet, *Sur la plage de Boulogne (On the Beach, Boulogne-sur-Mer)*, 1868.
Oil on canvas, 13 × 26 in. (32.4 × 66 cm). Virginia Museum of Fine Arts, Richmond.

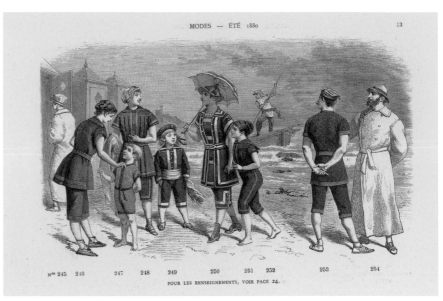

Fig. 126 Sales catalog for La Belle Jardinière, summer 1880.
Bibliothèque Forney/Ville de Paris, Paris.

28
Regarding this stay, see John
House, *Renoir in Guernsey,
1841–1919* (Guernsey: Guernsey
Museum and Gallery, 1988).

29
*Correspondance de Renoir et
Durand-Ruel, 1881–1906*, letters
gathered and annotated by Caroline
Durand-Ruel Godfroy (Lausanne:
La Bibliothèque des Arts, 1995), 40.

30
Ambroise Vollard, *Auguste Renoir
(1841–1919)* (Paris: Crès & Cie, 1919),
112.

31
The National Gallery, London.

32
Ny Carlsberg Glyptotek,
Copenhagen.

dealers, Paul Durand-Ruel and Ambroise Vollard, Renoir conveyed the enthusiasm he felt watching the spectacle of the bathers in the bay and on the beach at Moulin Huet.[28] On September 27, he wrote to Durand-Ruel, "Here we swim between the rocks that serve as changing cabins because there is nothing else. Nothing more beautiful than the mix of women and men squeezed together on those rocks."[29] To Vollard he wrote that "underwear is unheard of here for bathing," and that "none of the nice little 'misses' was offended by the idea of bathing next to a naked boy."[30] Renoir brought back several sketches from Guernsey, some of which, such as *La Baie de Moulin Huet, Guernesey (Moulin Huet Bay, Guernsey)*,[31] portray a natural coexistence between nude children and children in bathing suits, unlike what transpired on the Normandy coast. Certainly one of the most charming of these sketches is *Paysage de Guernesey avec baigneurs* (Guernsey landscape with bathers), showing a group of little girls wearing clothes walking among naked boys, some in the water, others sitting on the rocks.[32] Unfortunately, however, Renoir never produced a truly complete work from these sketches; this is all the more regrettable considering that he had shown an astonishing ability to flout the conventions of the male nude some fifteen years earlier, in a work from 1898, *Le Garçon au chat* (The boy with the cat; fig. 90). Rarely has a painter so skillfully rendered the transformations at work in the body of a young model on the threshold of puberty. Despite the fluid lines, these changes are evident in the contrast between the strength emanating from the muscular lower limbs and the gracefulness of the boy's still narrow torso.

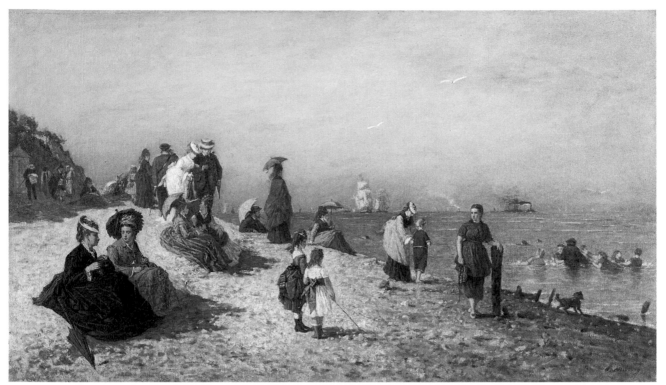

Fig. 127 Louis-Alexandre Dubourg, *Les Bains de mer à Honfleur* (Bathing at Honfleur), 1868.
Oil on canvas, 19½ × 34 in. (50 × 86 cm). Musée Eugène Boudin, Honfleur.

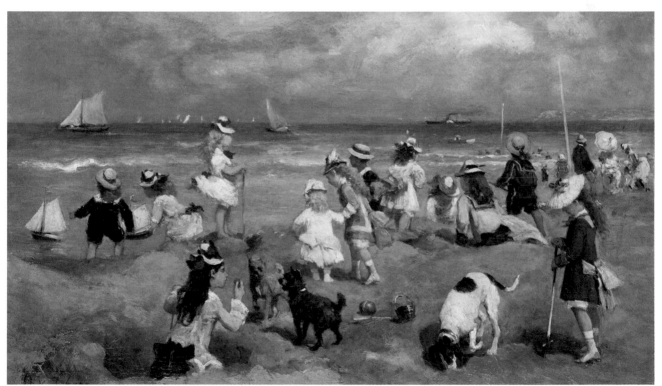

Fig. 128 Otto von Thoren, *Enfants jouant sur la plage de Trouville* (Children playing on the beach at Trouville), c. 1880.
Oil on wood, 12 × 20 in. (30 × 51 cm). Musée d'Orsay, Paris, on long-term loan to the Musée de Dieppe, Dieppe.

33
See her essay entitled "Posing Problems: Sargent's Model Children," in the catalog for the exhibition she curated: *Great Expectations: John Singer Sargent Painting Children*, exh. cat. (New York: Brooklyn Museum, 2004).

34
Sterling and Francine Clark Institute, Williamstown.

35
See Philippe Thiébaut, *Pudeur: De l'usage de la feuille de vigne* (Paris: La Table Ronde, 2014) and Sylvie Aubenas and Philippe Comar, *Cache-sexe: Le désaveu du sexe dans l'art* (Paris: La Martinière, 2014).

36
See Leila Krogh's text on this work in the exhibition catalog *Willumsen, 1863–1958, un artiste danois: Du symbolisme à l'expressionnisme* (Paris: Musée d'Orsay/RMN, 2006), 152–155.

37
Sammlung Hirschsprung, Copenhagen.

38
See Mette Harbo Lehmann, "Peder Severin Krøyer et la peinture de plein air danoise," in *L'Heure bleue de Peder Severin Krøyer*, exh. cat. (Paris: Musée Marmottan Monet/Hazan, 2021).

39
On Sorolla, see *Sorolla: Un peintre espagnol à Paris*, ed. Blanca Pons-Sorolla and Maria Lopez Fernandez, exh. cat. (Paris: Éditions El Viso, 2016).

As the French painters in question were turning their attention to what was happening on the beaches and at the seaside resorts on the coast where, in the name of decency, nudity was not permitted, other artists were working in more tolerant places. In the region around Naples, for example, there was nothing more natural for a child from the working classes than to swim nude in public, and perhaps to pose in exchange for a few coins. For this reason, many compositions that appear unplanned were almost certainly based on plein air sketches, but were ultimately reworked in the studio using studies painted after a model. Barbara Dayer Gallati has skillfully analyzed John Singer Sargent's use of this method.[33] Two studies of boys lying on the sand, made independently of one another, were used in 1879 for *Neapolitan Children Bathing*,[34] a painting that was highly praised by critics. In the study, the boy is lying on his back and his genitals are perfectly visible, but in the final composition, carried out in the studio, they are concealed by the head of another boy, who is lying nearby, sprawled on his belly. This is one of the many ruses that painters used to conceal male genitals.[35] Perhaps even more deceptive is the impression of immediacy in Danish painter Jens Ferdinand Willumsen's monumental painting *Sol og ungdom* (*Sun and Youth*; fig. 129). This youthful race toward the water, symbolizing a zest for life, which occupied the artist from 1902 to 1910, was actually the result of work carried out on beaches as far afield as Amalfi, Le Pouldu, and Skagen.[36] Willumsen began his work in Amalfi, Italy, where he stayed on two occasions, in 1902 and 1904. He carried out a number of sketches, and took many photographs of children running naked on the beach, before continuing on to Le Pouldu, in Brittany, in September 1904, where he studied the ocean's movements more specifically. Then, over the course of the following five summers, he worked in Skagen, Denmark, at Sønderstrand beach. There, he asked children and adolescents to replicate several poses from the photographs taken in Amalfi. The final work was largely made from memory, and based on visual experiences rooted in different times and in different places—a fact that tends to be forgotten, inasmuch as nude swimming is generally considered emblematic of Scandinavia. Indeed, the painter Peder Severin Krøyer, who died the same year that Willumsen finished his vitalist manifesto, returned to this theme many times. He produced a successful depiction in 1884, during a stay in Skagen: *Sommerdag ved Skagen Sønderstrand* (Summer day on Skagen's southern shore).[37] Krøyer also used photography, produced a large number of sketches, and used live models before refining his composition in the studio.[38] Krøyer's bathing sessions often take place in a vesperal, almost silent atmosphere—the famous golden hour—that contrasts with the turbulent ambience of works by the Spanish painter Joaquín Sorolla (fig. 130).[39] The latter were perhaps best described by an enthusiastic columnist for *Gil Blas* when they were presented at the Galerie Georges Petit in June and July of 1906: "His bathing scenes are extraordinarily lively and joyful. The salty, healthful air is palpable, and

40
Unsigned article published on
June 14, 1906.

41
Musée d'Orsay, Paris. See Françoise
Heilbrun and Philippe Néagu,
Pierre Bonnard photographe (Paris:
Philippe Sers/RMN, 1987).

the cries of adolescents splashing in the water audible."[40] The theme of nude children playing in the water under the beneficial rays of sunlight appears in a work that Sorolla painted during his first trip to Javea, in the province of Alicante, to which he returned in 1898 and 1900. In the following years, he also frequented Cabanyal beach in Valencia, where he continued to explore the topic. At the same time, it seemed the subject of children bathing was beginning to lose its spontaneity. A simple click of a Kodak could capture the fleeting sensations of a child's body playing in the water. Using his Kodak, Bonnard captured his nephews Charles, Jean, and Robert Terrasse bathing during the years 1899–1905 on the family estate in Grand-Lemps, in photos that, even today, thrum with life and the authentic joy of a timeless pleasure.[41]

Fig. 129 Jens Ferdinand Willumsen, *Sol og ungdom* (*Sun and Youth*), 1910.
Oil on canvas, 8 ft. 9 in. × 14 ft. (2.66 × 4.27 m). Göteborgs Konstmuseum, Göteborg.

Fig. 130 Joaquín Sorolla,
Sobre la arena, Playa de Zarauz
(*On the Sand, Zarauz Beach*), 1910.
Oil on canvas, 3 ft. 3 in. × 4 ft. 1 in.
(99 × 125 cm).
Museo Sorolla, Madrid.

Below:
Fig.131 Rineke Dijkstra,
*Maddy, Martha's Vineyard, MA,
USA, August 5, 2015,* 2015.
Ink-jet print, edition 3/15,
15 × 12 in. (38 × 30 cm).
Artist's collection.

Facing page:
Fig.132 Winslow Homer,
Beach Scene, c. 1869.
Oil on canvas mounted
on cardboard, 11½ × 9½ in.
(29.3 × 24 cm).
Carmen Thyssen-Bornemisza
Collection, on long-term loan
to the Museo Nacional
Thyssen-Bornemisza, Madrid.

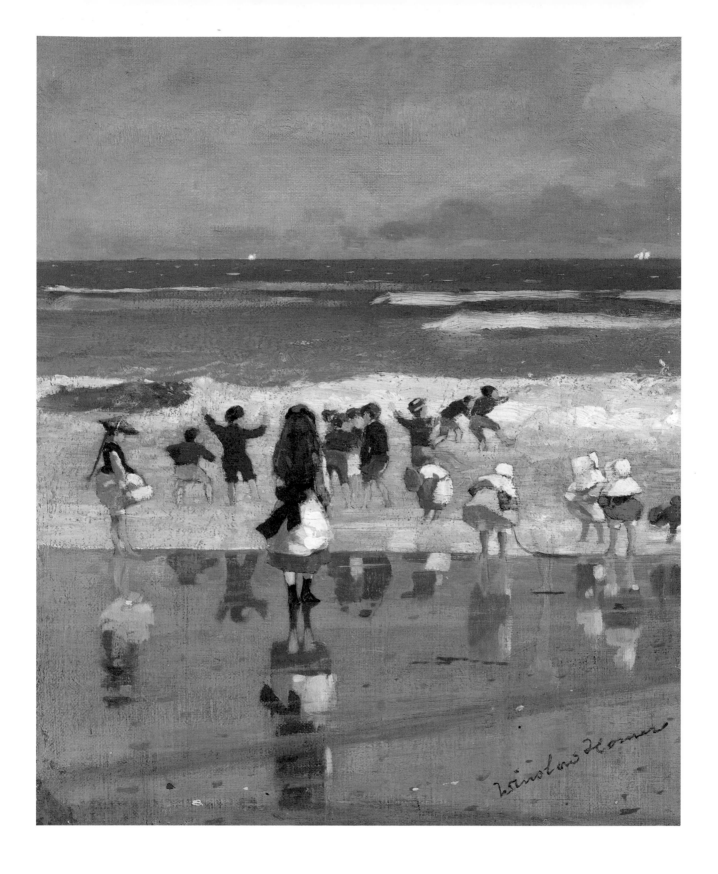

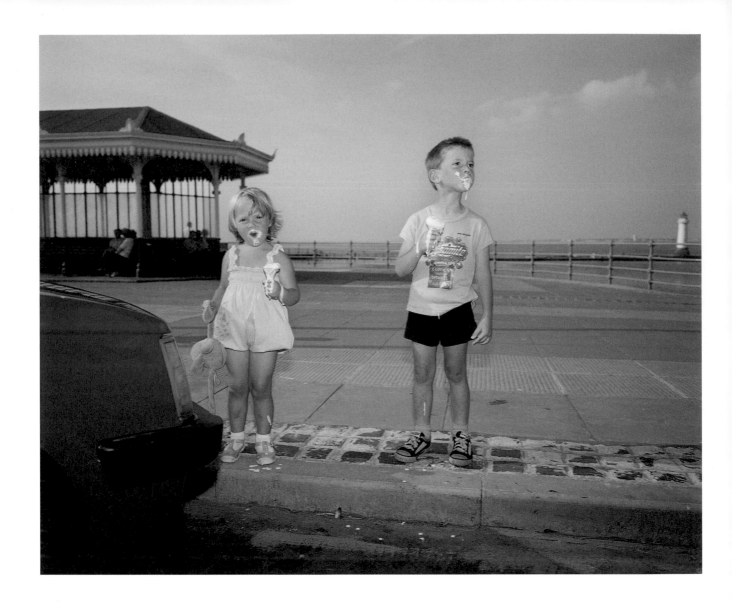

Above:
Fig.133 Martin Parr, Untitled, from the series *The Last Resort*, 1984–1985.
Color photograph, 12 × 16 in. (30 × 40 cm).
Frac Provence-Alpes-Côte d'Azur Collection, Marseille.

Facing page:
Fig.134 John Russell, *The Painter's Sons Playing with a Crab*, 1904–1906.
Oil on canvas, 26 × 26 in. (65.8 × 65.8 cm).
Musée d'Orsay, Paris, on long-term loan to the Musée de Morlaix, Morlaix.

The Australian painter John Russell fell under the spell of Belle-Île in 1886 and moved there two years later with his wife, Marianna. They raised their six children on the Breton island: a daughter (Jeanne) and five boys (Sandro, Cedric, Harald, Siward, and Lionel). Here, Russell has painted three of his sons, perhaps the youngest, who would have been between six and thirteen years old.

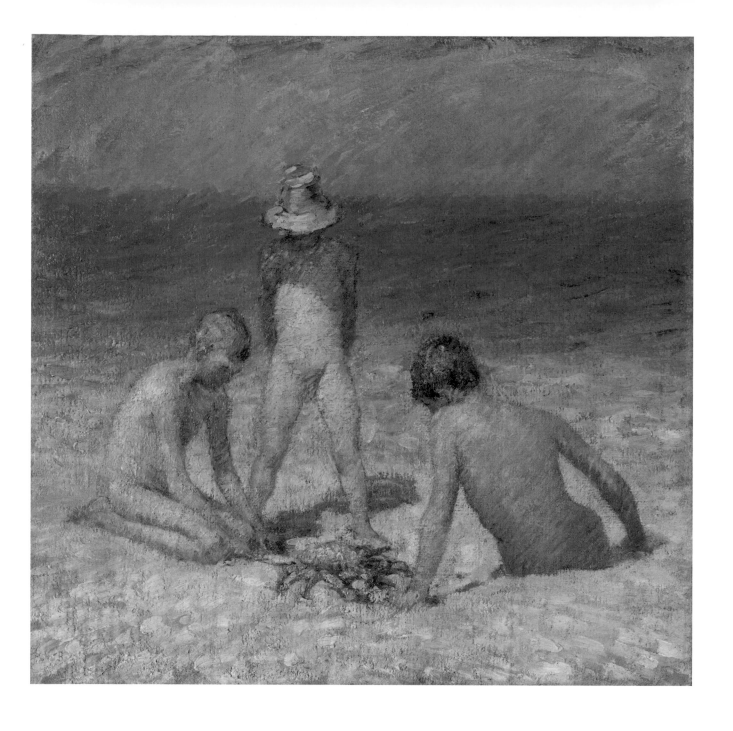

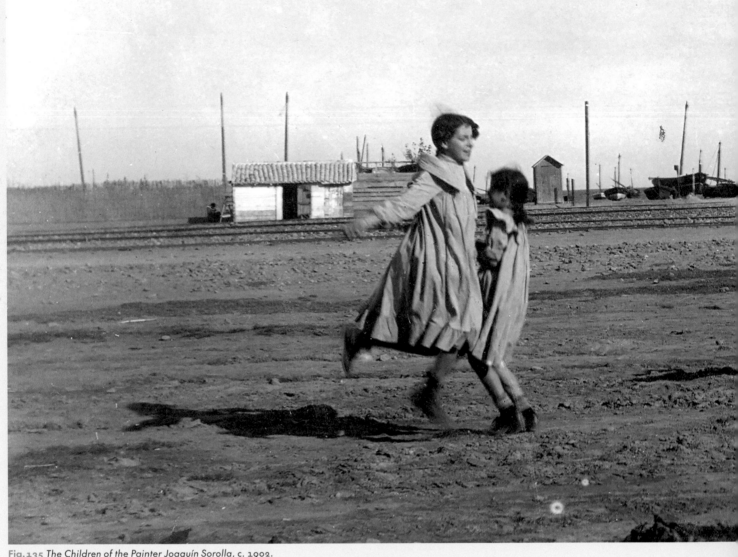

Fig. 135 *The Children of the Painter Joaquín Sorolla*, c. 1902.
Museo Sorolla, Madrid.

These young devils are a vexing matter for us.

Claude Monet to Alice Hoschedé, October 26, 1886

ADOLESCENCE

1
Nikolai Nekrasov, writer, poet, and editor in chief of *Le Contemporain* literary magazine, January 16, 1855.

Throughout the nineteenth century, following the publication of Jean-Jacques Rousseau's *The Confessions* in 1782, introspection and soul-searching developed significantly among young adults. Recollections, memoirs, and other intimate accounts by female and male authors alike offered audiences, often posthumously, a glimpse into a facet of their private lives that had never been revealed before. The tumult of their adolescent years was brought to light, especially by the romantic generation, in the works of authors such as François-René de Chateaubriand in his *Mémoires d'outre-tombe* (*Memoirs from Beyond the Grave*; 1848) and Alfred de Vigny's *Servitude et grandeur militaires* (*The Military Necessity*; 1835). During the impressionist period, other accounts appeared in France and abroad: in 1854, Leo Tolstoy published the second volume of his memoirs, *Boyhood*. This classic of nineteenth-century Russian literature had a significant impact. Critics at the time praised a work "full of poetry and originality, and artfully executed."[1] Sometime later, in 1875, his great rival, Fyodor Dostoyevsky, published *The Adolescent*, his next-to-last novel. In it, the protagonist recounts memories of his youth and offers a realist's account of society, but also of the relationship between a father and his son. In a series of striking scenes, Dostoyevsky addresses the themes of money, social unrest, religion, and the difficulty of building one's future.

In fact, when it comes to the subject of childhood and adolescence, painting and literature shared similar concerns. In Jules Vallès's famous trilogy—*L'Enfant* (*The Child*), *Le Bachelier* (*The Graduate*), *L'Insurgé* (*The Insurgent*)—the writer condemns social injustice. *The Graduate*, published in 1881, is known for its dedication: "To those who, fed on Greek and Latin, died of hunger." Vallès clearly identified the limits of what public education could accomplish in the face of rigid social stratification. Culture does not fill bellies. This critical observation was made just as the Jules Ferry Laws were passed in the early 1880s, making education secular, free, and mandatory. The impressionists also grappled with this period of adolescent doubt, which was the subject of study and narrative reflection in their day.

Adolescence: The Dream of Possibilities

Cyrille Sciama

2
Camille Pissarro to Lucien Pissarro,
Éragny, March 5, 1891,
in *Correspondance de Camille
Pissarro*, vol. 3, *1891–1894*,
ed. Janine Bailly-Herzberg (Paris:
Éditions du Valhermeil, 1988), 41.

3
Mallarmé's sobriquet for Julie,
and Jeannie and Paule Gobillard,
quoted in Julie Manet, *Journal,
1893–1899* (Paris: Scala, 1987), 147.

4
Claude Monet to Alice Hoschedé,
Kervilahouen, October 26, 1886,
in Daniel Wildenstein, *Claude
Monet: Biographie et catalogue
raisonné*, vol. 2, *1882–1886:
Peintures* (Lausanne and Paris:
La Bibliothèque des Arts, 1979), 283.

Fraternity, Sorority

Gauguin fathered five children; Monet led a blended family of eight children. The Pissarro family included five sons and two daughters, the first of whom died at the age of nine (a third daughter, born in 1870, lived for only a few weeks). The transition to adolescence provoked many unique situations that each family had to manage. Relationships between siblings could sometimes be very fraught. Camille Pissarro recounts the quarrels that sometimes erupted between Georges, nineteen, and Félix, sixteen: "The children are doing well at the moment, except for the arguments between these two big idiots who can't seem to avoid making scenes again!"[2] For some young women, the vagaries of fate led to sisterly bonds, "a band of girls," a female clan with ties that withstood any tragedy. Julie Manet, the only child of Berthe Morisot and Eugène Manet, was orphaned at the tender age of sixteen, but she would soon form the "flying squadron" with her Gobillard cousins,[3] while she found a trio of kind-hearted guardians in Stéphane Mallarmé, Pierre-Auguste Renoir, and her cousin Gabriel Thomas. Her home, an hôtel particulier on Rue de Villejust, in Paris, remained a refuge, even after she married Ernest Rouart. Julie Manet, who was a well-educated and independent adolescent with a comfortable financial situation, had modeled for her mother, but also for Renoir and Degas. The works presented here illustrate both her beauty and her independent nature—the singular personality of an exceptional human being. She is depicted drawing, in *La Leçon de dessin (Berthe Morisot et sa fille, Julie Manet)* (*The Drawing Lesson [Berthe Morisot and Her Daughter, Julie Manet]*; 1889, fig. 142), or daydreaming in *Sur un banc au bois de Boulogne* (On a bench in the Bois de Boulogne; 1894, fig. 136), or gathering cherries in *Le Cerisier* (*The Cherry Tree*; 1891, fig. 99); she is the archetype of the young woman whose future holds infinite possibilities. One of Morisot's most famous portraits of Julie, *Julie rêveuse* (Julie daydreaming; 1894, private collection), reveals the attitude of adolescent girls, caught up in their insouciance and their worries. But if she knew her strength and could confidently imagine her life to come, it was also thanks to her extensive cultural education, imparted to her by her parents, and by the extraordinary familial and artistic circles she moved in. Culture was a vehicle for values that enabled these sometimes-confused adolescents to find their way through life.

Reading, Daydreaming

Thinking about their futures, giving free rein to their imaginations as they considered future professions, and encouraging them to experiment, the impressionist parents were preoccupied with their adolescent children. Renoir, Monet, and Pissarro all shared the same concerns. At times, the angry or scolding parent came out. In 1886, during his stay on Belle-Île-en-Mer, Monet wrote to Alice Hoschedé regarding his sons Jean, nineteen, and Jacques Hoschedé, seventeen, "These young devils are a vexing matter for us; we must be energetic and not let them fall into this habit of idleness."[4]

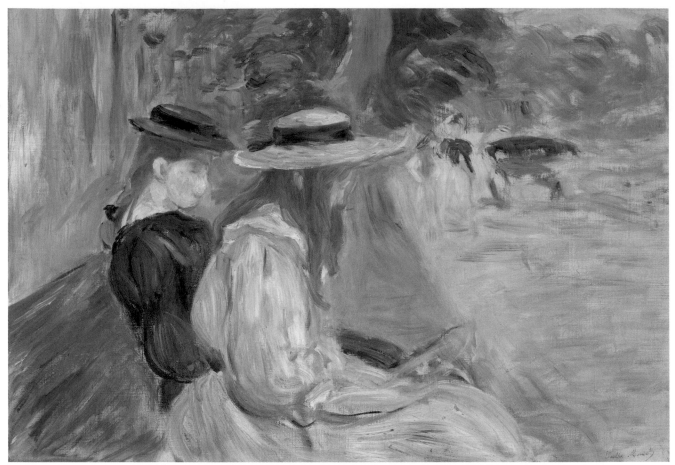

Fig. 136 Berthe Morisot, *Sur un banc au bois de Boulogne* (On a bench in the Bois de Boulogne), 1894.
Oil on canvas, 15 × 22 in. (38.2 × 55.3 cm). Musée d'Orsay, Paris.
Julie Manet poses next to her cousin Jeannie Gobillard, who is still mourning the death of her mother,
Yves, Berthe Morisot's older sister; she died the previous year.

5
Jean Renoir, *Renoir: My Father*
(Boston: Little, Brown, 1962), 425.

Jean Renoir recounts the total freedom he enjoyed while searching for his own path:

> During my parents' stay in these places [Grasse (Magagnosc), Le Cannet, Nice] I was mostly away at school and my recollections of them are therefore somewhat vague. Not that my school years were not interspersed with frequent visits home. I would get fed up from time to time and run away. I would arrive home, hungry and dirty, as I had come the whole way on foot. My mother would shrug her shoulders. My father concluded that I was destined for manual rather than for intellectual work. And he speculated on what a person with a nature like mine could do to earn a living. He saw me as a blacksmith, a musician—my mother had made me learn to play the piano—a dentist, carpenter, game warden, nurseryman. He was against my going into commerce "for which you have to have a special talent," and also plumbing, because he was afraid the soldering lamp might explode.[5]

Occasionally, artists capture private moments that should never have been revealed to the public. These are stolen instants, spaces of modesty exposed, a model's own way of holding their body that is not meant to be

6
Camille Pissarro to Lucien Pissarro,
Éragny, September 28, 1893,
in *Correspondance de Camille
Pissarro*, vol. 3, ed. Bailly-Herzberg,
48.

depicted. Federico Zandomeneghi gracefully translates a moment like this in *Fanciulla dormiente (A letto)* (*In Bed [Sleeping Girl]*); fig. 146), painted in 1878. The Italian painter, who belonged to the Macchiaioli movement, which looked to nature for inspiration, had been living in Paris for four years. He was friends with Monet, Renoir, Pissarro, and especially Degas, whose work influenced Zandomeneghi's choice of subjects. An outstanding pastel artist, the Italian presented work in four of the impressionist exhibitions. Lying in a bedroom, her face turned away from the viewer, the young woman appears to be asleep, her hair spread out on the pillow. She eludes any easy social categorization. The decor is carefully rendered, with floral wallpaper that matches the blue bedspread. The immaculate white sheet, bordering on abstraction, evokes the model's youthful age. To present-day viewers, the scene's ambiguous quality is thought-provoking and generates a certain unease. Zandomeneghi continued to explore the ambiguous period of adolescence throughout his life. In *La lezione* (The lesson; fig. 148), from 1902, his talent as a pastel artist comes to the fore in the way he renders texture in the girls' clothing, as well as in the thickness of their hair and the contours of the poses they lean into during the lesson. We do not know the subject (perhaps reading, or something else), but concentration can be read in the young women's postures: the one on the left appears to be correcting the one on the right, whose face is entirely hidden. We remain unaware of the figures' inner lives, which conveys a message about dreams and the possibilities of the young models' state of mind.

A Bold Age

Being an impressionist painter and having to dispense advice regarding education to his seven children, as Camille Pissarro did, was doubtless no easy task. It required him to encourage without flattering, to open up horizons without feeding illusions, and to provide guidance without being authoritarian. Pissarro's rich correspondence with his children gives us a glimpse into his method, as well as his apprehension regarding the world that was opening up before them. In 1893, Pissarro wrote to his son Lucien, older brother to Georges and Félix, to complain:

> Your mother wants me to take the boys to [Paris] and I don't have the money. It's really very annoying. These boys really are stupid, they don't want to give an inch; they play more than they work. It makes their mother angry and [she] reproaches me for not placing them in Paris in whatever trade, as long as they earn enough to feed themselves. You know the story!... What kind of work should they do? What position could we find them, no one would want them, and they have other ideas in mind. It grieves me much.[6]

Such were the preoccupations of parents facing the foolhardiness of youth and the fear of the future. Regarding Ludovic-Rodolphe, aged nineteen, who had just arrived in London and wanted his independence, Camille wrote the following to Lucien from Rouen on August 12, 1898:

> More often than not, far from preventing trouble, constraint throws you into worse trouble. Preventing a young man from following

7
Correspondance de Camille Pissarro, vol. 4, *1895–1898*, ed. Janine Bailly-Herzberg (Paris: Éditions du Valhermeil, 1989), 502–503.

8
Maria Tuke Sainsbury, *Henry Scott Tuke, R.A., R.W.S.: A Memoir* (London: Martin Secker, 1933), 81, quoted in *Henry Scott Tuke*, ed. Cicely Robinson (New Haven: Yale University Press, 2021), 43.

his passions is almost impossible.... Do you think that education and examples prevent anything at all? Look what happens in every society; here, as well as in any other country, young people are all the same.... In short, we have only one weapon: our own judgment. When I think that, as a young man, I found myself, like everyone else, left to my own devices in a foreign country—free, absolutely free—and that I had the good fortune not to encounter an unfavorable destiny, I wonder just what the right advice to give should be. I don't see anything other than judgment and a healthy wariness and even then! I am waiting for news from Rodolphe the grouch.

Pissarro goes on to explain what he believes kept him from erring in his own youth: "The author of these words had a powerful diversion: art!"[7]

In a series of portraits, one can also discern the models' confidence; their determination in facing a life that they are in the process of navigating in a decisive manner. The English painter Henry Scott Tuke stands out in this regard, with enigmatic full-frontal portraits of young men. Jack Rolling, the "lovable young barbarian"[8] from Falmouth (fig. 138), and William J. Martin, dressed in a telegram delivery boy's uniform (fig. 137), both call out to the viewer with their vital spark, their combination of impudence and doubt, their gazes slightly lost and yet proud at the same time. The photographic quality of certain impressionist works explains their kinship with a group of contemporary photographers. Laurence Reynaert uses the same hypnotic frontality in a series of black-and-white portraits of adolescents (2000–2003, figs. 9, 10, 15, 16, 51, 63, 119, 144); her subjects face the viewer head-on in minimalist settings. A few articles of clothing provide the only clues to social background or geographic context. Rineke Dijkstra also offers a portrait of a somewhat clumsy youth, caught in the grip of doubt under the adult gaze. Whether they are on the beach, or in a garden or park, the adolescents she photographs remain both fragile and bold, embodying the paradoxical affirmation of their lively youth. Elaine Constantine is also interested in this boldness, especially in *Girls on Bikes* (1997, fig. 152): a vibrant tribute to the joy and freedom experienced by British teenagers. The way young adults move is—as a theme—also suited to cinematic explorations. Forging unexpected ties with impressionism, Ange Leccia offers a very personal vision of adolescence. The filmmaker depicts youth beset by doubt, searching for a still elusive happiness. The young models he films are people from his entourage, often friends of his daughter, like *Laure*, a girl he followed for many years, documenting how she changed. Leccia's approach is well suited to this bumpy period between the end of childhood and the beginning of adult life. His works resonate with the writings of major psychoanalysts specialized in adolescence. Smoke, fog, and explosions, as well as clouds, blue skies, dazzling sunlight, fulfillment, tenderness, and melancholy collide in *Au film du temps* (*As Film Goes By*; 2022). In *Laure* (1998, fig. 7), the young woman's face is filmed through the window of a ferry. The waves are reflected on her features, imparting a timeless charm to this moment of suspension.

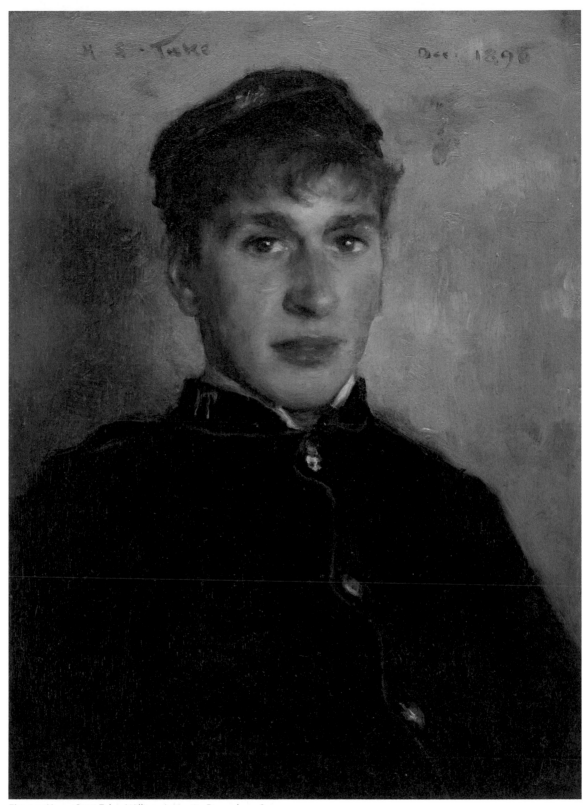

Fig. 137 Henry Scott Tuke, *William J. Martin*, December 1890.
Oil on mahogany panel, 14 × 10 in. (36 × 26 cm).
Royal Cornwall Polytechnic Society Collection, Falmouth Art Gallery, Falmouth.
William J. Martin posed several times for Henry Scott Tuke. The red piping on his uniform
and the gilded "T" on his collar indicate that he delivered telegrams for the British postal service.

Henry Scott Tuke

1858–1929

Portrait of Jack Rolling

1888

Oil on board
11¾ × 9½ in. (30 × 23.6 cm)
Royal Cornwall Polytechnic
Society Collection,
Falmouth Art Gallery, Falmouth

Captured here on the cusp of adulthood, Jack Rolling was an adolescent from Falmouth who regularly posed for Henry Scott Tuke, just like William J. Martin (**fig. 137**). The tight framing and neutral background bring out the expression in his eyes, his disheveled air, and a complexion flushed by a life lived outdoors. Maria Tuke Sainsbury, the painter's sister, described the young man as a "lovable young barbarian… who grew a little more civilised in the years he was with Harry."

Tuke studied at the Slade School of Art from 1875 to 1880, where he attended Alphonse Legros's printmaking class. He perfected his training in Florence, then in Paris with Jean-Paul Laurens, and shared a studio with Jacques Émile Blanche, whose father, like his own, was a renowned psychiatrist. In the fall of 1883, he stayed at the Newlyn artist colony, the "English Concarneau." In 1885, he settled in Falmouth, a major fishing port in Cornwall, where he had spent part of his childhood. A keen sailor and artist, he owned a flotilla of small boats, some of which he converted into floating studios. Although a student of academic painting, Tuke was also open to naturalism and impressionism, and he was as at home in the salons of London as he was on the docks in Cornwall. Tuke met with huge critical and commercial success during his lifetime. From 1879 to 1929, he exhibited nearly every year at the Royal Academy, and became a member in 1914. For British audiences, his seascapes, nautical scenes, and nude adolescents in the open air embodied a certain innocence and idealized vitality connected to the country's naval history and were a source of national pride. More recently, these scenes of seafaring, masculine comradery and young nude men painted outdoors, by the water's edge, in the sunlight, have been interpreted as sublimated images of homosexual desire.

M. D.

1
Maria Tuke Sainsbury, *Henry Scott Tuke, R.A., R.W.S.: A Memoir* (London: Martin Secker, 1933), 81, quoted in *Henry Scott Tuke*, ed. Robinson, 43.

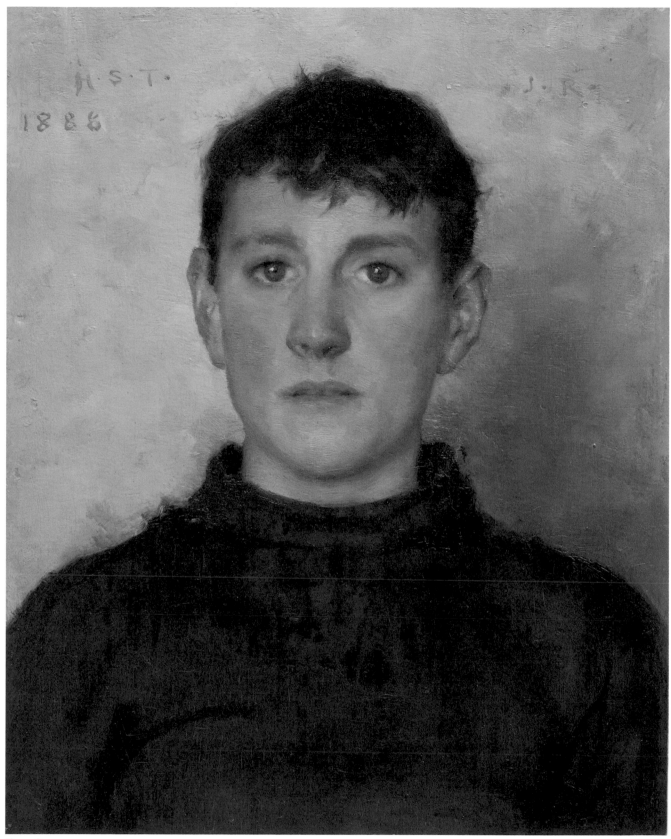

Fig.138

Fig. 139 Berthe Morisot,
La Petite Niçoise
(*The Little Girl from Nice*), 1889.
Oil on canvas, 24½ × 20½ in.
(62.8 × 52.5 cm).
Musée des Beaux-Arts, Lyon.

Morisot stayed in Nice with her
family from the fall of 1888 to the
spring of 1889. It was her second
visit to the region. The young girl
depicted here is Célestine Gigoux,
the daughter of friends, wearing
peasant attire and her hair down,
giving her the appearance of "an
untamed brunette," as Julie Manet
wrote in her *Journal*.

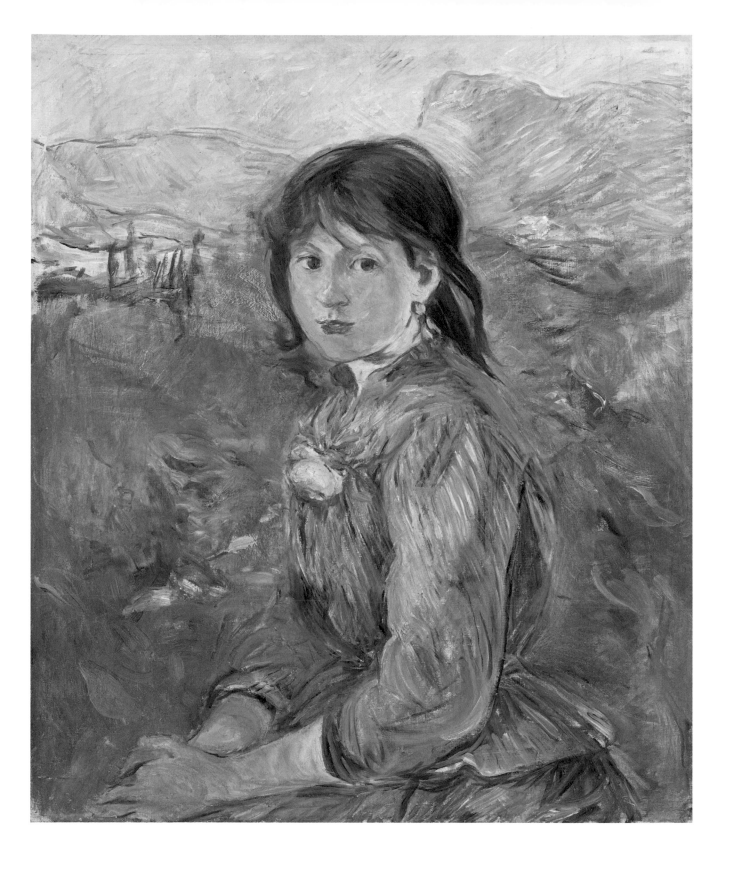

Julie Manet: The Darling of Impressionism

In Berthe Morisot's last letter to her daughter, Julie Manet, from March 2, 1895, she wrote:

My dearest Julie,
I love you as I lie dying; I shall still love you when I am dead. I beg of you, do not cry; this parting was inevitable. I would have liked to be with you until you married – Work hard and be good as you have always been; you have never caused me a moment's sorrow in your little life. You have beauty, money; make good use of them. I think the best thing would be for you to live with your cousins in the Rue de Villejust, but I do not wish to force you to do anything. Give a memento of me to your aunt Edma, and to your cousins too; and give Monet's *Bateaux en réparation* to your cousin Gabriel. Tell Monsieur Degas that if he founds his museum he is to choose a Manet. A keepsake for Monet; one for Renoir, and one of my drawings for Bartholomé. Give something to the two concierges. Do not cry, I love you even more when you are cheerful. All my love.
Jeannie, take care of Julie.[1]

Berthe Morisot's words had the force of law. The artist suggested that her only daughter, Julie, and her cousins, Paule and Jeannie Gobillard—all three of them orphans—should live together, and from then on, nothing could ever separate them. Everyone followed Morisot's last wishes, starting with her family: cousin Gabriel Thomas was officially tasked with managing Julie's estate, along with the artist's last living sister, Edma Pontillon, known as Aunt Edma, who had been Morisot's muse for her first masterpieces.[2] Others rallied around the young women: Stéphane Mallarmé, Pierre-Auguste Renoir, and Edgar Degas became their protectors, even more so than Claude Monet. They had known the cousins forever; they had watched them grow up and transition from children to teenagers, Julie in particular. They watched over the orphans, until it came time to pass that responsibility on to others. In doing so they stood in for their dear departed friend and ensured that one of her goals was accomplished: to guide the girls safely until they got married.

Fig. 140 *Julie Manet and Laërtes, Paris,* 1893. Private collection.

It all began at 9 Avenue d'Eylau, in the sixteenth arrondissement of Paris, in the apartment that Berthe Morisot and her husband, Eugène Manet, started to rent soon after their marriage in December 1874. In late 1876, their tranquil life was disturbed. The artist's sister, Yves—who was pregnant at the time and whose husband had just been institutionalized—found refuge in their home. She was accompanied by her two older children: Paule, aged nine, and five-year-old Marcel. Paule—one of the girls who had posed several years earlier for some of Morisot's seminal works[3]—soon enrolled at the École de la Légion d'Honneur, while her brother stayed with his mother. The little boy posed for Berthe (**fig. 162**), but only occasionally; he wore her out.[4] This was not true of his younger sister, Jeannie, who was born on January 16, 1877, in the apartment on Avenue d'Eylau. Morisot made several pastels of the girl and often had her pose with her only daughter, Julie, who was born almost two years later, on November 14, 1878.

Unpublished letters reveal that Miss Manet's first name was a subject of debate. Would it be Rose or Julie? Soon after her birth, Eugène, her father, wrote to one of his nieces: "My dear Jeanne, Rose Manet has finally arrived; she already has hair, and small, very bright eyes, and came into the world wriggling her arms and legs like a little frog. If Aunty is happy, it's because she hopes that she will look like you, but for the moment everyone says she looks like Uncle

Eugène."[5] Yet, on November 17, 1878, he recorded on her birth certificate the arrival of Julie Eugénie Manet, named, on the one hand, in tribute to Jules de Jouy, a close paternal cousin who had no children, and on the other for Eugénie Fournier-Manet, the child's grandmother. Jules and Eugénie were chosen to be Julie's godparents, strengthening their ties with the newborn. This was all part of a long-term plan. To her nieces, who had preferred the name Rose, Aunt Berthe said, "If you don't like the name Julie, you can call your little cousin Juliette."[6] To their mother, she continued, "It's flattery intended for the good cousin, which, I hope, will earn the dear girl a pretty penny one day."[7]

In this way, Julie's financial security was guaranteed from birth; her future fortune would come mostly from her godparents' inheritances. Berthe and Eugène wanted it that way. Morisot hoped to protect Julie from the loss of social position that she herself so feared—rightly or wrongly. She speaks of it in her letters to her sister Edma. Referring to her niece Jeanne, she asserts, "I am in favor of an elegant boarding school, where she's able to create useful relationships and not have too many contacts with democracy. I've always regretted not having gone to some convent; it seems to me that I would have made my way in the world by now, and I'd be someone, instead of a zero. But, after all, perhaps that's just another illusion."[8]

Morisot placed the highest importance on Julie's education. No doubt forgetting her own words

to her sister, she dismissed boarding school in favor of home tutoring. Morisot did not envisage separation. On the contrary, mother and daughter appeared to be as one. When Berthe painted, Julie posed. Julie was to Morisot what the water lilies would be to Monet: a reason for painting.

A founding member of the impressionists, Morisot was prevented by virtue of her gender and social status from meeting her peers in cafés or going to dance halls. She was excluded from an entire facet of their social life. But that would not stop her; instead, Morisot opened the doors of her salon and received her contemporaries in her home. Growing up with her mother, Julie had frequent contact with the Thursday regulars: painters and writers who had since become famous. They witnessed the little girl grow up over the years, developing an affection for her, and she naturally became one of their models. Besides her uncle, who immortalized her at fifteen months old (1880, private collection), then at three years old (1882, private collection), Mary Cassatt revealed her intention to paint mother and daughter. In 1882, Eugène Manet told his wife, "Yesterday at the exhibition I met Miss Cassatt, who seemed to want to develop closer relations. She asked to paint a portrait of you and Bibi. I said yes willingly, subject to the favor being returned."[9]

Edgar Degas, a very close friend, undertook a portrait of both parents and their child:

Tuesday evening,
Dear Madame,
Your excellent husband eludes me for Thursday. Tomorrow, Wednesday, I was to come to see you, in a way for him. For I want to put him in your place in the portrait, and it would have been very good for me to draw a little of his proportions in relation to his daughter first. Please give me leave, and believe in my insufferable friendship.[10]

None of these projects ever materialized; a few of Degas's preparatory sketches could probably be located.[11] To date, there is only one known photo of the family, taken in the garden at Bougival (fig. 4)—a meager treasure. Among the other lost images of Julie is a pastel by Armand Guillaumin.[12] Of all Morisot's peers, Renoir painted the most and the best-known portraits of Julie. Morisot's initial encounter and ensuing friendship with Renoir have been sufficiently documented elsewhere. With a shared interest in painting figures, producing a refined art that was skillfully studied and prepared,[13] they got along well. It should come as no surprise, then, that Berthe and her husband commissioned a portrait of Julie from Renoir—or would it be more appropriate to say the portrait of Julie (fig. 89)? Renoir's mission was to produce the official portrait of Mademoiselle Julie Manet and to depict not only her facial features, but her temperament, or even

something greater: her deepest nature. Whereas Morisot used the child's everyday life as a pretext to "record something of what is happening,"[14] to capture the moment and reproduce a fleeting vision (fig. 59), Renoir attempted something entirely different. He was responsible for portraying what no one can perceive in the space of a glance: to paint her entire being.

For this ambitious project, he asked Julie to pose at her home on Rue de Villejust; the interior and furnishings are recognizable from the flowery wallpaper,[15] and the Empire sofa inherited from the Morisot grandparents.[16] The familiar and the spontaneous stop there. Although pets were part of the decor at the apartment on Rue de Villejust, and scampered from canvas to canvas (they included Gamin, the bichon, a regular model in the years 1885–1886, and Colette, the greyhound that appears in several works produced by Morisot in Mézy), Renoir disregarded this tradition. In Julie's arms, he placed a cat that no one—until that day anyhow—had ever set eyes on. Did he choose the animal, as his preparatory studies seem to suggest,[17] for purely pictorial reasons,[18] accentuating the resemblance between the model and her companion for the day, transcribing in painting Morisot's description of her child in one of her letters: "[Julie is] like a little cat, always in a good mood. She is round as a ball with eyes that shine and a large mouth that's always pulling faces"?[19]

The portrait of a porcelain-complexioned Julie Manet

illustrates the happiness of early childhood, the contentment of a treasured and nurtured child who, once an adult, would draw strength from the memory of these foundational years to forge her own future. Her personal, unique friendship with Renoir began then. She learned to draw with her mother (fig. 142) and was encouraged by her portraitist. He always had a kind word for "his little friend,"[20] or "the excellent friend Julie,"[21] whom he saw as a "nice little future competitor,"[22] as of 1888. The apple never falls far from the tree.

In addition to Julie's connection with Renoir, another close relationship formed, again before she turned ten. In 1888, Eugène and Berthe Manet named Stéphane Mallarmé as their daughter's guardian in their wills. The mission involved verifying the accuracy and soundness of the management of the minor's interests, should the need arise. Mallarmé, whose friendship with Édouard Manet was as deep as it was with Berthe Morisot, thought of Julie as his own daughter. There was no need for misfortune to bring them together. His *pupille* (ward), as he called her in his letters, was an integral and permanent part of his family, and the feeling was mutual.[23]

Just like the model in *La Petite Niçoise* (*The Little Girl from Nice*; fig. 139), Julie and her cousins Paule, now a painter, and Jeannie, a pianist, posed for many paintings of girls in the full bloom of youth. Julie and Jeannie were muses for one of Morisot's most ambitious

compositions: *Le Cerisier* (*The Cherry Tree*; **fig. 99**). However, although she had been a model since birth, Julie never posed nude. In 1891, her mother turned to a little village girl in Mézy, Gabrielle Dufour, to pose for her *Bergère nue couchée* (*Reclining Nude Shepherdess*; **fig. 98**).

None of the cousins let their sadness, or anything else, show after losing loved ones. Julie poses in black after the death of her father, Eugène, in 1892 (**fig. 141**). Jeannie, who appears by her side in the composition *Sur un banc au bois de Boulogne* (On a bench in the Bois de Boulogne; **fig. 136**) is in mourning for her mother, Yves, who died in 1893. Berthe Morisot's death on March 2, 1895, marked a turning point. As mentioned in the introduction, and as detailed in other publications,[24] the impressionist's last wishes were respected to the letter. What is striking about Morisot's death is undoubtedly the power of love: a love of art that bound a group to the point of forming a family, shattering the last barriers of class.[25]
Marianne Mathieu

1
Translation based on those in Jean-Dominique Rey, *Berthe Morisot* (Paris: Flammarion, 2010), 217; and *Growing Up with the Impressionists: The Diary of Julie Manet*, ed. and trans. Jane Roberts (London/New York: I.B. Tauris & Co. Ltd., 2017). It also includes slight changes made by the author of this text to the transcription published in Rey's book, following her consultation of Berthe Morisot's original last letter, notably the following (differences are indicated with italics): "Tell M. Degas that if he founds a museum he is to choose a Manet. A keepsake for Monet; one for Renoir, and one of my drawings for Bartholomé. Give something to the two concierges. Do not cry, I love you *more than I can tell you*." For a reproduction of the original letter, see Rey, *Berthe Morisot*, 216–217.

2
For example, Berthe Morisot, *Le Berceau* (*The Cradle*), 1872, Musée d'Orsay, Paris.

3
Including Berthe Morisot, *Sur le balcon* (*Woman and Child on the Balcony*), 1871–1872, Musée Artizon, Tokyo.

4
"I don't have the strength to put up with Marcel my entire life. I can't tell you how much that child tires me and for nothing in return." Berthe Morisot to Edma Pontillon, n.d. [1878–early 1879], private collection, YR34.

5
Unpublished letter from Eugène Manet to Jeanne Pontillon, n.d. [c. November 14–16, 1878], private collection, YR42.

6
Unpublished letter from Berthe Morisot to Edma Pontillon, Tuesday morning [1878–early 1879], private collection, YR33.

7
Berthe Morisot to Edma Pontillon, Tuesday morning [1878–early 1879], private collection, YR33.

8
Berthe Morisot to Edma Pontillon, n.d. [1878–early 1879], private collection, YR31.

9
Eugène Manet to Berthe Morisot, Tuesday evening [1882], private collection, YR44.

10
Edgar Degas to Berthe Morisot, n.d., Musée Marmottan Monet, Paris, inv. D.4-1986.2013.232.

11
Julie Manet: La Mémoire impressionniste, ed. Marianne Mathieu, exh. cat. (Paris: Hazan, 2021).

12
Listed in "Toiles remisées dans la chambre louée chez Jennings 1886" (Canvases stored in the room rented at Jennings' 1886), Musée Marmottan Monet, Paris, inv. D.4-1986.2013.727.

13
"It would be strange to show all these studies done in preparation for a painting to a public who tend to imagine that impressionists work with the greatest nonchalance." Excerpt from Berthe Morisot, *Carnet vert A*, Musée Marmottan Monet, Paris, D.5-1986.2014.2.

14
Berthe Morisot, *Carnet de Mézy*, Musée Marmottan Monet, Paris, D.5-1986/2014.4.

15
The same background is found in the painting *Paule Gobillard peignant* (*Paule Gobillard Painting*; 1887, Musée Marmottan Monet, Paris) and in a photograph of Julie Manet (Musée Marmottan Monet, Paris; in *Julie Manet: La Mémoire impressionniste*, repr. p. 30).

16
It can be made out in *Madame Pontillon et sa fille Jeanne sur un canapé* (Madame Pontillon and her daughter Jeanne on a sofa), a watercolor made in 1872 at the home of Berthe Morisot's mother (BW 621, private collection).

17
See the preparatory drawings by Pierre-Auguste Renoir, *Julie Manet or L'Enfant au chat* (Child with cat; c. 1887: pencil on paper, signed in the lower right corner, 24 × 18¾ in. (61 × 47.5 cm), private collection; and charcoal and pencil on blue paper 24½ × 18½ in. (62 × 47 cm), private collection; in *Julie Manet: La Mémoire impressionniste*, repr. 209 and 211.

18
Regarding the connections between Renoir's *L'Enfant au chat* (Child with cat) and eighteenth-century painting, see Dominique d'Arnoult in *Berthe Morisot et le XVIIIᵉ siècle*, ed. Marianne Mathieu, oxh. cat. (Paris: Hazan, 2003).

19
Denis Rouart, *Correspondance de Berthe Morisot avec sa famille et ses amis: Manet, Puvis de Chavannes, Degas, Monet, Renoir et Mallarmé* (Paris: Quatre Chemins-Editart, 1950), 100.

20
Ibid., 163.

21
Ibid., 170.

22
Ibid., 135.

23
Julie Manet: La Mémoire impressionniste, 45.

24
Ibid.

25
Ibid., 45 ff.

Above:
Fig. 141 Berthe Morisot,
Sur le balcon (On the Balcony),
1893.
Pastel on paper, 18½ × 22 in.
(47 × 56 cm).
Musée Marmottan Monet, Paris.

A fourteen-year-old Julie Manet
leans against the balcony railing
of the apartment on Rue Weber
in Paris, where she moved with
her mother in 1892.

Facing page:
Fig. 142 Berthe Morisot,
*La Leçon de dessin (Berthe Morisot
et sa fille, Julie Manet)* (*The Drawing
Lesson [Berthe Morisot and Her
Daughter, Julie Manet]*), 1889.
Drypoint on wove paper,
10 × 7½ in. (25.4 cm × 18.8 cm).
Musée d'Art Moderne et
Contemporain, Strasbourg.

Berthe Morisot is depicted here
with her daughter, Julie.

Above:
Fig. 144 Laurence Reynaert,
Portraits, 2000–2003.
Black-and-white print on baryta
paper, 16 × 19½ in. (40 × 50 cm).
Frac Normandie Collection,
Sotteville-lès-Rouen.

Facing page:
Fig. 145 Gaston Bussière, *Jeune fille
aux iris* (Young girl with irises), n.d.
Oil on canvas, 18 × 15 in.
(46 × 38 cm).
Musée des Ursulines, Mâcon.

Above:
Fig. 146 Federico Zandomeneghi,
Fanciulla dormiente (A letto)
(*In Bed [Sleeping Girl]*), 1878.
Oil on canvas, 23½ × 29 in.
(60 × 74 cm).
Galleria d'Arte Moderna, Palazzo
Pitti, Florence.

Facing page:
Fig. 147 Jacques-Émile Blanche,
Portrait de jeune femme
(*Portrait of a young woman*), 1895.
Oil on canvas, 5 ft. 3½ in. × 3 ft. 1 in.
(161 × 95 cm).
Musée du Petit Palais, Geneva.

Above:

Fig. 148 Federico Zandomeneghi,
La lezione (The lesson), 1902.
Pastel on paper mounted
on cardboard, 21½ × 18 in.
(55 × 46.5 cm).
Musei Civici, Comune di Mantova,
Mantua.

Facing page:

Fig. 149 Albert Bréauté,
Jeune femme lisant
(Young woman reading), n.d.
Oil pastel on paper, 21 × 17½ in.
(53 × 44 cm).
Musée d'Allard, Montbrison.

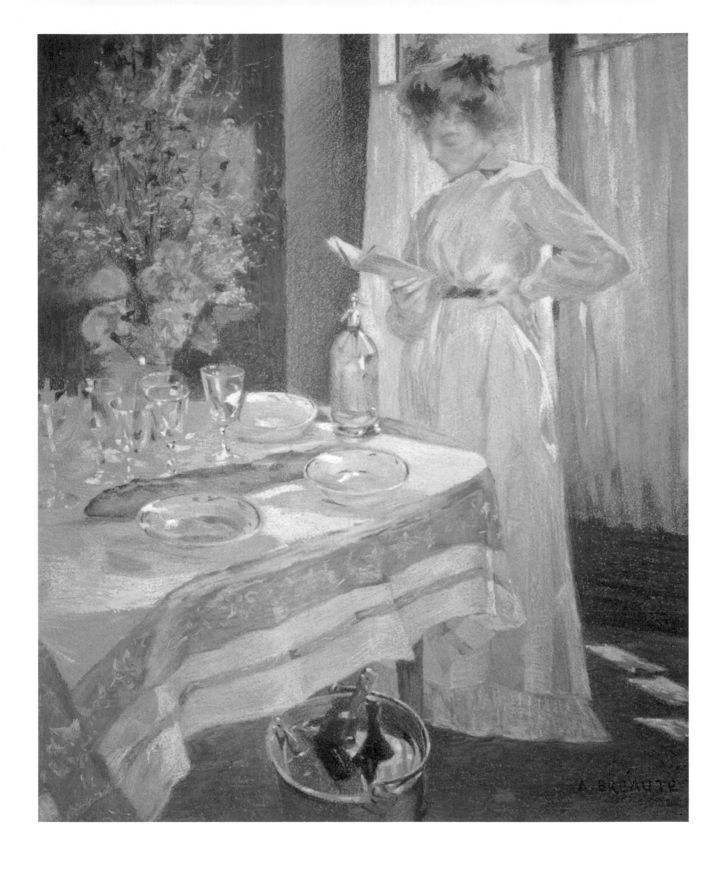

Above:
Fig. 150 Lilla Cabot Perry,
At the River's Bend (On the River II),
1895.
Oil on canvas, 25½ × 32 in.
(64.8 × 81.3 cm).
The Art Institute of Chicago,
Chicago.

Lilla Cabot Perry had three
daughters—Margaret, Edith,
and Alice—whom she often
painted, either alone or together.
Edith, aged fifteen,
posed for this portrait on the
banks of the Epte River.

Facing page:
Fig. 151 Rineke Dijkstra,
*Tiergarten, Berlin, June 27, 1999
(Girl with Clenched Fist)*, 1999.
Ink-jet print, edition of 10 (EC 1/1),
4 ft. 7 in. × 3 ft. 7 in. (139 × 108.5 cm).
Artist's collection.

Fig.152 Elaine Constantine,
Girls on Bikes, 1997.
Photograph mounted on Dibond,
2 ft. 11 in. × 4 ft. 1 in. (89 × 125 cm).
R & G Little Collection.

Fig. 153 *Paul-Émile Pissarro in His Father's Studio at Éragny, c. 1894.*
Pissarro Family Archives.

APPENDIXES

Maurice Boutet de Monvel
1850–1913

Maurice Boutet de Monvel's great-grandfather, Jacques-Marie Boutet (1745–1812), known as "Le Grand Monvel," was an actor, playwright, and poet, and a friend of the writers Pierre Choderlos de Laclos and Voltaire. Maurice Boutet de Monvel was a descendant of this free-thinker by way of Boutet's eldest son, Noël-Barthélémy Boutet de Monvel (1768–1847), an engineer who, after a stay in the United States, became secretary to Jean-Jacques-Régis de Cambacérès, the Second Consul of the French Republic, then arch-chancellor of the Empire. During the Restoration, he left the capital for Orléans with his wife, the actress Cécile Baptiste. It was in Orléans that Maurice Boutet de Monvel was born on October 18, 1850 to Noël-Barthélémy and Cécile's son, Benjamin Boutet de Monvel (1820–1898), and his wife Louise. In 1853, the family relocated to Paris, where Benjamin, a chemistry professor, had secured a position at the Lycée Charlemagne.

Maurice showed a talent for drawing at an early age, and his family encouraged his decision to pursue an artistic career. He became Cabanel's student at the École des Beaux-Arts in 1870. After the war, when he enlisted in the Armée de la Loire following the French defeat at the Battle of Sedan, he enrolled at the Académie Julian and studied under the supervision of Jules Lefebvre and Gustave Boulanger. He took part in the Salon de la Société des Artistes Français for the first time in 1874 with the work *Tentation de Saint Antoine* (The temptation of Saint Anthony; location unknown). He then worked briefly under the direction of Carolus-Duran, whose influence, along with a stay in Algeria in 1876, led him to lighten his palette—a shift that critics praised. In 1876, he married Jeanne Lebaigue (1852–1930), with whom he had two sons: Roger (1879–1951), who became a writer, and Bernard (1884–1949) who, like his father, pursued a career as a painter and illustrator. Despite several successes at the Salon, Boutet de Monvel turned to illustration to support his family. He collaborated with the publisher Charles Delagrave, a specialist in children's literature and textbooks (*La France en zig-zag: Livre de lecture courante à l'usage de toutes les écoles*, 1881; Louis Ratisbonne's *La Comédie enfantine*, 1881; and numerous contributions to the magazine *St. Nicolas*); and he also illustrated volumes by Anatole France for the publisher Hachette (*Nos enfants: Scènes de la ville et des champs*, 1887; *Filles et garçons: Scènes de la ville et des champs*, 1900). His most famous works are no doubt the illustrated volumes he produced for Plon, Nourrit et Cie, a publishing house founded in 1873 by his maternal uncle, Robert Nourrit, with Eugène Plon, his brother-in-law, and Émile Perrin. In 1883, Boutet de Monvel published *Vieilles chansons pour les petits enfants* and the following year *Chansons de France pour les petits Français*, following the same model. The delicate tones of his

watercolors were reproduced using zincography and stencils. The simple drawings harmonize with the light colors, the compositions are airy, and each image is suffused with the mischievous sense of humor that made Boutet de Monvel so successful. In 1887, he illustrated *La Civilité puérile et honnête, expliquée par l'oncle Eugène* (perhaps Eugène Plon himself; **figs. 105, 106, 107**), and the following year he published his version of La Fontaine's *Fables*. In 1896, also with Plon, Nourrit et Cie, he created his masterpiece, *Jeanne d'Arc*: a volume about Joan of Arc that upon publication became a collector's object as much as a children's book. His illustrations were particularly appreciated in the United States, where he was a regular contributor to *St. Nicholas for Boys and Girls* magazine, published by the Century Company. In 1899, the Art Institute of Chicago's Antiquarian Society dedicated its annual exhibition to Boutet de Monvel. He traveled to the United States for the occasion, then again in 1901.

Alongside his successful career as an illustrator, Boutet de Monvel continued painting. In 1885, his *Apothéose de la canaille*, or *Le Triomphe de Robert Macaire* (Apotheosis of the rabble, or The triumph of Robert Macaire; Musée des Beaux-Arts, Orléans)—a monumental history painting satirizing the Commune, in which a drunkard is crowned at the top of a barricade, while a young woman symbolizing France lies at his feet—was selected by the jury, but taken down the day before the inauguration on the orders of the State Undersecretary of Fine Arts for suspicions of anti-Republican sentiment. The same year, the portrait of the actress Réjane's daughter, which he presented upon his admission into the Société des Aquarellistes Français (Society of French watercolorists), attracted a great deal of attention and earned him many commissions, including the portrait *Mademoiselle Rose Worms* (c. 1900, **fig. 121**). Following the publication of *Jeanne d'Arc*, the architect Paul Sédille commissioned eight panels recounting the saint's life for the basilica in Domrémy. In 1900, he presented a first panel, *Jeanne à Chinon* (Joan in Chinon), at the World's Fair, where it won a gold medal. But poor health prevented him from finishing the project. Having retreated to Nemours, he painted a smaller, six-panel version for the American senator William Clark, now held at the National Gallery of Art in Washington, D.C. The artist spent the final years of his life working on an illustrated life of Saint Francis of Assisi, commissioned by the Century Company—a project that took him to Italy for the first time, in 1911. The book was published in 1912 in the United States, and a French edition appeared posthumously in 1921, published by Plon, Nourrit et Cie, and accompanied by a text written by the artist's son, Roger Boutet de Monvel.

M. D.

Lilla Cabot Perry
1848–1933

Born on January 13, 1848, in Boston to an old New England family, Lilla Cabot grew up in a literary, abolitionist environment. She mastered Greek and Latin, and was fluent in French, German, and Italian. In 1874, she married Thomas Sergeant Perry (1845–1928), a professor of English literature and a childhood friend of Henry James, and gave birth to three daughters: Margaret (1876–1970), Edith (1880–1958), and Alice (1883–1959). At the age of thirty-six, shortly after the birth of her youngest daughter, she began artistic training, first with the painter Alfred Quinton Collins, a student of Léon Bonnat, then at the Cowles Art School in Boston, where she studied with Denis Miller Bunker and Robert Vonnoh. In 1887, the Perry family left for Europe, first traveling to Munich, where Cabot Perry studied briefly with the naturalist painter Fritz von Uhde, then to Paris, where she enrolled in 1888 at the Académie Julian and the Académie Colarossi, in addition to taking private lessons with Alfred Stevens. In 1889, Cabot Perry exhibited at the Salon for the first time, and spent the summer with her family in Giverny. Drawn to the village after discovering Claude Monet's work in Paris, the couple became friends with the impressionist painter. The Perrys went to the village eight more times, renting the Hameau, the house neighboring the Monet property, on several occasions. The landscapes and portraits of children that Cabot Perry worked on during

these stays reveal that she had adopted the impressionist technique, as demonstrated by the portrait of her daughter Edith, *At the River's Bend* (*On the River II*, **fig. 150**). The Perrys' visits to Giverny were interrupted by a three-year stay in Japan, between 1898 and 1901, where Sergeant Perry was appointed professor of English literature at Keio University in Toyko, and Cabot Perry painted numerous landscapes and scenes of everyday life in Japan. After a final stay in Giverny in 1909, the Perrys returned to Boston permanently. Cabot Perry, whose reputation continued to grow in her native city, was instrumental in introducing Monet's work to the United States. Following the French painter's death, she published her memories of their time together in Giverny.[1] She pursued landscape painting for the rest of her life, dividing her time between Boston and the small town of Hancock, New Hampshire.

M. D.

1
Lilla Cabot Perry, "Reminiscences of Claude Monet from 1889 to 1909," *The American Magazine of Art* 18, no. 3 (March 1927): 119–126.

2
Joris-Karl Huysmans, "L'Exposition des Indépendants en 1881," in *Écrits sur l'art (1867–1905)* (Paris: Éditions Bartillat, 2006), 243.

Mary Cassatt
1844–1926

Mary Cassatt was considered a painter of childhood from her very first contributions to the impressionist exhibitions. In 1881, Joris-Karl Huysmans praised her "ravishing youngsters, peaceful and bourgeois scenes painted with a kind of delicate tenderness, all charming."[2]

Born on May 22, 1844, in the suburbs of Pittsburgh, Pennsylvania, Cassatt grew up in a wealthy family with ties to France through a Huguenot ancestor named Jacques Cossart, whose son settled in New Amsterdam (later to become New York) in the mid-seventeenth century. Her father, Robert Simpson Cassatt, founded a mercantile transport company in Pittsburgh in 1829. Six years later, he married Katherine Kelso Johnston, who had received an exceptional education as a boarder at the Institut de Saint-Germain. After their first daughter died at birth, they had Lydia Simpson in 1837, followed by Alexander Johnston and Robert Kelso. Mary was the couple's third daughter, and two sons were born after her: George Johnston, who died at one month old, and Joseph Gardner. At the age of seven, Mary traveled to Europe, a continent that her parents loved. Between 1851 and 1855, the Cassatt family traveled to Paris, Heidelberg, and Darmstadt. During this voyage, she learned French and German, and attended local schools, as did her brother Alexander. The primary objective of the trip was to find the best care for little Robert Kelso, who

suffered from a bone disease that he ultimately died from in 1855. Following this sad turn of events, the Cassatts returned to Philadelphia, where the two sons started families.

At the age of sixteen, Mary began studying art at the Pennsylvania Academy of the Fine Arts, but she became frustrated with the way the subject was taught to women there, and she decided to move to Paris in 1865. Her mother was encouraging, while her father expressed more reluctance regarding her decision. The young painter frequented various studios, choosing as her masters artists such as Jean-Léon Gérôme, Charles Chaplin, and Paul Constant Soyer. She also traveled to Italy, Spain, the Netherlands, and Belgium to continue her training. There, she studied and copied the great masters that she so admired, including Correggio, Diego Velázquez, Francisco Goya, and Peter Paul Rubens. She returned to Paris in 1874, where she exhibited twice at the Salon de l'Académie des Beaux-Arts, but soon found herself disappointed by the subsequent refusals she received.

In October 1877, her parents and her sister Lydia moved to Paris. Overjoyed, Mary regularly asked her sister, with whom she was close, to model for her. The same year, she met Edgar Degas, who invited her to exhibit with the impressionists at the Salon des Indépendants. At the group's sixth exhibition, in 1881, she presented four paintings and seven pastels, most of which were portraits of family members and their children. The previous summer, the Cassatts had

stayed in Marly-le-Roi with the artist's brother Alexander, his wife, and their four children. She captured tender scenes of daily life as she strove to convey the ties that exist between children and their parents or grandparents. Among her preferred models, Cassatt often painted Alexander and his son, as well as her other brother's wife, Eugenia Carter Cassatt, and their first child, Gardner. The print of her sister-in-law with her son is thought to be the first drypoint in a large series on the subject of maternity that she began in 1888.

Cassatt continued to make portraits of her family until she could no longer paint or draw, but she also enjoyed depicting Degas's nieces (**fig. 159**) and the children who lived near her home. Oil painting dominated her work until 1879, when she began producing prints and pastels. In these, she explored the themes of mother and child, presented in the simplest of everyday activities and moments. She worked in series, exploring different techniques with dedication and virtuosity. Her printed works in particular were admired by her friends Camille Pissarro and Degas, and were collected by dealers Paul Durand-Ruel and Ambroise Vollard from the 1890s. Deeply influenced by the major exhibition of Japanese prints at the Beaux-Arts in the spring of 1890, as well as by the colors in Persian miniatures, she produced aquatints in which she experimented with colors in novel ways. Their contours, made with drypoint technique, reflect her appreciation for fluid lines and simplified volumes.

According to Griselda Pollock, Cassatt viewed the relationship between a mother and her child as a subject suited to developing her artistic reflections.[3] It was by focusing on this specific theme, which assured her great success and conveyed her political and social vision of femininity,[4] that Cassatt developed her graphic and pictorial explorations. Her view of childhood is one of an observer attentive to the developing personalities of her models, one who appreciated their dreamy, sad, or bored expressions that innocently find escape from the restrictive attitudes governing social conventions.

E. W.

3
Griselda Pollock, *Mary Cassatt: Painter of Modern Women* (London/New York: Thames & Hudson, 2022), 200–201.

4
Regarding the theme of maternity as it relates to the social and commercial contexts in which Cassatt worked, see Norma Broude, "Mary Cassatt: Modern Woman or the Cult of True Womanhood?," *Woman's Art Journal* 21, no. 2 (fall 2000–winter 2001): 36–43.

Édouard Debat-Ponsan
1847–1913

Born on April 27, 1847, in Toulouse, Édouard Debat-Ponsan grew up in a family of musicians. His father, Jacques-Catherine Debat-Ponsan (1804–1866) taught music at the local conservatory and was the official organ player at Notre-Dame-de-la-Daurade. His brother, Georges (1851–1933), studied at the conservatory in Paris and also taught at the conservatory in Toulouse, as did the youngest member of the family, Adèle (1853–1936), a harp teacher. Édouard chose painting, and in 1861 he enrolled at the École des Beaux-Arts in Toulouse. He continued his training at the Beaux-Arts in Paris, in the studio of Alexandre Cabanel. There, he associated with Benjamin-Constant, Jean-André Rixens, and Jules Bastien-Lepage. He also spent time with Jules-Arsène Garnier, a classmate from the Beaux-Arts in Toulouse. He took part in the Salon for the first time in 1870 and unsuccessfully competed for the Prix de Rome on six occasions, between 1870 and 1877. However, he won the Prix Troyon in 1875 and a Second Prix de Rome in 1876, for *Priam réclamant le corps d'Hector* (Priam asking for Hector's body; Petit Palais, Musée des Beaux-Arts de la Ville de Paris, Paris). In 1877, the Académie des Beaux-Arts granted him money to spend a year in Italy. Upon his return, in 1878, he married classmate Jules-Arsène Garnier's sister, Marguerite. The couple had three children: Jeanne (1879–1929), Jacques (1882–1943), and Simone (1886–1986).

Jacques became an architect, winning the Prix de Rome in 1912, and was responsible for many reconstructions in the Somme following World War I. Jeanne developed a distinct liking for the sciences during her studies and chose to pursue medicine. Higher education was still an unusual path for young women from her social background and provoked incomprehension on her father's side of the family, but Debat-Ponsan supported his daughter and set up an office for her so she could study in peace. Jeanne Debat-Ponsan went on to become one of the first female interns and clinic directors in the Paris hospital system. She married Robert Debré (1882–1978), one of the founders of modern pediatrics, in 1908. Édouard Debat-Ponsan was grandfather to the statesman Michel Debré (1912–1996) and the painter Olivier Debré (1920–1999), the couple's eldest and youngest sons, respectively. In 1920, Édouard's third child, Simone, married André Morizet—her second husband, who was, for many years, the mayor of Boulogne-Billancourt—and she gave many of her father's paintings to the Musée des Beaux-Arts in Tours.

In the early years of his career, Édouard Debat-Ponsan focused on history painting and portraits. In 1882–1883, he traveled to Turkey with his two brothers-in-law, who were also painters: Jules-Arsène Garnier and Henri-Eugène Delacroix, husband of the watercolor artist Pauline Garnier (1863–1912), the younger sister of Jules-Arsène and Marguerite. He painted *Le Massage, scène de hammam* (Massage at the hammam; 1883, Musée des Augustins, Toulouse), one of his most famous works, on his return from this trip. Presented at the Salon in 1883, it was only modestly successful, and Debat-Ponsan abandoned the Orientalist style. He ultimately became known for his genre scenes and rural portraits, which he first sent to the Salon in 1886 and which displayed a distinct taste for plein air painting. His growing reputation earned him commissions to paint the portraits of high-profile figures in political, intellectual, and artistic circles. His native city called on him to decorate the city hall: for the Salle des Illustres in the Capitole building, he painted *La Couronne de Toulouse* (The crown of Toulouse), in 1894, and *La Visite en 1775 de l'archevêque Loménie de Brienne au sculpteur François Lucas travaillant au bas-relief de l'embouchure de la Garonne* (The Archbishop Loménie de Brienne visiting the sculptor François Lucas at work on the bas-relief of the mouth of the Garonne in 1775) in 1896. In 1898, at the Salon des Artistes Français, he exhibited a work openly supportive of Captain Dreyfus, *La Vérité sortant du puits* or *Nec Mergitur* (Truth coming out of the well, or Nec Mergitur; Musée d'Orsay, Paris, on long-term loan to the Musée de l'Hôtel de Ville, Amboise). The Army and the Church, represented by a swordsman and a cleric, claw at Truth, represented by a bare-breasted young woman

brandishing a mirror. After another presentation at the ten-year exhibition of the Beaux-Arts, held during the World's Fair in 1900, the painting was given to Émile Zola thanks to a public subscription. The artist was on bad terms with his family because of his support for Dreyfus, and was forced to abandon the Languedoc and the Préousse estate, in Gragnague, where the family met up each summer. Before the falling out in 1898, he had often painted his garden, and the surrounding countryside had provided him with many subjects, but in Touraine he found a new haven. In 1900, the painter settled with his wife and children several miles from Amboise, in the Château de Nazelles, while continuing to pursue a career in Paris. The exhibition of *Vérité sortant du puits* cost him some of his Catholic, bourgeois clientele in the capital, but he remained a sought-after portrait artist. Up until his death in 1913, he continued to receive public commissions (the foyer of the Nîmes Theater, the city council meeting room in the Toulouse city hall) and to take part in the Salon. He also turned to an English and American clientele, who adored his rural scenes, which benefited from his renewed interest in landscape and plein air painting following the move to Touraine.

M. D.

Mary Fairchild MacMonnies Low
1858–1946

Mary Fairchild was born in New England, in New Haven, Connecticut, on August 11, 1858. She spent her youth in the Midwest, however, in Saint Louis, Missouri, where her father was chief operator at the Western Union Telegraph Company. In 1874, Mary finished high school and became a teacher, a profession she held for five years, before discovering her talent and calling as a painter while helping her mother, a miniaturist, colorize images for a photographer. At the age of twenty-four, she enrolled in night classes at the fine arts school in Saint Louis, before enrolling full time the following year. There, she led a protest of female students to obtain access to live model classes, and caught the attention of one of her professors, Halsey Cooley Ives, who created a three-year scholarship for her to travel to Paris. She enrolled at the Académie Julian in 1885, and in 1886 she presented *Portrait of Mademoiselle Sarah Hallowell* (Robinson College, Cambridge University) at the Salon. During her third year, she studied with Carolus-Duran and met Frederick MacMonnies (1863–1937), another American student who was then in his second year at the École des Beaux-Arts, in the studio of sculptor Alexandre Falguière. They married in 1888, after Mary had completed her three years of study; the conditions of her scholarship prohibited them from doing so sooner. The young couple immediately began preparing for the Salon and the World's Fair of 1889, where they both won prizes. The MacMonnies began spending time in Giverny in 1890, first staying at the Hôtel Baudy, before renting a small house, the Besche Villa,

in 1895. Their eldest daughter, Berthe Hélène, known as Betty, was born in 1896, and in 1897, Marjorie Eudora, their youngest daughter, was born.

In 1898, the family moved into the Prieuré, a former monastery surrounded by a lush garden, where they lived and worked. Like the Perrys' Hameau, the Prieuré was a gathering place for American artists visiting the village. The couple had several major successes during this period, notably at the World's Fair in 1900: Mary's *Roses et lys* (*Roses and Lilies*, **fig. 34**) won a gold medal, while Frederick shared a Grand Prix with Augustus Saint-Gaudens and Daniel Chester French. However, this period was clouded by the loss of their son, Ronald, born in 1899, who died in 1901. Their respective careers led the two artists to spend more and more time apart. In 1908, they quietly divorced. In 1909, Mary Fairchild married the American painter Will Hicok Low (1853–1932) and returned to the United States with him, accompanied by her two daughters. Mary Fairchild, now Mary Fairchild Low, moved into Low's home-studio in Bronxville, an artists' colony in upstate New York, and continued to paint, while remaining discreet about her life in France and her first marriage to Frederick MacMonnies. With her two daughters enrolled at the National Academy of Design, she regularly spent time in the picturesque port of Gloucester, Massachusetts, another large American artists' colony.

M. D.

Ferdinand du Puigaudeau
1864–1930

Born in Nantes, Ferdinand Loyen du Puigaudeau had a chaotic career—one filled with both failure and success, which explains why he enjoyed less fame than his friends Paul Gauguin, Charles Laval, or Edgar Degas. A self-taught artist, he only really began to paint around 1882. Encouraged by his uncle, writer and painter Henri de Châteaubriant, du Puigaudeau set out to discover the world. He was free; his parents had divorced when he was a child. Several trips to Italy and Tunisia spurred him to pursue an artistic education. In 1886, he went to Pont-Aven, where he met Gauguin and Laval. He stayed at the Pension Gloanec, a boarding house frequented by artists. This encounter with Gauguin, whose technique and Breton subjects strongly influenced du Puigaudeau, was decisive. In 1889, in the company of the painter Allan Österlind, du Puigaudeau traveled to Sweden and Belgium. In Brussels, he met the Les Vingt group. He exhibited at the Salon de Nantes and the Salon des Indépendants in 1890: Degas purchased his *Feu d'artifice* (*Fireworks*) and the two men became friends. In 1893, the art dealer Paul Durand-Ruel took him under his wing until they parted ways in 1903. In 1893, he married Blanche van den Broucke, a portrait artist, and the couple settled in Saint-Nazaire. Their daughter Odette was born the following year. He moved to Pont-Aven in 1895, where, alongside American artists Childe Hassam and William Harrisson, he painted scenes of Brittany, enigmatic nightscapes (**fig. 67**), and animated scenes of rural life. *L'Office du soir* or *Le Calvaire de Rochefort-en-Terre* (Evening service, or The calvary

of Rochefort-en-Terre; 1894, Musée de Pont-Aven, Pont-Aven) is typical of his explorations into light. He developed the custom of making many preparatory sketches and reworking his paintings using tracing paper, and the same elements often appear throughout his compositions.

In 1899, du Puigaudeau moved to Sannois, near Argenteuil, where he lived for three years. His reputation grew: in 1900, he presented work at the World's Fair in Paris, and he held a personal exhibition at the Galerie des Artistes Modernes the same year. He traveled to Venice in 1905, then withdrew permanently to Le Croisic, in Brittany, near Nantes. There, in 1907, he began renting the fourteenth-century Kervaudu Manor, where he lived in increasing seclusion—"the hermit of Kervaudu," as Degas called him—until his death in 1930.

Few of du Puigaudeau's paintings are held in public French collections. Recently, the Musée de Pont-Aven acquired several important works: *La Lanterne magique* (The magic lantern; 1896), and *Fillettes du Bourg-de-Batz* (Little girls in Bourg-de-Batz; 1894, **fig. 83**). The Musée des Beaux-Arts de Quimper holds two of his landscapes: *Paysage avec arbres* (Landscape with trees; c. 1921) and *Paysage à la chaumière* (Landscape with cottage; 1921). Du Puigaudeau was in the habit of cycling around the salt marshes and landscapes of Brière. He rarely dated his paintings, and he made many different versions of the same scene. Sunsets, misty atmospheres, and nightscapes were his preferred subjects.

Fascinated by their naiveté and their clothing, du Puigaudeau often painted portraits of children.

He captured them in contemplation— before fireworks, carousels, sunsets, beach games, magic lanterns, shadow puppets; their world of dreams and wonder captivated him. He rooted his portraits in historical references, avoiding the depiction of what was no doubt a difficult way of life in Brittany at that time. Prehistoric sites (*Le Menhir* [The menhir]; 1911, Musée d'Arts de Nantes, Nantes), calvaries (Rochefort-en-Terre), and market squares (Saint-Pol-de-Léon and Batz-sur-Mer) were all pretexts for depicting children in places with a long history that transcended their youth. Symbols of transmission also featured heavily, contrasting the fragility of childhood with the strength of Breton traditions. He took a keen interest in the education of his daughter, Odette, who became a renowned ethnologist.

C. S.

Fig. 154 *Man with a Group of Children, Combronde, 1899.*
Musée d'Orsay, Paris.

Fig. 155

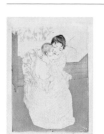

Fig. 156

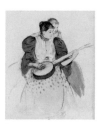

Fig. 157

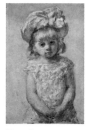

Fig. 158

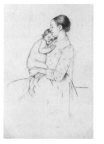

Fig. 159

Fig. 160

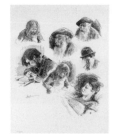

Fig. 161

Fig. 162

Fig. 163

Fig. 164

Fig. 165

Fig. 166

List of Works

Albert André (1869–1954)
Renoir peignant en famille
(Renoir painting his family),
1901
Oil on hardboard,
21 × 24½ in. (53 × 62 cm)
Musée d'Art Sacré du Gard,
Pont-Saint-Esprit,
CD 008.17.52
Fig. 42, p. 69

Frédéric Bazille (1841–1870)
La Terrasse de Méric (The
terrace at Méric), 1866
Oil on canvas, 3 ft. 2 in. ×
4 ft. 2½ in. (97 × 128 cm)
Musée du Petit Palais,
Geneva, 10748
Fig. 93, p. 153

Jacques-Émile Blanche
(1861–1942)
*Enfant couchée; Le réveil de
la petite princesse* (Reclining
child: The awakening of the
little princess), 1890
Oil on canvas, 3 ft. 6½ in. ×
2 ft. 8 ½ in. (107.5 × 209.5 cm)
Musée de Dieppe, Dieppe,
902.16.1
Fig. 113, pp. 178–179

Jacques-Émile Blanche
Portrait de jeune femme
(Portrait of a young woman),
1895
Oil on canvas, 5 ft. 3½ in. ×
3 ft. 1 in. (161 × 95 cm)
Musée du Petit Palais,
Geneva, 10110
Fig. 147, p. 231

Eugène Boudin (1824–1898)
*Conversation sur la plage
de Trouville* (Beach Scene,
Trouville), 1876
Oil on mahogany panel,
5 × 10 in. (12.5 × 24.7 cm)
Musée Eugène-Boudin,
Honfleur, 899.1.12
Fig. 123, p. 194

Eugène Boudin
Paysage avec personnages
(Landscape with figures),
c. 1880
Oil on mahogany panel,
10½ × 14 in. (26.4 × 35.2 cm)
Musée Eugène-Boudin,
Honfleur, 899.1.7
Fig. 96, p. 156

Eugène Boudin
Portrait de fillette (Portrait
of a young girl), c. 1880
Oil on mahogany panel,
11½ × 8½ in. (29.3 × 21.7 cm)
Musée Eugène-Boudin,
Honfleur, 899.1.3
Fig. 97, p. 157

Maurice Boutet de Monvel
(1850–1913)
Le Bain de l'enfant (The
child's bath), n.d.
Pen ink, ink wash, and white
gouache highlights on paper,
10 × 13 in. (25.5 × 33.6 cm)
Musée des Beaux-Arts,
Reims, 2015.1.1
Fig. 91, p. 148

Maurice Boutet de Monvel
Mademoiselle Rose Worms,
c. 1900
Oil on canvas, 27½ × 16 in.
(70 × 40 cm)
Musée des Impressionnismes,
Giverny, acquired with the
help of the museum's Société
des Amis, MDIG 2022.1.1
Fig. 121, p. 189

Albert Bréauté (1853–1941)
Jeune femme lisant
(Young woman reading), n.d.
Oil pastel on paper,
21 × 17½ in. (53 × 44 cm)
Musée d'Allard, Montbrison,
gift of Albert Bréauté, 1931,
2013.06.041
Fig. 149, p. 233

André Brouillet (1857–1914)
La Petite Fille en rouge
(Little girl in red), 1895
Oil on canvas, 6 ft. 6 in. ×
4 ft. 3 in. (1.99 × 1.3 m)
Centre National des Arts
Plastiques, FNAC 5027, on
long-term loan to the Musée
Sainte-Croix, Poitiers since
1915, D915.1.1
Fig. 62, p. 103

Gaston Bussière (1862–1928)
Jeune fille aux iris
(Young girl with irises), n.d.
Oil on canvas, 18 × 15 in.
(46 × 38 cm)
Musée des Ursulines, Mâcon,
A.1000
Fig. 145, p. 229

Gustave Caillebotte
(1848–1894)
*Le Parc de la propriété
à Yerres* (The park on the
Caillebottte property
at Yerres), 1875
Oil on canvas, 2 ft. 1½ in. ×
3 ft. (65 × 92 cm)
Private collection
Fig. 22, p. 34

Mary Cassatt (1844–1926)
The Banjo Lesson, c. 1893
Color drypoint and aquatint
with monoprint on light blue
paper, 12 × 9 in.
(29.8 × 23.4 cm)
Jacques Doucet Collection,
Bibliothèque de l'Institut
National d'Histoire de l'Art,
Paris, EM CASSATT 9b
Fig. 157, p. 247 (vignette)

Mary Cassatt
The Barefooted Child, c. 1898
Drypoint and aquatint,
printed in color, 12 × 17 in.
(30 × 43.5 cm [sheet])
Indivision Petiet
Fig. 30, p. 50

Mary Cassatt
By the Pond, c. 1898
Drypoint and aquatint,
printed in color, 17 × 10 in.
(43 × 51 cm [sheet])
Indivision Petiet
Fig. 155, p. 247 (vignette)

Mary Cassatt
Family Group Reading, 1898
Oil on canvas, 1 ft. 10½ in. ×
3 ft. 8 in. (56.5 × 112.4 cm)
Philadelphia Museum of Fine
Arts, Philadelphia
Fig. 71, p. 119

Mary Cassatt
Feeding the Ducks,
c. 1893–1895
Drypoint, softground etching,
and aquatint, 13½ × 20½ in.
(34.7 × 52.4 cm)
Jacques Doucet Collection,
Bibliothèque de l'Institut
National d'Histoire de l'Art,
Paris, EM CASSATT 13
Fig. 86, p. 143

Mary Cassatt
Gathering Fruit (L'Espalier),
c. 1893
Soft-ground etching,
drypoint, and color aquatint,
19½ × 17 in. (49.9 × 42.7 cm)
Jacques Doucet Collection,
Bibliothèque de l'Institut
National d'Histoire de l'Art,
Paris, EM CASSATT 8b
Fig. 31, p. 51

Mary Cassatt
Little Girl in a Blue Armchair,
1878
Oil on canvas, 2 ft. 11½ in. ×
4 ft. 3 in. (89.5 × 129.8 cm)
Mr. and Mrs. Paul Mellon
Collection, National Gallery
of Art, Washington, D.C.
Fig. 110, p. 173

Mary Cassatt
Maternal Caress, c. 1891
Soft-ground etching,
drypoint, and color aquatint,
19 × 12 in. (47.8 × 30.2 cm)
Jacques Doucet Collection,
Bibliothèque de l'Institut
National d'Histoire de l'Art,
Paris, EM CASSATT 6
Fig. 156, p. 247 (vignette)

Mary Cassatt
*Mother and Child
(Maternal Kiss)*, 1891
Soft-ground etching,
drypoint, and aquatint,
19 × 12 in. (47.8 × 30.9 cm)
Jacques Doucet Collection,
Bibliothèque de l'Institut
National d'Histoire de l'Art,
Paris, EM CASSATT 5b
Fig. 29, p. 50

Mary Cassatt
Portrait de fillette
(Portrait of a young girl), 1879
Oil on canvas, 24½ × 16 in.
(62.3 × 41 cm)
Musée des Beaux-Arts,
Bordeaux, gift of René
Domergue, 1983.9, Bx 1983.9.5
Fig. 158, p. 247 (vignette)

Mary Cassatt
Quietude, c. 1891
Drypoint, 14 × 8 in.
(35.5 × 20.8 cm [sheet])
Indivision Petiet
Fig. 159, p. 247 (vignette)

Mary Cassatt
*Sara Wearing Her Bonnet
and Coat*, c. 1904
Transfer lithograph, 24½ ×
19 in. (62.5 × 48 cm [sheet])
Indivision Petiet
Fig. 160, p. 247 (vignette)

Mary Cassatt
*Under the Horse Chestnut
Tree*, 1895–1897
Etching, drypoint, and color
aquatint, 20 × 17 ½ in.
(50.3 × 44.1 cm)
Jacques Doucet Collection,
Bibliothèque de l'Institut
National d'Histoire de l'Art,
Paris, EM CASSATT 18
Fig. 33, p. 53

Émile Claus (1849–1924)
*Les Glaneurs (Gathering
Corn)*, 1894
Oil on canvas, 15 × 22 in.
(38.5 × 55.8 cm)
Museum voor Schone
Kunsten, Ghent, 1950–AH
Fig. 101, p. 161

Elaine Constantine (b. 1965)
Girls on Bikes, 1997
Photograph mounted on
Dibond, 2 ft. 11 in. × 4 ft. 1 in.
(89 × 125 cm)
R & G Little Collection
Fig. 152, pp. 236–237

Elaine Constantine
Juliet on Swing, 1998
Digital Lambda print,
23 × 31½ in. (58.56 × 80 cm)
Elaine Constantine Ltd.
Fig. 66, p. 107

Édouard Debat-Ponsan
(1847–1913)
*Mère et fille dans un jardin
breton (Mother and daughter
in a Breton garden)*, 1898
Oil on canvas, 19 × 25½ in.
(49 × 65 cm)
Musée des Beaux-Arts, Tours,
1981-1-10
Fig. 75, pp. 124–125

Édouard Debat-Ponsan
*Le Petit Bernard jouant dans
l'atelier (Little Bernard
playing in the studio)*, 1912
Oil on wood, 22 × 12½ in.
(56 × 32 cm)
Musée des Beaux-Arts, Tours,
1981-1-9
Fig. 60, p. 100

Edgar Degas (1834–1917)
*Aux courses en province
(At the Races in the
Countryside)*, 1869
Oil on canvas, 14½ × 22 in.
(36.5 × 55.9 cm)
Museum of Fine Arts, Boston
Fig. 21, p. 33

Edgar Degas
L'Écolière (The Schoolgirl),
c. 1880
Plaster statuette, 11½ × 5 × 6 in.
(29.3 × 12.7 × 15.6 cm)
Musée d'Orsay, Paris, gift of
Mr. Grégoire Triet through
the Société des Amis du
Musée d'Orsay, 1997, RF 4614
Fig. 70, p. 116

Edgar Degas
*Petite fille peignée par sa
bonne, or Scène de plage
(Beach Scene)*, c. 1869–1870
Oil on paper on canvas,
18½ × 32½ in. (47.5 × 82.9 cm)
The National Gallery,
London
Fig. 124, p. 197

Henry d'Estienne (1872–1949)
*Portrait de fillette (Portrait of
a young girl)*, c. 1913
Oil on canvas, 4 ft. 5 in. ×
2 ft. 9 in. (135 × 85 cm)
Musée d'Orsay, Paris,
acquired in 1913, RF 1980-15
Fig. 120, p. 187

Rineke Dijkstra (b. 1959)
*Maddy, Martha's Vineyard,
MA, USA, August 5, 2015*, 2015
Ink-jet print, edition 3/15,
15 × 12 in. (38 × 30 cm)
Artist's collection
Fig. 131, p. 204

Rineke Dijkstra
*Parque de la Ciudadela,
Barcelona, June 4, 2005*,
2005
Ink-jet print, edition 9/10,
2 ft. 6 in. × 3 ft. 1 in.
(75.5 × 94 cm)
Artist's collection
Fig. 95, p. 155

Rineke Dijkstra
*Tiergarten, Berlin, June 27,
1999 (Girl with Clenched Fist)*,
1999
Ink-jet print, edition of 10
(EC 1/1), 4 ft. 7 in. × 3 ft. 7 in.
(1.39 × 1.08 m)
Artist's collection
Fig. 151, p. 235

Paul Gauguin (1848–1903)
*Intérieur avec Aline Gauguin
(Interior with Aline Gauguin)*,
1881
Oil on canvas, 20½ × 24 in.
(52.4 × 60.3 cm)
Private collection, on
long-term loan to the
Sheffield Museums Trust,
Sheffield, VIS.LI.901
Fig. 53, p. 87

Eva Gonzalès (1849–1883)
*La Nurse et l'enfant (Nanny
and Child)*, 1877–1878
Oil on canvas, 25½ × 32 in.
(65 × 81.4 cm)
National Gallery of Art,
Washington, D.C.
Fig. 58, p. 97

Armand Guillaumin
(1841–1927)
*Portrait de petite fille
(Portrait of a young girl)*, 1894
Pastel on beige laid paper,
19 × 22½ in. (48 × 57.5 cm)
Musée d'Orsay, Paris,
RF12837
Fig. 114, p. 180

Winslow Homer (1836–1910)
Beach Scene, c. 1869
Oil on canvas mounted on
cardboard, 11½ × 9½ in.
(29.3 × 24 cm)
Carmen Thyssen-Bornemisza
Collection, on long-term loan
to the Museo Nacional
Thyssen-Bornemisza,
Madrid, CTB.1985.12
Fig. 132, p. 205

Pierre Laprade (1875–1931)
*Vue de Paris; D'un balcon du
quai Henri IV (View of Paris:
From a balcony on Quai
Henri IV)*, c. 1919
Oil on wood, 20 × 27 in.
(50.6 × 69 cm)
Musée de Grenoble,
Grenoble, purchased from
the artist in 1921, MG 2084
Fig. 102, pp. 162–163

Ange Leccia (b. 1952)
Laure, 1998
Video, 36 min. 2 sec.
Musée des Impressionnismes,
Giverny, gift of the artist in
2022, MDIG 2022.12.1
Fig. 7, p. 6

Timoléon Lobrichon
(1831–1914)
*La Vitrine du magasin de
jouets (The toy-shop
window)*, n.d.
Oil on canvas, 3 ft. 8 in. ×
2 ft. 9 in. (112 × 84 cm)
Private collection
Fig. 57, p. 95

Maximilien Luce (1858–1941)
*Croquis: La famille Pissarro
(The Pissarro Family)*,
1870–1910
Lithograph, 17 × 12½ in.
(43.5 cm × 31.5 cm)
Jacques Doucet Collection,
Bibliothèque de l'Institut
National d'Histoire de l'Art,
Paris, EM LUCE 113
Fig. 161, p. 247 (vignette)

Maximilien Luce
Félix Pissarro, 1890
Lithograph, 8½ × 5 in.
(21 cm × 12.8 cm)
Jacques Doucet Collection,
Bibliothèque de l'Institut
National d'Histoire de l'Art,
Paris, EM LUCE 99
Fig. 80, p. 132

Mary Fairchild MacMonnies
(1858–1946)
Roses et lys (Roses and Lilies),
1897
Oil on canvas, 4 ft. 4 in. ×
5 ft. 9 in. (1.33 × 1.76 m)
Musée des Beaux-Arts,
Rouen, 1903.2
Fig. 34, pp. 54–55

Édouard Manet (1832–1883)
*La Famille Monet au jardin
à Argenteuil (The Monet
Family in Their Garden at
Argenteuil)*, 1874
Oil on canvas, 2 ft. × 3 ft. 3 in.
(61 × 99.7 cm)
The Metropolitan Museum of
Art, New York, Joan Whitney
Payson bequest, 1975
Fig. 109, p. 171

Édouard Manet
Le Gamin (The Urchin), n.d.
Lithograph on violet-toned
chine collé, 25 × 19 in.
(63.8 cm × 48.5 cm)
Musée Carnavalet – Histoire
de Paris, Paris, G.17056
Fig. 87, p. 143

Édouard Manet
*Sur la plage de Boulogne
(On the Beach, Boulogne-
sur-Mer)*, 1868
Oil on canvas, 13 × 26 in.
(32.4 × 66 cm)
Virginia Museum of Fine Arts,
Richmond
Fig. 125, p. 197

Ernest Marché (1864–1932)
*Le Jeune Pêcheur (The young
fisherman)*, n.d.
Oil on canvas, 16 × 13 in.
(41 × 33 cm)
Château-Musée, Nemours,
2016.0.332
Fig. 94, p. 154

Henri Martin (1860–1943)
*Étude pour l'été (Study for
"The summer")*, c. 1905
Oil on canvas, 2 ft. 11 in. ×
3 ft. 11 in. (89 × 120 cm)
Musée de Grenoble,
Grenoble, acquired in 1914,
MG 1921
Fig. 100, p. 160

Paul Mathey (1844–1929)
*Enfant et femme dans un
intérieur (Woman and child
in an interior)*, c. 1890
Oil on canvas, 19 × 15 in.
(48.5 × 38 cm)
Musée d'Orsay, Paris, gift of
Mademoiselle Dubreil, 1982,
RF 1982-9
Fig. 64, p. 105

Claude Monet (1840–1926)
*Camille Monet et un enfant
au jardin (Camille Monet and
a Child in the Artist's Garden
in Argenteuil)*, 1875
Oil on canvas, 22 × 25½ in.
(55.3 × 64.7 cm)
Museum of Fine Arts, Boston
Fig. 23, p. 38

Claude Monet
*Un coin d'appartement
(A Corner of the Apartment)*,
1875
Oil on canvas, 32 × 23½ in.
(81.5 × 60 cm)
Musée d'Orsay, Paris,
bequest of Gustave
Caillebotte, 1894, RF 2776
Fig. 49, p. 81

Claude Monet
*Fille avec un chien (Girl with
Dog)*, 1873
Oil on canvas, 21½ × 18 in.
(55.2 × 45.7 cm)
The Barnes Foundation,
Philadelphia
Fig. 104, p. 166

Claude Monet
Jean Monet dans son berceau (The Cradle—Camille with the Artist's Son Jean), 1867
Oil on canvas, 3 ft. 10 in. × 2 ft. 11 in. (116.2 × 88.8 cm)
Mr. and Mrs. Paul Mellon Collection, National Gallery of Art, Washington, D.C., 1983.1.25
Fig. 25, p. 45

Claude Monet
Jean Monet sur son cheval mécanique (Jean Monet on His Horse Tricycle), 1872
Oil on canvas, 24 × 29½ in. (60.6 × 74.3 cm)
The Metropolitan Museum of Art, New York
Fig. 20, p. 31

Claude Monet
La Maison de l'artiste à Argenteuil (The Artist's House at Argenteuil), 1873
Oil on canvas, 24 × 29 in. (60.2 × 73.3 cm)
Mr. and Mrs. Martin A. Ryerson Collection, The Art Institute of Chicago, Chicago, 1933.1153
Fig. 92, pp. 150–151

Claude Monet
Michel Monet au chandail bleu (Michel Monet wearing a blue sweater), 1883
Oil on canvas, 18½ × 15 in. (46.5 × 38.5 cm)
Musée Marmottan Monet, Paris, bequest of Michel Monet, 1966, 5019
Fig. 52, p. 85

Daniel de Monfreid (1856–1928)
Portrait de la fille de l'artiste, or L'Infante (Portrait of the artist's daughter, or Infante), 1906
Oil on cardboard, 25½ × 21½ in. (65 × 55 cm)
Musée d'Orsay, Paris, RF 1977-264
Fig. 118, p. 185

Étienne Moreau-Nélaton (1859–1927)
Enfants au piano (Children at the piano), 1902
Oil on canvas, 24 × 20 in. (61.4 × 50.5 cm)
Musée des Beaux-Arts, Pau, 04.2.1
Fig. 77, p. 128

Étienne Moreau-Nélaton
Le Jeune Amateur (The young amateur), 1903
Oil on canvas, 24 × 19 ½ in. (61.1 × 50.1 cm)
Musée des Beaux-Arts, Reims, 928.7.1
Fig. 76, p. 127

Berthe Morisot (1841–1895)
Bergère nue couchée (Reclining Nude Shepherdess), 1891
Oil on canvas, 22½ × 34 in. (57.5 × 86.4 cm)
Carmen Thyssen-Bornemisza Collection, on long-term loan to the Museo Nacional Thyssen-Bornemisza, Madrid, CTB.2000.9
Fig. 98, p. 158

Berthe Morisot
Le Cerisier (The Cherry Tree), started in 1891
Oil on canvas, 5 ft. 1 in. × 2 ft. 9 in. (154 × 84 cm)
Musée Marmottan Monet, Paris, bequest of Annie Rouart, 1993, 6020
Fig. 99, p. 159

Berthe Morisot
Dans le parc (In the park), 1874
Pastel on paper, 2 ft. 4½ in. × 3 ft. (72.5 × 91.8 cm)
Petit Palais, Musée des Beaux-Arts de la Ville de Paris, Paris
Fig. 88, p. 144

Berthe Morisot
L'Enfant à la poupée, or Intérieur de cottage (Young girl with doll, or Interior on Jersey), 1886
Oil on canvas, 19½ × 24 in. (50 × 61 cm)
Musée d'Ixelles, Brussels, FT 104
Fig. 59, pp. 98–99

Berthe Morisot
La Leçon de dessin (Berthe Morisot et sa fille, Julie Manet) (The Drawing Lesson [Berthe Morisot and Her Daughter, Julie Manet]), 1889
Drypoint on wove paper, 10 × 7½ in. (25.4 cm × 18.8 cm)
Graphic Arts Gallery, Musée d'Art Moderne et Contemporain, Strasbourg, 55.001.0.227
Fig. 142, p. 225

Berthe Morisot
Neveu de Berthe Morisot (Berthe Morisot's nephew), 1876
Oil on canvas, 13 × 9½ in. (32.5 × 24.3 cm)
Musée des Beaux-Arts, Bordeaux, Bx 1983.9.2
Fig. 162, p. 247 (vignette)

Berthe Morisot
La Petite Marcelle (Portrait of Marcelle), 1895
Oil on canvas, 25 × 18 in. (64 × 46 cm)
Musée Marmottan Monet, Paris, bequest of Annie Rouart, 1993, 6002
Fig. 111, p. 176

Berthe Morisot
La Petite Niçoise (The Little Girl from Nice), 1889
Oil on canvas, 24½ × 20½ in. (62.8 × 52.5 cm)
Musée des Beaux-Arts, Lyon, B 814
Fig. 139, p. 219

Berthe Morisot
Sur le balcon (Woman and Child on the Balcony), 1893
Pastel on paper, 18½ × 22 in. (47 × 56 cm)
Musée Marmottan Monet, Paris, bequest of Annie Rouart, 1993, 6031
Fig. 141, p. 224

Berthe Morisot
Sur un banc au bois de Boulogne (On a bench in the Bois de Boulogne), 1894
Oil on canvas, 15 × 22 in. (38.2 × 55.3 cm)
Musée d'Orsay, Paris, bequest of Nadia Boulanger, 1980, RF 1980-43
Fig. 136, p. 212

Martin Parr (b. 1952)
Untitled, from the series *The Last Resort*, 1984–1985
Color photograph, 12 × 16 in. (30 × 40 cm)
Frac Provence-Alpes-Côte d'Azur Collection, Marseille, 86.109 (A)
Fig. 133, p. 206

Martin Parr
Untitled, from the series *The Last Resort*, 1984–1985
Color photograph, 12 × 16 in. (30 × 40 cm)
Frac Provence-Alpes-Côte d'Azur Collection, Marseille, 86.109 (D)
Fig. 32, p. 52

Lilla Cabot Perry (1848–1933)
At the River's Bend (On the River II), 1895
Oil on canvas, 25½ × 32 in. (64.8 × 81.3 cm)
The Art Institute of Chicago, Chicago, partial gift of Abbot W. and Marcia L. Vose; through prior bequest of Arthur Rubloff; through prior gift of James D. Thornton, Mrs. Abram Poole, and Elizabeth Sprague Coolidge; through prior bequest of Celia Schmidt; Mr. and Mrs. Frank G. Logan Purchase Prize Fund; Mr. and Mrs. Frederick G. Wacker Endowment Fund, 2020.219
Fig. 150, p. 234

Camille Pissarro (1830–1903)
Les Enfants jouant sur le tapis (Rodo et Jeanne) (Children playing on the rug [Rodo and Jeanne]), 1883
Watercolor and gouache on paper, 9 × 11 in. (23 × 28 cm)
Private collection
Fig. 65, p. 106

Camille Pissarro
Femme étendant du linge (Woman hanging laundry), 1887
Oil on canvas, 16 × 13 in. (41 × 33 cm)
Musée d'Orsay, Paris, bequest of Enriqueta Alsop, in the name of Dr. Eduardo Mollard, 1972, RF 1972 29
Fig. 35, p. 57

Camille Pissarro
Jeanne Pissarro dite Minette (Portrait of Minette), 1872
Oil on canvas, 18 × 14 in. (45.7 × 35.2 cm)
The Ella Gallup Sumner and Mary Catlin Sumner Collection Fund, Wadsworth Atheneum Museum of Art, Hartford, CT, 1958.144
Fig. 47, p. 78

Camille Pissarro
Jeanne Pissarro dite Minette, au bouquet (Portrait of Jeanne Pissarro), 1872
Oil on canvas, 28½ × 23½ in. (72.7 × 59.5 cm)
John Hay Whitney Collection, Yale University Art Gallery, New Haven, B.A. 1926, M.A. (Hon.) 1956, 1982.111.4
Fig. 115, p. 181

Camille Pissarro
Jeune homme écrivant (Portrait de Rodo) et Paul-Émile Pissarro (Young man writing [Portrait of Rodo] and Paul-Émile Pissarro), c. 1895
Original lithograph on zinc, 9 × 5 in. (23 × 13 cm); 14 × 10½ in. (35.8 × 27 cm) including margins
Musée des Impressionnismes, Giverny, acquired in 2022, MDIG 2022.10.1
Fig. 82, p. 134

Camille Pissarro
Paul-Émile Pissarro, 1890
Oil on canvas, 16 × 13 in. (41 × 33.6 cm)
Private collection
Fig. 46, p. 77

Camille Pissarro
Paul-Émile Pissarro peignant (Paul-Émile Pissarro painting), 1898
Oil on canvas, 21½ × 18 in. (55 × 46 cm)
Private collection
Fig. 81, p. 133

Camille Pissarro
Portrait de Jeanne dite Cocotte, au chignon (Portrait of Cocotte with her hair in a chignon), 1898
Oil on canvas, 22 × 18½ in. (56 × 47 cm)
The Rau Collection for Unicef, Arp Museum Bahnhof Rolandseck, Remagen, GR 1.621
Fig. 48, p. 79

Ferdinand du Puigaudeau (1864–1930)
Fête nocturne à Saint-Pol-de-Léon (Night Fair at Saint-Pol-de-Léon), 1894–1898
Oil on canvas, 23½ × 28½ in. (60 × 73 cm)
Carmen Thyssen-Bornemisza Collection, on long-term loan to the Museo Nacional Thyssen-Bornemisza, Madrid, CTB.1999.15
Fig. 67, pp. 108–109

Ferdinand du Puigaudeau
Fillettes de Bourg-de-Batz (Little girls in Bourg-de-Batz), 1895
Oil on canvas, 21½ × 15 in. (55 × 38 cm)
Musée de Pont-Aven Collection, Pont-Aven, 1998.12.1
Fig. 83, p. 135

Ferdinand du Puigaudeau
Mère et enfant (Mother and
child), c. 1894–1898
Pen and blue pencil on
tracing paper, 12½ × 8½ in.
(31.2 × 21.1 cm)
Private collection
Fig. 167, p. 252

Pierre-Auguste Renoir
(1841–1919)
*L'Après-midi des enfants
à Wargemont* (Children's
Afternoon at Wargemont),
1884
Oil on canvas, 4 ft. 2 in. ×
5 ft. 8 in. (127 × 173 cm)
Alte Nationalgalerie,
Staatliche Museen zu Berlin,
Berlin
Fig. 72, p. 120

Pierre-Auguste Renoir
*Le Chapeau épinglé, or Les
Jeunes Filles: La fille de
Berthe Morizot [sic] et sa
cousine (2ᵉ planche)* (Pinning
the hat, or Young girls: The
daughter of Berthe Morizot
[sic] and her cousin [2nd
plate]), 1898
Lithograph printed in color,
36 × 18 in. (91 × 46.2 cm
[sheet])
Jacques Doucet Collection,
Bibliothèque de l'Institut
National d'Histoire de l'Art,
Paris,
EM RENOIR 12 gdf
Fig. 143, p. 227

Pierre-Auguste Renoir
Coco écrivant (Coco writing),
c. 1906
Oil on canvas, 12 × 14½ in.
(31 × 37.4 cm)
Musée des Beaux-Arts, Lyon,
bequest of Léon et Marcelle
Bouchut, 1974, 1974-29
Fig. 163, p. 247 (vignette)

Pierre-Auguste Renoir
Coco écrivant (Coco writing),
1906
Lithograph, 13 × 19½ in.
(33 × 50 cm)
Musée Albert-André,
Bagnols-sur-Cèze,
AA 013.0.94
Fig. 164, p. 247 (vignette)

Pierre-Auguste Renoir
*Enfant assis en robe bleue
(Portrait d'Edmond Renoir
fils)* (Seated child in a blue
dress [Portrait of Edmond
Renoir, son]), 1889
Oil on canvas, 25½ × 21½ in.
(65 × 54 cm)
David and Ezra Nahmad
Collection
Fig. 112, p. 177

Pierre-Auguste Renoir
La Famille de l'artiste
(The Artist's Family), 1896
Oil on canvas, 5 ft. 8 in. ×
4 ft. 6 in. (1.73 × 1.37 m)
The Barnes Foundation,
Philadelphia
Fig. 43, p. 71

Pierre-Auguste Renoir
Femme allaitant un enfant
(A Woman Nursing a Child),
1893–1894
Oil on canvas, 16 × 13 in.
(41.2 × 32.5 cm)
National Galleries of
Scotland, Edinburgh, gift of
Sir Alexander Maitland in
memory of his wife, Rosalind,
1960, NG 2230
Fig. 27, p. 47

Pierre-Auguste Renoir
Fernand Halphen enfant
(Fernand Halphen as a Boy),
1880
Oil on canvas, 18 × 15 in.
(46.2 × 38.2 cm)
Musée d'Orsay, Paris, gift of
Georges Halphen, 1995,
RF 1995-12
Fig. 116, p. 182

Pierre-Auguste Renoir
Gabrielle et Jean (Gabrielle
and Jean), 1895–1896
Oil on canvas, 25½ × 21½ in.
(65 × 54 cm)
Walter-Guillaume Collection,
Musée de l'Orangerie, Paris,
RF 1960-18
Fig. 28, p. 49

Pierre-Auguste Renoir
Le Garçon au chat (The boy
with the cat), 1868
Oil on canvas, 4 ft. ½ in. ×
2 ft. 2 in. (123.5 × 66 cm)
Musée d'Orsay, Paris
Fig. 90, p. 146

Pierre-Auguste Renoir
*Geneviève Bernheim
de Villers*, 1910
Oil on canvas, 21 × 17½ in.
(53 × 44.5 cm)
Musée d'Orsay, Paris, gift of
M. and Mme. Gaston
Bernheim de Villers, 1951,
RF 1951-30
Fig. 61, p. 101

Pierre-Auguste Renoir
*Irène Cahen d'Anvers
(Irène Cahen d'Anvers
[Little Irène])*, 1880
Oil on canvas, 25½ × 21½ in.
(65 × 54 cm)
Emil Bührle Collection, on
long-term loan to the
Kunsthaus, Zurich
Fig. 37, p. 60

Pierre-Auguste Renoir
Jean dessinant (The Artist's
Son, Jean, Drawing) 1901
Oil on canvas, 18 × 21½ in.
(45.1 × 54.6 cm)
Mr. and Mrs. Paul Mellon
Collection, Virginia Museum
of Fine Arts, Richmond, 83.48
Fig. 45, p. 75

Pierre-Auguste Renoir
*La Leçon (Bielle, l'institutrice
et Claude Renoir lisant)* (The
lesson [Bielle, the teacher,
and Claude Renoir reading]),
c. 1906
Oil on canvas, 26 × 33½ in.
(65.5 × 85.5 cm)
David and Ezra Nahmad
Collection
Fig. 69, p. 112

Pierre-Auguste Renoir
*Madame Georges
Charpentier et ses enfants
(Madame Georges
Charpentier and Her
Children)*, 1878
Oil on canvas, 5 ft. ½ in. ×
6 ft. 3 in. (1.53 × 1.9 m)
The Metropolitan Museum of
Art, New York
Fig. 85, p. 140

Pierre-Auguste Renoir
*Madame Monet et son fils
(Madame Monet and Her
Son)*, 1874
Oil on canvas, 20 × 27 in.
(50.4 × 68 cm)
Ailsa Mellon Bruce Collection,
National Gallery of Art,
Washington, D.C.
Fig. 108, p. 171

Pierre-Auguste Renoir
Maternité (Motherhood),
1885
Oil on canvas,
3 ft. × 2 ft. 4½ in. (92 × 72 cm)
Musée d'Orsay, Paris
Fig. 41, p. 69

Pierre-Auguste Renoir
Mère et enfant (Mother and
Child), 1890
Sanguine on paper,
12½ × 8½ in. (32 × 22 cm)
Musée Albert-André,
Bagnols-sur-Cèze,
AA 013.0.98
Fig. 165, p. 247 (vignette)

Pierre-Auguste Renoir,
Richard Guino (1890–1973)
Mère et enfant (Mother and
Child), 1916
Bronze, 21½ × 11 × 12½ in.
(55 × 28 × 32 cm)
Musée des Beaux-Arts, Lyon,
1974-62
Fig. 26, p. 46

Pierre-Auguste Renoir
*Pêcheuses de moules
à Berneval* (Mussel Fishers at
Berneval), 1879
Oil on canvas, 5 ft. 9½ in. ×
4 ft. 3½ in. (1.76 × 1.3 m)
The Barnes Foundation,
Philadelphia
Fig. 38, p. 64

Pierre-Auguste Renoir
Portrait de Coco (Head
of Coco), 1907–1908
Bronze, 14½ × 8 × 8 in.
(37 × 20 × 20 cm)
Petit Palais, Musée des
Beaux-Arts de la Ville de
Paris, Paris PPS3420
Fig. 166, p. 247 (vignette)

Pierre-Auguste Renoir
Portrait de Jean (Portrait of
Jean), 1899
Oil on canvas, 16 × 12½ in.
(40 × 32 cm)
Musée des Beaux-Arts,
Limoges, gift of the artist to
the city of Limoges in 1900,
P.212
Fig. 44, p. 73

Pierre-Auguste Renoir
Portrait de Joseph Le Cœur
(Portrait of Joseph Le Cœur),
1870
Oil on canvas, 10½ × 8½ in.
(27 × 21.5 cm)
Musée Unterlinden, Colmar,
88.RP.413
Fig. 40, p. 66

Pierre-Auguste Renoir
*Portraits des enfants
de Martial Caillebotte*
(The Children of Martial
Caillebotte), 1895
Oil on canvas, 25½ × 32½ in.
(65 × 82 cm)
Private collection
Fig. 74, p.123

Pierre-Auguste Renoir
*Robert Nunès, or Jeune
garçon sur la plage d'Yport
(Sailor Boy [Portrait of Robert
Nunès])*, 1883
Oil on canvas, 4 ft. 4 in. ×
2 ft. 7½ in. (131 × 80 cm)
The Barnes Foundation,
Philadelphia
Fig. 39, p. 66

Laurence Reynaert (b. 1957)
Portraits, 2000–2003
Black-and-white print on
baryta paper, 16 × 19½ in.
(40 × 50 cm)
Frac Normandie Collection,
Sotteville-lès-Rouen,
2005.125.4
Fig. 144, p. 228

Laurence Reynaert
Portraits, 2000–2003
Black-and-white print on
baryta paper, 16 × 19½ in.
(40 × 50 cm)
Frac Normandie Collection,
Sotteville-lès-Rouen,
2005.126.5
Fig. 119, p. 186

Laurence Reynaert
Portraits, 2000–2003
Black-and-white print on
baryta paper, 16 × 19½ in.
(40 × 50 cm)
Frac Normandie Collection,
Sotteville-lès-Rouen,
2005.127.6
Fig. 10, p. 8

Laurence Reynaert
Portraits, 2000–2003
Black-and-white print on
baryta paper, 16 × 19½ in.
(40 × 50 cm)
Frac Normandie Collection,
Sotteville-lès-Rouen,
2005.128.7
Fig. 9, p. 8

Laurence Reynaert
Portraits, 2000–2003
Black-and-white print on
baryta paper, 16 × 19½ in.
(40 × 50 cm)
Frac Normandie Collection,
Sotteville-lès-Rouen,
2005.129.8
Fig. 63, p. 104

Laurence Reynaert
Portraits, 2000–2003
Black-and-white print on
baryta paper, 16 × 19½ in.
(40 × 50 cm)
Frac Normandie Collection,
Sotteville-lès-Rouen,
2005.130.9
Fig. 51, p. 84

Laurence Reynaert
Portraits, 2000–2003
Black-and-white print on
baryta paper, 16 × 19½ in.
(40 × 50 cm)
Frac Normandie Collection,
Sotteville-lès-Rouen,
2005.131.10
Fig. 16, p. 13

Laurence Reynaert
Portraits, 2000–2003
Black-and-white print on
baryta paper, 16 × 19½ in.
(40 × 50 cm)
Frac Normandie Collection,
Sotteville-lès-Rouen,
2005.132.11
Fig. 15, p. 13

John Russell (1858–1930)
Fils du peintre jouant avec un crabe (The Painter's Sons Playing with a Crab), 1904–1906
Oil on canvas, 26 × 26 in. (65.8 × 65.8 cm)
Musée d'Orsay, Paris, 20666, on long-term loan to the Musée de Morlaix, Morlaix, D.997.1.1.17
Fig. 134, p. 207

Joaquín Sorolla (1863–1923)
Sobre la arena, Playa de Zarauz (On the Sand, Zarauz Beach), 1910
Oil on canvas, 3 ft. 3 in. × 4 ft. 1 in. (99 × 125 cm)
Museo Sorolla, Madrid, MSM-00888
Fig. 130, pp. 202–203

Philip Wilson Steer (1860–1942)
Mrs. Cyprian Williams and Her Two Little Girls, 1891
Oil on canvas, 2 ft. 6 in. × 3 ft. 4 in. (76.2 × 102.2 cm)
Tate, London
Fig. 73, p. 123

Alfred Stevens (1823–1906)
René Peter enfant (René Peter as a child), 1880
Oil on canvas, 11 × 9 in. (27.5 × 22.5 cm)
Musée d'Orsay, Paris, bequest of the model, René Peter, 1948, RF 1948-19
Fig. 117, p. 183

Otto von Thoren (1828–1889)
Enfants jouant sur la plage de Trouville (Children playing on the beach at Trouville), 1890–1900
Oil on wood, 12 × 20 in. (30 × 51 cm)
Musée d'Orsay, Paris, recovered after World War II and entrusted to the French national museums; on long-term loan to the Musée de Dieppe since 1961, MNR 968
Fig. 128, p. 199

Henry Scott Tuke (1858–1929)
Portrait of Jack Rolling, 1888
Oil on board, 12 × 9½ in. (30 × 23.6 cm)
Royal Cornwall Polytechnic Society Collection, Falmouth Art Gallery, Falmouth, A15
Fig. 138, p. 217

Henry Scott Tuke
William J. Martin, December 1890
Oil on mahogany panel, 14 × 10 in. (36 × 26 cm)
Royal Cornwall Polytechnic Society Collection, Falmouth Art Gallery, Falmouth, FAMAG RCPS, 2015.8.405
Fig. 137, p. 215

Jens Ferdinand Willumsen (1863–1958)
Sol og ungdom (Sun and Youth), 1910
Oil on canvas, 8 ft. 9 in. × 14 ft. (2.66 × 4.27 m)
Göteborgs Konstmuseum, Göteborg
Fig. 129, p. 201

Federico Zandomeneghi (1841–1917)
Fanciulla dormiente (A letto) (In Bed [Sleeping Girl]), 1878
Oil on canvas, 23½ × 29 in. (60 × 74 cm)
Galleria d'Arte Moderna, Palazzo Pitti, Florence, Catalogo Generale 261, Comune n. 11
Fig. 146, p. 230

Federico Zandomeneghi
La lezione (The lesson), 1902
Pastel on paper mounted on cardboard, 21½ × 18 in. (55 × 46.5 cm)
Musei Civici, Comune di Mantova, Mantua
Fig. 148, p. 232

Federico Zandomeneghi
La Leçon de chant, or *La lezione di canto (The Singing Lesson)*, 1890
Oil on canvas, 25½ × 21½ in. (65 × 54.6 cm)
Intesa Sanpaolo Collection, Gallerie d'Italia, Milan, 003202
Fig. 78, p. 129

Selected Bibliography

Works by Artists

Cabot Perry, Lilla. "Reminiscences of Claude Monet from 1889 to 1909." *The American Magazine of Art* 18, no. 3 (March 1927): 119–126.

Degas, Edgar. *Degas: Letters*. Edited by Marcel Guérin. Oxford: Bruno Cassirer, 1947.

Manet, Julie. *Journal, 1893–1899*. Paris: Scala, 1987.

Mirbeau, Octave. *Correspondance générale*. Edited by Pierre Michel and Jean-François Nivet. 4 vols. Lausanne: L'Âge d'Homme, 2002–2022.

Morisot, Berthe. *The Correspondence of Berthe Morisot with Her Family and Her Friends: Manet, Puvis de Chavannes, Degas, Monet, Renoir, and Mallarmé*. Edited by Denis Rouart. Translated by Betty W. Hubbard. New York: George Wittenborn Inc., 1957.

Pissarro, Camille. *Correspondance de Camille Pissarro*. Edited by Janine Bailly-Herzberg. 4 vols. Paris: Éditions du Valhermeil, 1980–1991.

Renoir, Pierre-Auguste. *Écrits et propos sur l'art*. Edited by Augustin de Butler. Paris: Hermann, 2009.

Renoir, Pierre-Auguste, and Paul Durand-Ruel. *Correspondance de Renoir et Durand-Ruel 1881–1906*. Edited by Caroline Durand-Ruel Godfroy. Lausanne: La Bibliothèque des Arts, 1995.

General Works

Baudot, Jeanne. *Renoir: Ses amis, ses modèles*. Paris: Éditions Littéraires de France, 1949.

Breeskin, Adelyn Dohme. *Mary Cassatt: A Catalogue Raisonné of the Oils, Pastels, Watercolors, and Drawings*. Washington, D.C.: Smithsonian Institution Press, 1970.

Caradec, François. *Histoire de la littérature enfantine en France*. Paris: Albin Michel, 1977.

D'Allemagne, Henry René. *Histoire des jouets*. Paris: Hachette, 1902.

Delarue, Bruno. *Boudin à Deauville-Trouville*. Fécamp: Éditions Terre en Vue, 2015.

Énaud-Lechien, Isabelle. *Mary Cassatt: Une Américaine chez les impressionnistes*. Paris: Éditions Somogy, 2018.

Florisoone, Michel. "Renoir et la famille Charpentier." *L'Amour de l'art* (February 1938).

Gélineau, Jean-Claude. *Jeanne Tréhot: La fille cachée de Pierre-Auguste Renoir*. Essoyes: Éditions du Cadratin, 2007.

Georgel, Chantal. *L'Enfant et l'image au XIXe siècle*. Les Dossiers du Musée d'Orsay (Paris: Réunion des Musées Nationaux), no. 24 (1988).

Gobillard-Valéry, Jeannie. *Eurêka: Souvenirs & journal (1894–1901)*. Edited by Marianne Mathieu and Claire Gooden. Paris: Musée Marmottan Monet/Éditions de Cendres, 2022.

Heller, Friedrich C. "Maurice Boutet de Monvel, illustrateur de livres d'enfant." *Revue de la Bibliothèque nationale*, no. 27 (Spring 1988).

Herbert, Robert L. *Impressionism: Art, Leisure, and Parisian Society*. New Haven: Yale University Press, 1991.

Hoschedé, Jean-Pierre. *Blanche Hoschedé–Monet, peintre impressionniste*. Rouen: Lecerf, 1961.

———. *Claude Monet, ce mal connu: Intimité familiale d'un demisiècle à Giverny de 1883 à 1926*. Geneva: Pierre Cailler, 1960.

Le Cœur, Marc. *Renoir au temps de la bohème*. Paris: L'Échoppe, 2002.

Lecomte, Georges. *Camille Pissarro*. Paris: Bernheim-Jeune, 1922.

Mowll Mathews, Nancy, and Barbara Stern Shapiro. *Mary Cassatt: The Color Prints*. New York: Harry N. Abrams, 1989.

Murard, Lion, and Patrick Zylberman. *L'Hygiène dans la République: La santé publique en France ou l'utopie contrariée (1870–1918)*. Paris: Fayard, 1998.

Perrot, Michelle. *La Vie de famille au XIXe siècle*. Paris: Points, 2015.

Pissarro, Joachim, and Claire Durand-Ruel Snollaerts. *Pissarro: Critical Catalog of Paintings*. Translated by Mark Hutchinson and Mike Taylor. 3 vols. Geneva: Wildenstein Institute/Skira, 2005.

Pollock, Griselda. *Mary Cassatt: Painter of Modern Women*. London and New York: Thames & Hudson, 2022.

Renoir, Jean. *Renoir: My Father*. Boston: Little, Brown, 1962.

———. *Écrits (1926–1971)*. Paris: Ramsay, 2006.

Robida, Michel. *Renoir: Children*. New York: French and European Publications, 1962.

Robinson, Cicely. *Henry Scott Tuke*. New Haven: Yale University Press, 2021.

Rollet, Catherine. *La Politique à l'égard de la petite enfance sous la IIIe République*. Paris: Ined/PUF, 1990.

———. *Les Enfants au XIXe siècle*. La Vie Quotidienne. Paris: Hachette Littératures, 2001.

Savy, Nicole, ed. *Les Petites Filles modernes*. Les Dossiers du Musée d'Orsay 33. Paris: Réunion des Musées Nationaux, 1989.

Segard, Achille. *Mary Cassatt: Un peintre des enfants et des mères*. Paris: P. Ollendorff, 1913.

Fig. 167 Ferdinand du Puigaudeau (1864–1930), *Mère et enfant* (Mother and child), c. 1894–1898.
Pen and blue pencil on tracing paper, 12½ × 8½ in. (31.2 × 21.1 cm). Private collection.

Simon, Marie. *Fashion in Art: The Second Empire and Impressionism.* London: Philip Wilson Publishers, 1995.

Smart, Mary. "Sunshine and Shade: Mary Fairchild MacMonnies Low." *Woman's Art Journal* 4, no. 2 (Fall 1983–Winter 1984).

Thiébaut, Philippe. "Baigneurs au 19ᵉ siècle: caleçons, costumes et slips." *Cultures physique –Cultures visuelles, Apparence(s)* 10 (2021).

Todd, Pamela. *The Impressionists at Home.* London: Thames & Hudson, 2005.

Wildenstein, Daniel. *Claude Monet: Biographie et catalogue raisonné.* Lausanne and Paris: La Bibliothèque des Arts, 1974–1985.

Exhibition Catalogs

André Brouillet, 1857–1914. Philippe Bata, Marie-Véronique Clin, Catherine Duffault, et al. Poitiers: Musée de la Ville de Poitiers and Musée de la Société des Antiquaires de l'Ouest/ Saintes: Musées de la Ville de Saintes, 2000. Published in conjunction with the exhibition held at the Musée Sainte-Croix, Poitiers; Musée de l'Échevinage, Saintes.

L'Art et l'enfant: Chefs-d'œuvre de la peinture française. Edited by Jacques Gélis, contributions by Marianne Mathieu and Dominique Lobstein. Paris: Musée Marmottan Monet/ Vanves: Hazan, 2016. Published in conjunction with the exhibition held at the Musée Marmottan Monet, Paris.

Berthe Morisot. Edited by Sylvie Patry. Paris: Musée d'Orsay/Flammarion, 2019. Published in conjunction with the exhibition held at the Musée d'Orsay, Paris.

Dans la lumière de l'impressionnisme: Édouard Debat-Ponsan (1847–1913). Sophie Join-Lambert, Véronique Moreau, and Karine Kukielzak. Paris: Mare et Martin, 2014. Published in conjunction with the exhibition held at the Musée des Beaux-Arts, Tours.

Les Enfants modèles: De Claude Renoir à Pierre Arditi. Jean-Marc Irollo, Paul Denis, Marie-Madeleine Massé, et al. Paris: Réunion des Musées Nationaux, 2009. Published in conjunction with the exhibition held at the Musée de l'Orangerie, Paris.

Être jeune au temps des impressionnistes, 1860–1910. Dominique Lobstein and Yannick Marec. Honfleur: Société des Amis du Musée Eugène-Boudin, 2016. Published in conjunction with the exhibition held at the Musée Eugène-Boudin, Honfleur.

Gauguin. Richard R. Brettell, Françoise Cachin, Claire Frèches-Thory, and Charles F. Stuckey. Paris: Réunion des Musées Nationaux, 1988. Published in conjunction with the exhibition held at the National Gallery of Art, Washington, D.C.; The Art Institute of Chicago, Chicago; Galeries Nationales du Grand Palais, Paris.

Impressionism, Fashion, and Modernity. Edited by Gloria Groom. Chicago: The Art Institute of Chicago, 2012. Published in conjunction with the exhibition held at the Musée d'Orsay, Paris; the Metropolitan Museum of Art, New York; The Art Institute of Chicago, Chicago.

Impressionists by the Sea. John House. London: Royal Academy of Arts, 2007. Published in conjunction with the exhibition held at the Royal Academy of Arts, London; The Phillips Collection, Washington, D.C.; Wadsworth Atheneum Museum of Art, Hartford.

Julie Manet: An Impressionist Heritage. Edited by Marianne Mathieu. Paris: Musée Marmottan Monet/ Hazan, 2022. Published in conjunction with the exhibition held at the Musée Marmottan Monet, Paris.

La Mode et l'enfant, 1780–2000. Catherine Join-Diéterle, Françoise Tétart-Vittu, and Isabelle Jolfre. Paris: Paris-Musées, 2001. Published in conjunction with the exhibition held at the Musée Galliera and Musée de la Mode de la Ville de Paris, Paris.

Lilla Cabot Perry: An American Impressionist. Meredith Martindale and Pamela Moffat. Washington, D.C.: The National Museum of Women in the Arts, 1990. Published in conjunction with the exhibition held at the National Museum of Women in the Arts, Washington, D.C.

Livres d'enfants, livres d'images. Ségolène Le Men and Anne Renonciat. Paris: Les Dossiers du Musée d'Orsay 35, Réunion des Musées Nationaux, 1989. Published in conjunction with the exhibition held at the Réunion des Musées Nationaux, Paris.

Lobstein, Dominique. "Les portraits d'enfants dans les Salons parisiens." In Sandrine Duclos, ed. *Carolus-Duran: Portraits d'enfants,* CD-ROM. Saintes: Musée des Beaux-Arts, 2003. Published in conjunction with the exhibition held at the Musée des Beaux-Arts, Saintes.

Mary Cassatt: An American Impressionist in Paris. Edited by Flavie Durand-Ruel Mouraux, Nancy Mowll Mathews, and Pierre Curie. Brussels: Mercatorfonds, 2018. Published in conjunction with the exhibition held at the Musée Jacquemart-André, Paris.

Mary Cassatt: Modern Woman. Edited by Judith A. Barter. Chicago: Art Institute of Chicago/New York in association with H. N. Abrams, 1998. Published in conjunction with the exhibition held at the Boston Museum of Fine Arts; the National Gallery in Washington, D.C.; the Art Institute of Chicago, Chicago.

Mary Cassatt: Prints and Drawings from the Collection of Ambroise Vollard. Marc Rosen, Nancy Mowll Mathews, and Sarah Bertalan. New York: Adelson Galleries, 2008. Published in conjunction with the exhibition held at the Adelson Galleries, New York.

Origins of Impressionism. Henri Loyrette and Gary Tinterow. New York: Metropolitan Museum of Art, 2013. Published in conjunction with the exhibition shown at the Galeries Nationales du Grand Palais, Paris; Metropolitan Museum of Art, New York.

Les Pissarro: Une famille d'artistes au tournant des XIXᵉ et XXᵉ siècles. Edited by Christophe Duvivier. Pontoise: Musées de Pontoise, 2015. Published in conjunction with the exhibition held at the Musées de Pontoise, Pontoise.

Renoir: Father and Son/ Painting and Cinema. Edited by Sylvie Patry. Paris: Musée d'Orsay/Flammarion, 2018. Published in conjunction with the exhibition held at the Musée d'Orsay, Paris; the Barnes Foundation, Philadelphia.

Renoir/Renoir. Edited by Serge Lemoine and Serge Toubiana. Paris: La Martinière, 2005. Published in conjunction with the exhibition held at the Cinémathèque Française, Paris.

Sorolla: Un peintre espagnol à Paris. Edited by Blanca Pons-Sorolla and Maria Lopez Fernandez. Giverny: Musée des Impressionnismes/Paris: Éditions El Viso, 2016. Published in conjunction with the exhibition held at the Musée des Impressionnismes, Giverny.

Index

Page numbers in **bold** refer to illustrations

Photographic Credits